More Praise for Impure *Acts*

"There is no one writing in the U.S. today who can bridge culture, politics, and pedagogy as brilliantly as Henry Giroux does in Impure *Acts*. Once again with this book Giroux remains unchallenged as the premiere scholar of critical and cultural pedagogy."

—**Kostas Myrsiades**, West Chester University

"This is a hardhitting work. Giroux refuses to yield any ground to the right and its current attacks on cultural studies and the politics of the left. Once again Giroux advances the discourse in this field, outlining a critical pedagogical project that locates resistance and political insurgency at every level of daily cultural life. This work requires careful study and close analysis."

—**Norman K. Denzin**, University of Illinois at Urbana-Champaign

"Henry Giroux deftly shows how corporate culture functions as a cultural teaching machine that thwarts democratic practice. By forging links between critical educators and cultural studies scholars, he redefines the crucial role both can play as public intellectuals attuned to the economic, social, and ideological power relations of multinational capitalism."

—**Lee Quinby**, Rochester Institute of Technology

impure
acts

THE PRACTICAL

POLITICS OF

CULTURAL

STUDIES

Henry A. Giroux

Routledge
New York London
2000

Published in 2000 by

Routledge
29 West 35th Street
New York, NY 10001

Published in Great Britain by

Routledge
11 New Fetter Lane
London EC4P 4EE

Library of Congress Cataloging-in-Publication Data

Giroux, Henry A.
 Impure acts : the practical politics of cultural studies /
 Henry A. Giroux.
 p. cm.
 Includes bibliographical references and index.
 ISBN 0-415-92655-6 (hb) — ISBN 0-415-92656-4 (pb)
 1. Politics and culture—United States.
 2. United States—Civilization—1970.
 3. Culture—Study and teaching—United States.
 4. Political culture—United States.
 5. Multiculturalism—United States.
 6. Popular culture—United States.
 7. Mass media—Political aspects—United States.
 8. Technological innovations—Social aspects—
 United States. I. Title.

E169.12.G565 2000
973.92—dc21 99-054011

For Susan

contents

acknowledgments

In writing this book, I have drawn on the help and work of a number of people. I owe an enormous theoretical debt to Lawrence Grossberg, Stuart Hall, Stanley Aronowitz, Robin Kelley, and David Theo Goldberg. I also want to thank Carol Becker for her unfailing support in providing me with an opportunity to teach and think through some of the ideas in this book while in Chicago during the summer of 1999. Paul Youngquist, Imre Szeman, Ralph Rodriquez, and Donaldo Macedo offered feedback and wonderful conversations about different sections of the manuscript. Eric Weiner provided extraordinary research assistance and Heidi Hendershott was always looking over my shoulder and providing new material for me to read. Ken Saltman provided invaluable criticism on a number of chapters. I am deeply indebted to Bill Germano, my editor, for supporting this project from its inception and pushing me hard to make a number of important revisions, and to Sue Stewart for all of her great administrative help. I would also like to thank my students and all the members of the Wednesday study group, who are always a great source of hope and education for me. Thanks, Grizz. Thanks to my three wonderful boys, Jack, Brett, and Chris, whose visits always saved me from working too much. To my wonderful partner, Susan Searls Giroux, who read, edited, and was engaged in every page of this manuscript. This book is dedicated to her for her intelligence, warmth, and comradeship in both good and hard times.

Needless to say, the views represented in this book are my own, and I make no pretense to speak for the field(s) of cultural studies. This book has been in my head for over a decade and based on my ongoing experiences in and outside of the academy, many conversations with friends, and ongoing research in the areas of social theory, critical pedagogy, and cultural politics. What emerges is a critical analysis that hopefully will contribute to the ongoing debate about the purpose and meaning of cultural studies, particularly one that links theory and practice, knowledge and power, and economic justice and cultural politics as part of a broader project of deepening and expanding the principles of a radical democracy to all aspects of society.

Some of these chapters contain sections drawn from previously published material, which appeared in the following: *The Arizona Journal of Hispanic Cultural Studies*; *Journal of Composition Theory*; and Henry A. Giroux, *Corporate Culture and the Attack on Higher Education and Public Schooling* (Bloomington, Ind.: Phi Delta Kappa Educational Foundation, 1999); Henry A. Giroux, "The War Against Cultural Politics: Beyond Conservative and Neo-Enlightenment Left 'Oppositions': A Critique," in Carlos J. Ovando and Peter McLaren, eds. *The Politics of Multiculturalism and Bilingual Education: Students and Teachers Caught in the Crossfire* (New York: McGraw-Hill, 2000) pp. 50-61.

Revitalizing
the Culture
of Politics

An Introduction

What does it mean to take seriously, in our present conjuncture, the thought that cultural politics and questions of culture, of discourse, of metaphor are absolutely deadly political questions?

—Stuart Hall, "Subjects in History: Making Diasporic Identities"

THE CRISIS OF POLITICAL CULTURE

Within the current historical conjuncture, cultural issues appear to dominate the American political landscape, but in a framework that might best be described as schizophrenic. Viewed as a sphere of impressive technological inventiveness, on the one hand, and a terrain beset by the increasing contradictions of democracy on the other, culture is both celebrated and scorned. In the first instance, there is the general recognition that the new technologies of culture, obvious in all things electronic and computer based, have radically altered the traditional relationship between science and progress, on one hand,

and the private and public spheres on the other. Information has now become capital; the circulation of texts, speech, and images are no longer impeded by space. Moreover, the culture of print has been forever altered by the rise of a powerful visual and digitally produced culture. For many, this radical change within the cultural sphere represents a new revolution in the marriage of technology and the applied sciences, refashioning how we think of power, politics, and everyday life as part of a larger, wired global reality. But the breakthrough in the computer-based information revolution elicits more than awe; it also signals new configurations of wealth, power, and leadership, partly mirrored in the control exercised by media conglomerates such as Disney, Viacom, and Time Warner, and in the endless media celebration of corporate leadership patterned after the Bill Gates clones that sprout up daily in Silicon Valley.[1]

The electronic and technical innovations in the cultural sphere, such as the Internet, cable television, and digitally based communication systems, constitute new and powerful components in shaping how we define, understand, and mediate all things social. Yet the largely positive view of culture that accompanies such innovations appears almost exclusively in technical and practical terms, which leads in the second instance to the negative "other" of culture. Although the politics of culture fashioned as a technological laboratory (what Herbert Marcuse calls "the totality of instruments, devices and contrivances which characterize"[2] the cultural sphere) retains a glimmer of progress in the popular imagination, the culture of politics — culture's capacity to give rise to and nourish those discursive resources and material relations of power that shape democratic public life — appears to be in crisis, subject to derision and scorn by forces that occupy a wide range of ideological perspectives. Many educators, intellectuals, and policy makers view the notion of culture as a dangerous or romantic form of practical politics, with its proliferation of critical discourses designed to address major social problems and remake institutional arrangements.[3] According to pundits across the ideological spectrum, the strategic and performative nature of culture as a terrain of politics, having some purchase on creating social change through the expansion of democratic identities, relations, and institutional arrangements, is posed as either a threat to estab-

lished configurations of power or as a cynical diversion from "real" class-based, political struggles.

The evisceration of political culture is especially evident in a post–Littleton, Colorado, and post–Monica Lewinsky climate in which cynicism replaces hope as the vast majority of the nation's people feel removed from an electoral democratic system whose impact seems most felt in the tabloid media, while largely absent from social life. Politics signals its own exhaustion as it appears largely as a choice, as Russell Jacoby sees it, "between the status quo or something worse. Other alternatives do not seem to exist."[4] Coupled with the general public's increasing loss of faith in public government, public institutions, and the democratic process, the only form of agency or civic participation offered to the American people is consumerism as opposed to substantive forms of citizenship.[5] As Robert W. McChesney argues,

> To be effective, democracy requires that people feel a connection to their fellow citizens, and that this connection manifests itself through a variety of nonmarket organizations and institutions. A vibrant political culture needs community groups, libraries, public schools, neighborhood organizations, cooperatives, public meeting places, voluntary associations, and trade unions to provide ways for citizens to meet, communicate, and interact with their fellow citizens. Neoliberal democracy, with its notion of the market uber alles, takes dead aim at this sector. Instead of citizens, it produces consumers. Instead of communities, it produces shopping malls. The net result is an atomized society of disengaged individuals who feel demoralized and socially powerless.[6]

The erasure of democratic politics from the cultural arena can also be seen in the suppression of dissent across a wide variety of public spheres, including the media, universities, and public schools, which are increasingly coming under the control of megacorporations or being corporatized.[7]

As conglomerates such as Disney, Viacom, Time Warner, and Bertelsmann gobble up tv networks, radio stations, music industries, and a host of other media outlets, it becomes more difficult for stories critical of these concentrated industries to see the light of day. When

Viacom recently acquired CBS most of the stories covering the event in the dominant media focused on the personalities of the top CEOs involved in the deal. With the exceptions of a few reports in the *Boston Globe*, the *New York Times*, and the *Chicago Tribune*, the threat the deal posed to the free flow of information and the implications it might have for undermining a healthy democracy were largely ignored in the dominant media. Concentrated corporate control does not welcome stories or investigative reports that are critical of corporate culture and its policies and practices. For example, soon after Disney bought ABC, Jim Hightower, a popular radio talk show host, was fired for making critical remarks about the Telecommunications Act of 1996 and the Disney corporation. Similarly, in 1998 Disney-owned ABC refused to air a 20/20 segment by Brian Ross that was critical of Disney World and its hiring practices, specifically its refusal to do adequate background checks on its employees. Similar examples can be found in all of the major networks. What is clear is that hard-hitting progressives such as Noam Chomsky, Howard Zinn, Stanley Aronowitz, Angela Davis, and bell hooks rarely appear on national television, national radio, or in the dominant print media.

Similarly, as higher education is increasingly corporatized, it also becomes subject to policies and practices that limit dissent and the free flow of information. For example, progressive and leftist intellectuals find it increasingly difficult to either protect their existing appointments or to get hired. The attack on the democratic principles of academic freedom and intellectual diversity are further exacerbated by the moral panics created in the media by conservative politicians, academics, and policy makers such as William Bennett, Pat Buchanan, Roger Kimball, Charles J. Sykes, Roger Shattuck, and William Kristol. These conservatives benefit significantly from an endless amount of financial backing from such right-wing sources as the John M. Olin Foundation, the Harry Bradley Foundation, and the Smith Richardson Foundation, to name only a few. These conservative public intellectuals are far outside of the mainstream of popular opinion on many issues. Yet they are regularly hosted in the dominant media as celebrities unwaveringly dedicated to bashing left progressive academics and offering instant sound bites about the decline of civility, the corruption of Western values, and the growing need to

purge the universities of any dissenting voices, especially if they come from the left. Clearly, left progressive positions that might offer a challenge to such views are conspicuously missing from the dominant media. Such an assault on the culture of democratic politics is further strengthened as schools divorce themselves from pedagogies and models of learning that address important social issues, interrogate how power works in society, or engage crucial considerations of social justice as constitutive of the interrelationship between cultural practice and democratic politics.

Though most commentators would argue that political culture has been on the decline since Watergate, there is little understanding of the dialogical relationship between culture and democracy. Typically, conservatives believe that American culture is in crisis and the problem is democracy. In this discourse, democracy promotes unpatriotic dissent, moral relativism, the dumbing down of schools, welfare, and the lowering of standards, most of which can be traced to the upheavals of the 1960s.[8] Such sentiments are echoed in the halls of Congress by majority whip Tom DeLay, who believes that the culture of politics has been corrupted by the breakdown of religious values, moral relativism, and the bodies of welfare recipients who drain the national treasury.[9] For DeLay, moral righteousness is the defining postulate of civic virtue and is considered far more important than the democratic principles of liberty, freedom, and equality, which more often than not give rise to forms of dissent that undermine the true believer's faith in "certainty and the absolute conviction [that] they are right."[10] Such views can also be found in high-profile conservatives such as presidential hopefuls Pat Buchanan and Gary Bauer.

For many neoliberals, in contrast, the crisis of political culture is presented in somewhat different terms. In this perspective, democracy is in crisis and the problem is culture. Yet culture is less a problem for its lack of moral principles than it is for its proliferation of cultural differences, its refusal to offer a unified homage to the dictates of the market, and its spread of violence and incivility through popular culture. In this model of liberalism, popular culture threatens the image of the public sphere as white, undermines the liberal notion of consensus, and challenges dominant values that celebrate instant gratification and the endless pursuit of getting and spending.

In this view, the public sphere undermines the freedom associated with private gain and resurrects a notion of the social marked by political differences and the allegedly antagonistic calls for expanding democratic rights. On the other hand, liberalism in its more "compassionate" strains advocates a discourse of culture as gentility and civility, one which dismisses the democratic impulses of mass culture as barbaric, and the ethos and representations of an electronically based popular culture as irredeemably violent, crude, and in poor taste.[11] What both positions share is a cynicism toward and a condemnation of national political culture as impure, sullied, and corrupted by the logic and discourse of difference. Both positions condemn those democratic, nonmarket, noncommodified forces which provide a critical vocabulary for challenging the self-serving notion that the free market and corporate domination of society represent the only feasible alternative to the status quo and that the neoliberal view of society represents humanity at its best. Neither position offers any hope that America's future will be any different from its present.

Finally, there is the notion largely held by an orthodox materialist left that culture as a potential sphere of political education and change undermines the very notion of politics itself, which is often reduced to struggles over material issues rather than struggles that accentuate language, experience, pedagogy, and identity.[12] This position appears stuck in time, collapsing under the weight of its own intellectual weariness and political exhaustion. Weighted down in a nineteenth-century version of Marxism, contemporary scholarship from the left often refuses to pluralize the notion of antagonism by simply reducing it to class conflicts while further undermining the force of political economy by limiting it to a ghostly economism.[13] In addition, orthodox leftist criticism mirrors the increasing cynicism and despair exemplified in its endless invocation of such terms as "reality politics" and its call for a return to materialism. In the end, its rhetoric appears largely as high-minded puritanism ("the only true members of the church") matched only by an equally staunch ideological rigidity that barely conceals its contempt for notions of difference, cultural politics, and social movements.

BEYOND THE CULTURE OF CYNICISM

In contrast to these positions, I argue in this book that struggles over culture are not a weak substitute for a "real" politics, but are central to any struggle willing to forge relations among discursive and material relations of power, theory, and practice, as well as pedagogy and social change. I want to address the contemporary politics of cynicism by making a more substantial case for both the politics of culture and the culture of politics—as well as the primacy of the pedagogical as a constitutive element of a democratic political culture that links struggles over identities and meaning to broader struggles over material relations of power. In the chapters that follow, I offer some examples of what it might mean to theorize cultural studies as a form of practical politics in which the performative and the strategic emerge out of a broader project informed by the shifting and often contradictory contexts in which popular politics and power intersect so as to extend the possibilities of democratic public life. Such examples, and the implications they have for a practical version of cultural studies, range from an analysis of the multicultural discourses of academia to the popular representations and institutional formations of the Disney empire. All of these examples point to the need for a new kind of cultural politics—and a new kind of political culture—in which discourse, image, and desire intersect with the operations of material relations of power to foreground the ways in which power is deployed, experienced, and made productive within and across multiple spheres of daily life.[14] Such examples also speak to the necessity of reinvigorating the intellectual life necessary to sustain a vibrant political culture and, as Elizabeth Long sees it, "putting knowledge in the service of a more realized democracy."[15]

The regulatory nature of culture and its power to circulate goods, discipline discourses, and regulate bodies suggests that the nervous system of daily life is no longer to be found in the simple workings and display of raw industrial power—the old means of production—but in the wired infrastructures that compute and transmit information at speeds that defy the imagination. As it becomes increasingly clear that the politics of culture is a substantive and not secondary force in shap-

ing everyday and global politics, the culture of politics provides the ideological markers for asserting the ethical and public referents to think at the limits of this new merging of technology and politics. No longer relegated simply to the Olympian heights of high culture, or summarily dismissed simply as a reflection of the economic base, culture has finally gained its rightful place institutionally and productively as a crucial object of debate, a powerful structure of meaning-making that cannot be abstracted from power, and a site of intense struggle over how identities are to be shaped, democracy defined, and social justice revived as a serious element of cultural politics.

CULTURE AND POLITICS

As the interface between global capital and new electronic technologies refigure and reshape the face of culture, the importance of thinking through the possibilities and limits of the political takes on a new urgency. What constitutes both the subject and the object of the political mutates and expands as the relationship between knowledge and power becomes a powerful force in producing new forms of wealth, increasing the gap between the rich and the poor, and radically influencing how people think, act, and behave. Culture as a form of political capital becomes a formidable force as the means of producing, circulating, and distributing information transform all sectors of the global economy and usher in a veritable revolution in the ways in which meaning is produced, identities are shaped, and historical change unfolds within and across national boundaries. For instance, on the global and national levels, the foreshortening of time and space has radically altered how the power and wealth of multinational corporations shape the cultures, markets, and material infrastructures of all societies, albeit with unevenly distributed results.[16] As wealth accumulates in fewer hands, more service jobs command the economies of both strong and weak nations. Furthermore, Westernized cultural forms and products erode local differences, producing increasingly homogenized cultural landscapes. Finally, as state services bend to the forces of privatization, valuable social services such as housing, schools, hospitals, and public broadcasting are aban-

doned to the logic of the market. For many, the results are far-reaching: an increase in human poverty and suffering, massive population shifts and migrations, and a crisis of politics marked by the erosion and displacement of civic values and democratic social space.

Increasingly within this new world order, the culture-producing industries have occupied a unique and powerful place in shaping how people around the globe live, make sense of their lives, and shape the future, often under conditions not of their own making. Stuart Hall succinctly captures the substantive nature of this "cultural revolution" when he argues,

> The domain constituted by the activities, institutions and practices we call 'cultural' has expanded out of all recognition. At the same time, culture has assumed a role of unparalleled significance in the structure and organization of late-modern society, in the processes of development of the global environment and in the disposition of its economic and material resources. In particular, the means of producing, circulating and exchanging culture have been dramatically expanded through the new media technologies and the information revolution. Directly, a much greater proportion of the world's human, material and technical resources than ever before go into these sectors. At the same time, indirectly, the cultural industries have become the mediating element in every other process.[17]

According to Hall, culture has become the primary means through which social practices are produced, circulated, and enacted, on one hand, and given meaning and significance on the other. Culture becomes political not only as it is mobilized through the media and other institutional forms as they work to secure certain forms of authority and legitimate specific social relations but also as a set of practices that represents and deploys power thereby shaping particular identities, mobilizing a range of passions, and legitimating precise forms of political culture. Culture in this instance becomes productive, inextricably linked to the related issues of power and agency. As Lawrence Grossberg points out, the politics of culture is foregrounded in "broader cultural terms [of how] questions of agency involve the possibilities of action as interventions into the processes

by which reality is continually being transformed and power enacted. . . . Agency involves relations of participation and access, the possibilities of moving into particular sites of activity and power, and of belonging to them in such a way as to be able to enact their powers."[18] What Grossberg is suggesting here regarding the possibilities for critical agency has important implications for engaging culture in both political and pedagogical terms.

As I have written elsewhere, culture has now become the pedagogical force par excellence and its function as a broader educational condition for learning is crucial in putting into place forms of literacy within diverse social and institutional spheres through which people define themselves and their relationship to the social world.[19] The relationship between culture and pedagogy in this instance cannot be abstracted from the central dynamics of politics and power.

Culture from the broadest perspective is always entangled with power and becomes political in a double sense. First, questions of ownership, access, and governance are crucial to understanding how power is deployed in regulating the images, meanings, and ideas that frame the agendas that shape daily life. Second, culture deploys power in its connections with the realm of subjectivity—that is, it offers up identifications and subject positions through the forms of knowledge, values, ideologies, and social practices it makes available within unequal relations of power to different sectors of the national and global communities. As a pedagogical force, culture makes a claim on certain histories, memories, and narratives. As James Young has noted, it tells "both the story of events and its unfolding as narrative" in order to influence how individuals take up, modify, resist, and accommodate themselves to particular forms of cultural citizenship, present material relations of power, and specific notions of the future.[20]

I argue in this book that the current crisis of cultural politics and political culture facing the United States is intimately connected to the erasure of the social as a constitutive category for expanding democratic identities, social practices, and public spheres. In this instance, memory is not being erased as much as it is being reconstructed under circumstances in which public forums for serious debate are being eroded. The crisis of memory and the social is further amplified by the withdrawal of the state as a guardian of the public trust

and its growing lack of investment in those sectors of social life that promote the public good. Moreover, the crisis of the social is further aggravated, in part, by an unwillingness on the part of many liberals and conservatives to address the importance of formal and informal education as a force for encouraging critical participation in civic life, and pedagogy as a crucial cultural, political, and moral practice for connecting politics, power, and social agency to the broader formative processes of democratic public life. Such concerns not only raise questions about the meaning and role of politics and its relationship to culture, but also suggest the necessity to rethink the purpose and function of pedagogy in light of the calls by diverse ideological interests to corporatize all levels of schooling in the United States. The importance of challenging the threat to public life and political culture posed by the corporatizing of schools cannot be underestimated.

The demise of politics as a progressive force for change within the cultural sphere is particularly evident in the recent attempts to corporatize higher education, which, while offering one of the few sites for linking learning with social change, is increasingly being redefined in market terms as corporate culture subsumes democratic culture and critical learning is replaced by an instrumentalist logic that celebrates the imperatives of the bottom line, downsizing, and outsourcing. Obsessed with grant writing, fund-raising, and capital improvements, higher education increasingly devalues its role as a democratic public sphere committed to the broader values of an engaged and critical citizenry. Private gain now cancels out the public good, and knowledge that does not immediately translate into jobs or profits is considered ornamental. In this context, pedagogy is depoliticized and academic culture becomes the medium for sorting students into an iniquitous social order that celebrates commercial power at the expense of broader civil and public values.

Under attack by corporate interests, the political right, and neoliberal doctrines, pedagogical discourses that define themselves in political and moral terms—particularly as they draw attention to the operations of power and its relationship to the production of knowledge and subjectivities—are either derided or ignored. Reduced to the status of training, pedagogy in its conservative and neoliberal versions appears

completely at odds with those versions of critical teaching designed to provide students with the skills and information necessary to think critically about the knowledge they gain, and what it might mean for them to challenge antidemocratic forms of power. All too often critical pedagogy, within and outside of the academy, is either dismissed as irrelevant to the educational process or is appropriated simply as a technique. The conservative arguments are well-known in this regard, particularly as they are used to reduce pedagogical practice either to the transmission of beauty and truth or to management schemes designed to teach civility, which generally means educating various social groups about how to behave within the parameters of their respective racial, class, and gender-specific positions. Missing from these discourses is any reference to pedagogy as an ideology and social practice engaged in the production and dissemination of knowledge, values, and identities within concrete institutional formations and relations of power.

Similarly, those liberal and progressive discourses that do link pedagogy to politics often do so largely within the logic of social reproduction and refuse to recognize that the effects of pedagogy are conditioned rather than determined and thus are open to a range of outcomes and possibilities. Lost here is any recognition of a pedagogy without guarantees, a pedagogy that because of its contingent and contextual nature holds the promise of producing a language and set of social relations through which the just impulses and practices of a democratic society can be experienced and related to the power of self-definition and social responsibility.[21] On the other hand, neoliberalism with its celebration of the logic of the market opts for pedagogies that confirm the autonomous individual rather than empower social groups and celebrates individual choice over plurality and participation. Excellence for too many neoliberals and conservatives is often about individual achievement and has little to do with equity or providing the skills and knowledge that students might need to link learning with social justice and motivation with social change.

The evisceration of democratic political culture from public life is also evident in the current attempts of conservatives and liberals to hollow out the state by withdrawing support from a number of sectors of social life whose deepest roots are moral rather than commer-

cial and provide a number of services for addressing dire social problems, particularly as they affect the poor, excluded, and oppressed. The evisceration of politics is also visible in the ongoing legislative attacks on immigrants and other people of color, in the containment of political discourse by corporations that increasingly control the flow of information in the public sphere, and in the shrinking of noncommodified public spheres that provide opportunities for dialogue, critical debate, and public education.

TOWARD A PRACTICAL CULTURAL POLITICS

Central to any practical politics of cultural studies is the need to reinvent power as more than resistance and domination, as more than a marker for identity politics, and as more than a methodological ploy for linking discourse to material relations of power. All of these notions of power are important, but none adequately signifies the need for cultural studies to foreground the struggle over relations of power as a central principle that views cultural politics as a civic and moral performance linking theory to practice and knowledge to strategies of engagement and transformation. The reinvigoration of political culture in this position becomes a strategic and pedagogical intervention that has a purchase on people's daily struggles and defines itself partly through its (modest) attempts to keep alive a notion of citizenship as a crucial performative principle for activating democratic change. Toward this end, cultural studies must be guided by the political insight that its own projects emerge out of social formations in which power is not simply put on display but signifies ongoing attempts to expand and deepen the practice of democracy. Cultural studies is more than simply an academic discourse; it offers a critical vocabulary for shaping public life as a form of practical politics.

This book was written in response to the growing academicization of cultural studies and the increasing cynicism and despair that has taken over national political life in the United States. It grew out of my concern with the deception of the discourse of democracy and ethics among progressive cultural workers and educators. Cultural studies, like education, no longer appears as a way of intervening in

the production of an active citizenry. Too much of what passes for analysis in these fields represents the bad faith of careerism and the obscure discourse of hermetic academics who no longer believe that it is necessary to either speak with and to a larger public or address important social issues. Where the vestiges of careerism are not in place, the cultural politics of the left appears to be embroiled in what Michel Foucault once called *polemics*.[22] Lost here is any attempt to persuade or convince, to produce a serious dialogue.[23] All that remain are arguments buttressed by an air of privileged insularity that appear beyond interrogation, coupled with forms of rhetorical cleverness built upon the model of war and unconditional surrender, designed primarily to eliminate one's opponent but having little to say about what it means to offer alternative discourses to conservative and neoliberal efforts to prevent the democratic principles of liberty, equality, and freedom from being put into practice in our schools and other crucial spheres of society.[24] As Chantal Mouffe argues, this is the Jacobin model of scholarship (or as Herbert Marcuse aptly put it, "scholarshit") in which one attempts "to destroy the other in order to establish [one's] point of view and then not allow the other the possibility of coming back democratically. That is the struggle among enemies — the complete destruction of the other."[25] In short, the avoidance principle at work in political culture often finds its counterpart in the academy in forms of theorizing that do little more than instrumentalize, polemicize, obscure, or insulate — and, of course, this is a discourse and pedagogy that generally threatens no one. However, the best work in cultural studies and cultural politics challenges the culture of political avoidance while demonstrating how intellectuals might live up to the historical responsibility they bear in bridging the relationship between theoretical rigor and social relevance, social criticism and practical politics, individual scholarship and public pedagogy, as part of a broader commitment to defending democratic societies. Evidence of models can be found in the work of Robin Kelley, Nancy Fraser, Chantal Mouffe, Stanley Aronowitz, Cornel West, Michael Dyson, Joy James, Lawrence Grossberg, Toni Morrison, Edward Said, Arif Dirlik, Stuart Hall, Meachan Morris, Ellen Willis, Carol Becker, Rey Chow, Susan Bordo, and others. It can also be found in the struggles of young people today, many of them in the

universities who are breaking down the boundaries between academic life and public politics. Such activism was recently visible in the actions of thousands of college students participating in the campus anti-sweatshop movement as well as in the actions of those brave students from the University of California-Berkeley who demonstrated and went on hunger strikes to save the Ethnic Studies department.[26] It was also on display in the demonstrations in Seattle at the World Trade Organization meeting. All of these academics and students appear to take seriously Pierre Bourdieu's admonition that "[t]here is no genuine democracy without genuine opposing critical powers . . . [and it is the obligation of such intellectuals to be able] to make their voices heard directly in all the areas of public life in which they are competent."[27] Hopefully, this book makes a small contribution to such an effort.

one

Rethinking Cultural Politics

*Challenging Political
Dogmatism from
Right to Left*

... the multiculturalists, the hordes of camp-followers, afflicted by the French dis-
eases, the mock-feminists, the commissars, the gender-and-power freaks, the
hosts of new historicists and old materialists . . . [seem] to me a monumental rep-
resentation of the enemies of the aesthetic who are in the act of overwhelming us.

—Harold Bloom, "They Have the Numbers; We Have the Heights"

If we wish to do politics, let us organize groups, coalitions, demonstrations, lobbies,
whatever; let us do politics. Let us not think our academic work is already that. ✓

—Todd Gitlin, "The Anti-Political Populism of Cultural Studies"

INTRODUCTION

Besieged by the powerful forces of vocationalism and neoconserva-
tive cultural warriors, on one hand, and the growing presence of left
orthodoxy on the other, many academics are caught in an ideological
crossfire regarding their civic and political responsibilities. Under pres-
sure from conservatives, educators are increasingly being influenced to

16

define their roles within the language of the corporate culture, buttressed by an appeal to a discourse of objectivity and neutrality that separates political questions from cultural and social issues. Within such a discourse, educators are being pressured to become servants of corporate power, multinational operatives functioning primarily as disengaged specialists wedded to the imperatives of academic professionalism. Yet conservatives are not the only ones willing to attack the notion of a progressive cultural politics—one that links knowledge and power to the imperatives of social change—as a democratic, countervailing force to the corporatizing of academic culture. A small but influential number of progressives and educators on the left are urging professors to renounce, if not altogether flee, the university in order to engage in "real" political struggles. Within this discourse, it is ideologically damning to argue, as Andrew Ross does, that cultural politics is "an inescapable part of any advocacy of social change."[1]

What is surprising about the current attack on education, especially in light of the growing corporatization and privatization at all levels of schooling, is the refusal on the part of many theorists to rethink the role academics might play in defending the university as a crucial democratic public sphere. Lost in these debates is a view of the university that demands reinvigorated notions of civic courage and action that address what it means to make teaching and learning more socially conscious and politically responsive in a time of growing conservatism, racism, and corporatism. Even more surprising is the common ground shared by a growing number of conservatives and progressives who attempt to reduce pedagogy to a reified methodology, on one hand, or narrowly define politics and pedagogy within a dichotomy that pits the alleged "real" material issues of class and labor against a fragmenting and marginalizing politics of culture, textuality, and difference on the other.

CONSERVATIVE AND LIBERAL ATTACKS ON CULTURAL POLITICS

The right-wing attack on culture as a site of pedagogical and political struggle is evident in the work of such traditionalists as Harold

Bloom and Lynn Cheney and such liberals as Richard Rorty, all of whom bemoan the death of romance, inspiration, and hope as casualties of the language of power, politics, and multiculturalism. For Bloom, literary criticism has been replaced in the academy by cultural politics, and the result is nothing less than the renunciation of the search for truth and beauty that once defined universalistic and impartial scholarship. Bloom cannot bear the politics of what he calls "identity clubs," arguing that "multiculturalism is a lie, a mask for mediocrity for the thought-control academic police, the Gestapo of our campuses."[2] Bloom wishes to situate culture exclusively in the sphere of beauty and aesthetic transcendence, unhampered and uncorrupted by politics, the struggle over public memory, or the democratic imperative for self- and social criticism. For Bloom, cultural politics is an outgrowth of cultural guilt, a holdover from the sixties that begets what he calls "the School of Resentment."[3]

Yet there is more at stake in delegitimating the investigation of the relationship between culture and power for Bloom and his fellow conservatives. Eager to speak for disenfranchised groups, conservatives claim that cultural politics demeans the oppressed and has nothing to do with their problems. It neither liberates nor informs, they maintain, but rather contributes to an ongoing decline in standards and civility by prioritizing visual culture over print culture, and popular culture over high culture. For Bloom, replacing *Julius Caesar* with *The Color Purple* is indicative of the lowering of such standards and the "danger of cultural collapse."[4] As a custodian of the good old days, Bloom holds no punches in equating literature that has been traditionally marginalized in the university with degrading forms of popular culture. He writes that

the Resenters prate of power, as they do of race and gender: they are careerist stratagems and have nothing to do with the insulted and injured, whose lives will not be improved by our reading the bad verses of those who assert that they are the oppressed. Our schools as much as our universities are given away to these absurdities; replacing *Julius Caesar* by *The Color Purple* is hardly a royal road to enlightenment. A country where television, movies, computers, and Stephen King have replaced reading is already in acute danger of cultural collapse. That

danger is dreadfully augmented by our yielding education to the ideo-
logues whose deepest resentment is of poetry itself.[5]

By conflating minority literature with popular culture and the decline
of academic standards, Bloom conveniently and unabashedly reveals
the contempt he harbors for minorities of race, class, and gender and
their "uncivil" demands for inclusion in the curricula of higher edu-
cation and the history and political life of the nation. Bloom's tirade
is all the more disingenuous given his appeal to excellence and objec-
tivism. Bloom's conservative stance would be more interesting if his
disdain of the ideological could be read as simply ironic, but he ap-
pears, unfortunately, dead serious when he maps out his retrograde
view of the canon, academics, and the purpose of the university as a
position free from the tainted discourse of politics and ideology.

There is no room in Bloom's discourse for theorizing the dialecti-
cal connections between culture and politics. There is little regard for
the ways in which cultural processes are inextricably part of the
power relations that structure the symbols, identities, and meanings
that shape dominant institutions such as education, the arts, and the
media. Nor is there the slightest attempt to theorize how the political
character of culture might make possible a healthy and ongoing en-
gagement with all forms of pedagogical practice and the institution-
ally sanctioned authority that gives them legitimacy. Bloom has
nothing but contempt for educators who attempt to understand how
cultural politics can be appropriated in order to teach students to be
suspicious, if not critical of dominant forms of authority—both
within and outside the schools—that sanction what counts as theory,
that legitimate knowledge, that put particular subject positions in
place, and that make specific claims on public memory. Rather, Bloom
echoes other right-wing spokespersons such as George Will, Dinesh
D'Souza, Hilton Kramer, and Richard Bernstein who deride multicul-
turalists, feminists, and others for propagating "oppression studies,"
"victim studies," "therapeutic history," and forms of "ethnic cheer-
leading." In this discourse, oppositional voices within the academy
are dismissed as "barbarians" because they threaten what are alleged
to be transcendent notions of "civilization," "truth," "beauty," and
"common culture."

Pedagogy for Bloom is both depoliticized and unproblematic. Dismissing the contribution that radical educators have made to theorizing pedagogical practice, Bloom is utterly dismissive toward any critical attempts within the university to expand the political possibilities of the pedagogical. Lost in Bloom's discourse is any serious attempt to grapple with the implications of treating pedagogy as a form of moral and political regulation rather than as a technique or fixed method. Similarly, Bloom's arguments do not offer any theory of pedagogy. Hence, he is unable to engage pedagogical practice as the outcome of social struggles between different groups over how citizens are to be defined, the role pedagogy plays in mediating what forms of knowledge are to be considered worthy of serious inquiry, or how pedagogy provides the conditions for students to recognize antidemocratic forms of power. But this is clearly beyond Bloom's theoretical and ideological reach, because to suggest that such issues are worthy of serious debate would mean that Bloom would have to recognize his own pedagogy as a political activity, and his criticism of cultural politics as participating in the very ideological processes he so vehemently dismisses.

Lynn Cheney, on the other hand, embraces the political as part of a more activist critique of leftist cultural politics both within and outside the university. As the former head of the National Endowment for the Humanities (NEH) and the current director of the activist National Alumni Forum, Cheney argues that progressive trends in the academy are undermining what she terms the national cultural heritage. Claiming that "activist" faculty are abusing the principle of academic freedom, Cheney has sought to demonize progressive scholars by defining them as a threat to both the university and to the most valued traditions of Western civilization. Cheney has spelled this out in a speech to the American Council of Learned Societies. She writes,

> When I become most concerned about the state of the humanities in our colleges and universities is not when I see theories and ideas fiercely competing, but when I see them neatly converging, when I see feminist criticism, Marxism, various forms of poststructuralism, and other approaches all coming to bear on one concept and threatening to displace it. I think specifically of the concept of Western civiliza-

tion, which has come under pressure on many fronts, political as well as theoretical. Attacked for being elitist, sexist, racist, Eurocentric, this central and sustaining idea of our educational system and our intellectual heritage is being declared unworthy of study.[6]

Cheney's attack on cultural politics in the university redefines the relationships among culture, power, and knowledge by shifting the political emphasis away from struggles over curricula to struggles over policy that would shape the institutional conditions under which knowledge is produced, faculty are hired and evaluated, and credentials awarded. As Ellen Messer-Davidow has brilliantly documented, this is evident in the efforts of conservatives such as William Bennett, and Irving Kristol, among others, along with the backing of conservative groups such as the Olin and Bradley foundations, to attack extra-academic institutions and resources in order to restructure higher education along retrograde ideological lines.[7] Examples abound, and include conservative attempts to defund both the National Endowment for the Arts and the NEH, to dismantle affirmative action policies in universities and state agencies, and to encourage "alumni and trustees to censure and/or defund 'inappropriate' courses and curricula."[8] Under the charge of political correctness, conservatives such as Cheney deride the politicization of culture, the rise of "advocacy" programs such as those in African-American studies, cultural studies, and women's studies. John Silber, the former president of Boston University, reveals in a 1993 report to its board of trustees the blatant disregard for academic freedom that parades under the rubric of fighting political correctness in the university. Silber writes, without irony, that

> this University has remained unapologetically dedicated to the search for truth and highly resistant to political correctness . . . we have resisted the fad toward critical legal studies. . . . In the English Department and the departments of literature, we have not allowed the structuralists or the deconstructionists to take over. We have refused to take on dance therapy. . . . We have resisted revisionist history. . . . In the Philosophy Department we have resisted the Frankfurt School of Critical Theory. . . . We have resisted the official dogmas of radical

feminism. We have done the same thing with regard to gay and lesbian liberation, and animal liberation. . . . We have resisted the fad of Afro-centrism. We have not fallen into the clutch of multi-culturalists.[9]

If conservatives are to be believed, they are not engaging in a form of cultural and institutional politics, at least the ideological version, but simply purging the university of feminists, multiculturalists, and other progressive groups in order to promote excellence, raise academic standards, and create an objective scholarly climate that facilitates the intellectual pursuit of truth and beauty. Such actions, underwritten with resources and power provided by conservative forces such as the Madison Center for Educational Affairs, the Intercollegiate Studies Institute, the Olin Foundation, and the National Association of Scholars reveals a dangerous ideological orthodoxy. In this instance, the threat to academic freedom comes less from left-wing professors than it does from administrative demagogues and right-wing organizations willing to police and censor knowledge that does not silence itself before the legitimating imperatives of the traditional academic canon.

LIBERALISM AND THE POWER OF POSITIVE THINKING

Although Richard Rorty does not reject the political as a meaningful category of public life, he does abstract it from culture and in so doing legitimates a sharp conceptual division between politics and culture as well as an ideologically narrow reading of aesthetics, peda-gogy, and politics. According to Rorty, you cannot "find inspirational value in a text at the same time as you are viewing it as a . . . mecha-nism of cultural production."[10] Rorty steadfastly believes in the rigid division between understanding and hope, mind and heart, thought and action. He rejects implicitly the work of such critical theorists as Stuart Hall, Larry Grossberg, Paulo Freire, and others who believe that hope is a practice of witnessing, an act of moral imagination and po-litical passion that helps educators and other cultural workers to think otherwise in order to act otherwise. Moreover, Rorty shares with Bloom—though for different reasons—the fall-from-grace narrative

that seems to be the lament of so many well-established white male academics. Rorty wants progressives to be more upbeat, to give up their whining cultural politics and provide positive images of America. He wants feminists to stop indulging in victim politics by linking the political and the personal so that they can get on with a politics that addresses the "real thing." Moreover, as Lindsay Waters points out, "Rorty wants to hear good stories. He is not, however, interested in popular culture, even though it sometimes presents positive images of America, because popular culture, in his view, is a source of chauvinistic, right-wing, simpleminded images of America. It's 'high culture' that concerns him."[11]

Given Rorty's distaste for popular culture, it should not come as a surprise that he is equally dismissive of educators who situate texts within the broader politics of representation and engage pedagogy as a political practice. Yet the brunt of his criticism is reserved for a cultural left that refuses to "talk about money," legislation, or welfare reform and squanders its intellectual and critical resources on "such academic disciplines as women's history, black history, gay studies, Hispanic-American studies, and migrant studies."[12] Rorty disdains progressive academics for elevating cultural politics over real politics, and, as Waters points out, "accuses the aging New Leftists who populate the academy of something worse than a failure of nerve. They are quislings, he says, collaborators: in permitting cultural matters to supplant 'real politics,' they have collaborated with the Right in making cultural issues central to the political debate."[13]

For Rorty, the cultural left needs to transform itself into a reformed economic left that addresses "concrete" political issues such as changing campaign finance laws, abolishing the local financing of public education, and fighting for universal health insurance. These are laudable goals for any left, but for Rorty they cannot be addressed by means of a cultural politics that complicates and burdens political resistance through a language that speaks to how power works within popular culture or engages politics through the connected registers of race, gender, and sexuality. Nor, for Rorty, can such goals be addressed by expanding the political field to include various social movements organized around issues such as AIDS, sexuality, environmentalism, feminism, and antiracist struggles. He seems to forget, as

Homi Bhabha points out, that his call for a reconstructed politics of the left comes perilously close to reproducing the legacy of an orthodox Marxism. Constitutive of such a legacy are: "the reduction of the cultural public sphere to the realm of economic determinism; the support of trade unions at the expense of raced and gendered workers whose 'differences' and discriminations become subordinated to class interest; the homophobia and xenophobia that so easily perverts patriotism."[14]

Rorty, along with conservative ideologues like Harold Bloom, believes that the university and public schools are not a viable public arena in which to wage nondoctrinaire political struggles. For Rorty, the political does not include cultural spheres that trade in pedagogy, knowledge, and the production of identities that mediate the relationship between the self and the larger society. Culture is not a sphere in which political struggles can be effectively conducted over broad visions of social justice. Within the narrow confines of this language, cultural politics is dismissed either as a self-serving and narrow politics of difference or as victim politics.

If Rorty is to be believed, the left can get itself out of its alleged political impasse only by giving up on theory (which has produced a few good books, but has done nothing to change the country) and by shedding its "semi-conscious anti-Americanism, which it carried over from the rage of the late '60s."[15] Criticism that focuses on race, gender, sexuality, popular culture, schooling, or any other "merely" cultural issue represents not only a bad form of identity politics but contains an unwarranted (unpatriotic?) "doubt about our country and our culture" and should be replaced with "proposals for legislative change."[16] Rorty wants a progressive politics that is color-blind and concrete, a politics for which the question of difference is largely irrelevant to a resurgent materialism that defines itself as the antithesis of the cultural. In Rorty's version of politics, the pedagogical is reduced to old-time labor organizing, which primarily benefited white men and failed to question the exclusions so central to its self-definition. In the end, Rorty provides a caricature of the cultural left, misrepresents how social movements have worked to expand the arena of democratic struggle,[17] and ignores the centrality of culture as a pedagogical force for making politics meaningful as both an object of cri-

tique and transformation. Moreover, liberals such as Rorty conveniently forget the specific historical conditions and forms of oppression that gave rise to the New Left and new social movements that British cultural theorist Stuart Hall makes central to his arguments against a facile return to the totalizing politics of class struggle—that is, a politics that defines itself as so all-encompassing in its view of the world that it dismisses any other explanation. Hall insightfully reminds us that in order to think politics in the sixties, progressives had to confront the legacy of Stalinism, the bureaucracy of the Cold War, and the stiflingly racist and sexist hierarchies within traditional leftist organizations.[18] Class was not the only form of domination, and it was to their credit that some New Left theorists made visible the diverse and often interconnected forms of oppression organized against women, racial minorities, gay men and lesbians, the aged, the disabled, and others.

LEFT ORTHODOXY AND THE SCOURGE OF CULTURAL POLITICS

The attack on culture as a terrain of politics is not only evident in the works of such conservatives as Harold Bloom and Lynn Cheney, and such liberals as Richard Rorty, but it also is gaining ground in the writings of a number of renegades from the New Left, the most notable of whom are Todd Gitlin, Michael Tomasky, and Jim Sleeper.[19] Unlike Bloom and Rorty, Gitlin and his ideological cohorts speak from the vantage point of leftist politics but display a similar contempt for cultural politics, popular culture, cultural pedagogy, and differences based on race, ethnicity, gender, and sexual orientation. In what follows, I highlight some of the recurrent arguments made by this group, focusing on the work of Todd Gitlin, who has extensively criticized many leftists' and progressive academics' current preoccupation with cultural politics.[20]

For Gitlin, contemporary cultural struggles—especially those taken up by social movements organized around sexuality, gender, race, the politics of representation, and, more broadly, multiculturalism—are nothing more than a weak substitute for a "real world"

politics, notably one that underscores class, labor, and economic in-
equality. According to Gitlin, social movements that reject the pri-
macy of class give politics a bad name; they serve primarily to
splinter the left into identity sects, and, as Judith Butler has noted, fail
"to address questions of economic equity and redistribution,"[21] and
offer no unifying vision of the common good capable of challenging
corporate power and right-wing ideologues.

Gitlin's critique of social movements rests on a number of omis-
sions and evasions. First, in presupposing that class is a transcendent
and universal category that can unite the left, Gitlin fails to acknowl-
edge a history in which class politics was used to demean and domes-
ticate issues raised by those groups oppressed under the signs of race,
gender, and sexual orientation. Marked by the assumption that race
and gender considerations could not contribute to a general notion
of emancipation, the legacy of class-based politics is distinguished by
a history of subordination and exclusion toward marginalized social
movements. Moreover, it was precisely because of the subordination
and smothering of difference that social groups organized to articu-
late their respective goals, histories, and interests outside of the or-
thodoxy of class politics. Judith Butler is right in arguing, "How
quickly we forget that new social movements based on democratic
principles became articulated against a hegemonic Left as well as a
complicitous liberal center and a truly threatening right wing."[22]
Moreover, not only does Gitlin limit social agency to the pristine cat-
egory of class, but he can imagine class only as a unified, pregiven
subject position rather than as a shifting, negotiated space marked by
historical, symbolic, and social mediations that include the complex
negotiations of race and gender.[23] Within this discourse, the history
of class-based sectarianism is forgotten, the category of class is essen-
tialized, and politics is so narrowly defined as to freeze the open-
ended and shifting relationship between culture and power.[24]

Second, in reducing all social movements to the most essentialistic
and rigid forms of identity politics, Gitlin fails to understand how
class is actually lived through the everyday relations of race and gen-
der. In Gitlin's discourse, social movements are defined as narrowly
particularistic; hence, historian Robin Kelley notes that it is impossible
for him to "conceive of social movements as essential to a class-based

politics."[25] Kelley insightfully points out the failure of Gitlin and others to recognize how the AIDS Coalition to Unleash Power (ACT UP)—a movement that brought attention to AIDS and fought discrimination against gays and lesbians—through its varied demonstrations and media-blitz campaigns made AIDS visible as a deadly disease that is now taking its greatest toll among poor black women.[26] Nor is there any recognition of how the feminist movement made visible the radical political character of everyday experience in order to expose how particular forms of male oppression operated unchallenged in spheres traditionally regarded as distinctly unpolitical. For example, by linking the personal and the political, feminists exposed the dynamics of sexual abuse, particularly as it raged through the communities of poor households. Nor is there any understanding of how a whole generation of young people might be educated to recognize the racist, sexist, colonialist, and class-specific representations that permeate advertising, films, and other aspects of media culture that flood daily life. There is little mention of how young people have actively engaged in forms of cultural politics through radical community and youth work, struggles against sweatshop labor policies supported by university investments, gay and lesbian civil rights drives, Rock against Racism, or other forms of political protest. In each case, such movements on the cultural front have registered important forms of resistance designed to reclaim the political struggle over challenging dominant modes of "common sense" as a precondition for building larger social movements and changing institutional power.

Third, Gitlin's appeal to majority principles slips easily into the reactionary tactic of blaming minorities for the current white backlash, going so far as to argue that because the followers of identity politics (struggles organized around the specific interests of gender, race, age, and sexuality) abandoned a concern for materialist issues they opened the door for an all-out attack by right-wing conservatives on labor and the poor. At the same time, identity politics bears the burden in Gitlin's discourse for allowing, as Iris Young has noted, the Right to attack "racialized rhetoric as a way of diverting attention from the economic restructuring that has been hurting most Americans."[27] Thoughtlessly aligning himself with the right, Gitlin seems unwilling to acknowledge how the historical legacies of slavery, imperialism,

urban ghettoization, segregation, the extermination of Native Americans, the war against immigrants, and the discrimination against Jews as they have been rewritten into the discourse of American history may upset a majority population that finds it more convenient to blame subordinate groups for their problems than to acknowledge their own complicity.

Against this form of historical amnesia, the call to patriotism, majority values, and unity shares an ignoble relationship to a past in which such principles were rooted in the ideology of white supremacy, the presumption that the public sphere was exclusively white, and the prioritizing of, according to Judith Butler, a "racially cleansed notion of class."[28] If identity politics poses a threat to the endearing (because transcendent and universal) category that class represents to some critics, as Robin Kelley argues, it may be because such critics fail to understand how class is actually lived through race, sexual orientation, and gender, or it may be that the return to a form of class warfare against corporate power represents simply another form of identity politics—an identity-based campaign that stems from the anxiety and revulsion of white males who cannot imagine participating in movements led by African Americans, women, Latinos, or gays and lesbians speaking for the whole, or even embracing radical humanism.[29]

Finally, Gitlin's materialism finds its antithesis in a version of cultural studies that is pure caricature. According to Gitlin, cultural studies is a form of populism intent on finding resistance in the most mundane of cultural practices, ignoring the ever-deepening economic inequities, and dispensing entirely with material relations of power. Banal in its refusal to discriminate between a culture of excellence and the political and economic order, on one hand, and the trivial pursuits of consumer culture on the other, cultural studies becomes a symbol of bad faith and political irresponsibility. According to Gitlin, "popular culture is the consolation prize" seized upon by progressives who refuse to "dwell on unpleasant realities" associated with the worsening conditions of the poor and the deepening of class inequalities.[30] For theorists in cultural studies, Gitlin argues, it is irrelevant that African Americans suffer gross material injustice because what really matters is that "they have rap."[31] It seems that for

Gitlin, cultural studies should "free itself of the burden of imagining itself to be a political practice,"[32] since the locus of much of its work is the university—a bankrupt site for intellectuals addressing the most pressing questions of our age. Rather than take responsibility for what Stuart Hall calls "translating knowledge into the practice of culture,"[33] academics, according to Gitlin, should put "real politics" ahead of cultural matters, "not mistake the academy for the larger world," and put their efforts into organizing "groups, coalitions, and movements."[34]

Gitlin's model of politics is characteristic of a resurgent economism rooted in a notion of class struggle in which it is argued that "we can do class or culture, but not both."[35] Within this view, social movements are dismissed as merely cultural, and the cultural is no longer acknowledged as a serious terrain of political struggle. Unfortunately, this critique not only fails to recognize how issues of race, gender, age, sexual orientation, and class are intertwined; it also refuses to acknowledge the pedagogical function of culture in constructing identities, mobilizing desires, and shaping moral values. Gitlin dismisses as "false consciousness" the attempt on the part of many theorists to acknowledge that cultural studies is, in part, a pedagogical project concerned with how knowledge is constructed and disseminated in relation to the materiality of power, conflict, and oppression. He is utterly indifferent to the political project of analyzing how the educational force of the culture (high and low) has relevance for enabling adults, students, workers, and others to become attentive to the different dynamics of power through ongoing critical analyses of how knowledge, meaning, and values operate in the production, reception, and transformation of social identities, diverse forms of ethical address, and a range of claims on historical memory. Gitlin has no understanding of the importance of cultural pedagogy in illuminating how identities are shaped in a vast array of pedagogical sites outside of the schools. Nor is he sensitive to the pedagogical task of teaching people how to challenge authority, resist, "unlearn privilege," and strategically deploy theory and knowledge in order to make learning fundamental to social change itself.

What is surprising about Gitlin's attack on cultural studies and his contemptuous dismissal of cultural politics is that the pedagogical and

political relevance of such work is part of a long theoretical history that is indebted to critical Marxism. For instance, the crucial importance of linking the political and pedagogical is evident in Antonio Gramsci's insight that "[e]very relationship of 'hegemony' is necessarily an educational relationship."[36] It is also clear in Raymond Williams's perceptive argument that a critical cultural politics must acknowledge "the educational force of our whole social and cultural experience [as an apparatus of institutions and relationships that] actively and profoundly teaches."[37] In addition, one could add the insistence of Theodor Adorno and Max Horkheimer that questions about culture cannot be abstracted from questions regarding economics and politics, nor can they be dismissed as merely superstructural.[38] Unfortunately, Gitlin's critique of cultural studies as a retrograde form of populism ignores the relevance of cultural politics and pedagogy as a historical project as well as its current political importance for engaging the interrelated issues of culture, agency, resistance, and power. By separating politics from culture, Janet Batsleev and colleagues note that critics such as Gitlin end up "not only depoliticizing culture but also, with equally impoverishing results, of 'deculturalizing' politics."[39] Ironically, the consequences of such an act undermine the very viability of politics and political struggle, especially among those for whom making the political more pedagogical is crucial to their political awakening and potential involvement against various forms of oppression. As Batsleer and her colleagues point out, "Removing politics from the semiotic domain of signs, images and meanings, it segregates it from the lives and interest of 'ordinary people', who are in turn induced to accept the representation of themselves as incapable of, and bored by, political reflection and action."[40] By arguing that cultural politics diverts our attention from real concerns, predominantly economic in this case, Gitlin constructs a dichotomy between culture and economics that is, as Andrew Ross points out, both "disabling and divisive."[41] In opposition to such a claim, Ross insightfully argues that cultural and economic forces are mutually interdependent and central to any radical theory of cultural politics. As he explains,

> The vast economic forces that take their daily toll on our labor, communities, and natural habitats are the most powerful elements in our

social lives. The power with which they work on our world is exercised through cultural forms: legal, educational, political, and religious institutions; valued artifacts and documents; social identities; codes of moral sanctity; prevailing ideas about the good life; and fears of ruination, among many others. Without these forms, economic activity remains a lifeless abstraction in the ledgers and databases of financial record. Without an understanding of them, we impoverish our chances of building on those rights, aspirations, and collective affinities that promise alternatives to the status quo.[42]

By furthering a false dichotomy between cultural politics and "real" economically based politics, Gitlin substitutes a rigorous engagement with the interrelated and complex modalities of meaning, culture, institutional power, and the material context of everyday life with a dogmatic and narrow view of politics. Moreover, Gitlin's economism comes dangerously close to promoting an anti-intellectual and anti-theoretical claim to politics that largely registers as an incitement to organizing and pamphleteering.

This discourse is troubling because it separates culture from politics and leaves little room for capturing the contradictions within dominant institutions that open up political and social possibilities for contesting domination, doing critical work within the schools and other public spheres, or furthering the capacity of students and others to question oppressive forms of authority and the operations of power.

UNDERTAKING CULTURAL POLITICS

Unfortunately, the current onslaught on cultural politics by conservatives and the orthodox left tends to disregard the substantive and critical role of culture, particularly popular culture, in pedagogy and learning, especially for young people. There is no sense in this position of the enormous influence Hollywood films, television, comics, magazines, video games, and Internet culture exert in teaching young people about themselves and their relationship to the larger society. Moreover, neither group addresses the role that academics and public

school teachers might assume as public intellectuals mindful of the part that culture plays in shaping public memory, moral awareness, and political agency; similarly, neither group addresses the significance of higher and public education as important cultural sites that function as spheres essential to sustaining a vibrant democracy.

In its best moments, the debate over the politics of culture has reinvigorated the dialogue about the role that public and higher education might play in creating a pluralized public culture essential for animating basic precepts of democratic public life—that is, educating students to be critical and active citizens. At the same time, the right- and left-wing orthodox versions of the debate have failed to consider more fundamental issues about the importance of culture as a teaching force that goes far beyond institutionalized schooling. With the rise of new media technologies and the global reach of the highly concentrated culture industries, the scope and impact of the educational force of culture in shaping and refiguring all aspects of daily life appear unprecedented. Yet the current debates have generally ignored the powerful pedagogical influence of popular culture, along with the implications it has for shaping curricula, questioning notions of high-status knowledge, and redefining the relationship between the culture of schooling and the cultures of everyday life. Consequently, the political, ethical, and social significance of the role that popular culture plays as the primary pedagogical medium for young people remains largely unexamined. For instance, there is little recognition by either conservatives or progressives of the importance of using Hollywood films such as *Schindler's List* to examine important historical events, or incorporating Disney's animated cartoons in the curriculum to examine how gender roles are constructed within these films and what they suggest about the subject positions that young people should take up, question, or resist in a patriarchal society. Nor do conservatives or liberals who disavow cultural politics and pedagogy exhibit any understanding of the importance of expanding literacy in the schools beyond the culture of the book to teach students how to use the new electronic technologies that characterize the digital age.

Informal learning for many young people is directly linked to their viewing videos, films, television, and such computer technology as CD-

ROMs and the Internet. Students need to learn how to read these new cultural texts critically, but they should also learn how to create their own cultural texts by mastering the technical skills needed to compose television scripts, use video cameras, write programs for computers, and produce and direct documentaries. This is not to suggest that young people are unaware of how to use these technologies. On the contrary, many young people, as Jon Katz points out, "are at the center of the information revolution, ground zero of the digital world [because] they helped build it, [and] they understand it as well, or better than anyone else."[43] The problem is that the schools, primarily from the elementary grades to high school, are too big and out of touch with the new technologies and the new literacies that they have produced, though some schools at the secondary level have begun to take note of the importance of the new technologies while higher education is moving more quickly to catch up with the digital revolution. For instance, a growing number of alternative school programs and universities have developed very successful media literacy programs and mass communications programs, which, unlike computer technology programs, do not reduce digital literacy simply to learning new skills. These programs combine literacy aimed at reading and writing with literacy classes aimed at learning the basics of video production and television programming. These programs allow kids to tell their own stories, learn to write scripts, and get involved in community action programs.[44] They also challenge the assumption that popular cultural texts cannot be as profoundly important as traditional sources of learning in teaching about important issues framed through, for example, the social lenses of poverty, racial conflict, and gender discrimination. Within these approaches, hands-on learning, basic literacy skills, and more advanced classroom studies are combined with the skills and knowledge needed to both produce and critically examine the new media technologies. This is not so much a matter of pitting popular culture against traditional curricula sources as it is of using both in a mutually informative way.

As culture, especially popular culture, becomes the most powerful educational force in shaping the perceptions of young people about themselves and their relationships to others, educators must ask new kinds of questions. How might teachers address education anew,

given the new forms of cultural pedagogy that have arisen outside of traditional schooling? In light of such changes, how do educators respond to value-based questions regarding the purposes that schools should serve, what types of knowledge are of the most worth, and what it means to claim authority in a world where borders are constantly shifting? How might pedagogy be understood as a political and moral practice rather than a technical strategy? And what relation should public and higher education have to young people as they develop a sense of agency, particularly with respect to the obligations of critical citizenship and public life in a radically transformed cultural and global landscape?

As citizenship becomes more privatized and public and higher education more vocationalized, youth are increasingly educated to become consumers rather than critical social subjects. Under such circumstances, it becomes all the more imperative for educators to rethink how the educational force of the culture works to both secure and exclude particular identities and values, and how such a recognition can be used to redefine what it means to link knowledge and power, expand the meaning and role of public intellectuals, and take seriously the assumption that pedagogy is always contextual and must be understood as the outcome of particular struggles over identity, citizenship, politics, and power. In opposition to Harold Bloom, Richard Rorty, and Todd Gitlin, educators need to foreground their role as public intellectuals and affirm the importance of such critical work in expanding the possibilities for democratic public life, especially as it addresses the education of youth within rather than outside of the relations of politics and culture. What exactly does this suggest?

Assuming the role of public intellectuals, educators might begin by establishing the pedagogical conditions for students to be able to develop a sense of perspective and hope in order to recognize that the way things are is not the way they have always been or must necessarily be in the future. More specifically, it suggests that educators develop educational practices that are informed by both a language of critique and possibility. Within such a discourse, hope becomes anticipatory rather than compensatory and employs the language of critical imagination to enable educators and students to consider the structure, movement, and opportunities in the contemporary order

of things and how they might act to resist forms of oppression and domination while developing those aspects of public life that point to its best and as yet unrealized possibilities. At the current historical moment, such hope rejects a fatalism that suggests that the only direction in which education can move is toward adopting the overriding goals of the corporate culture—to prepare students at all levels of schooling in order to simply take their places in the new corporate order. Hope in this context is not simply about lost possibilities, or a negative prescription to resist, but an ethical ideal rooted in the daily lives of educators, adults, students, and others who deny the machinery of corporate authoritarianism along with other forms of domination by embracing what Anson Rabinach calls the "spark that reaches out beyond the surrounding emptiness."[45]

This is a language of educated hope and democratic possibilities, which asserts that schools play a vital role in developing the political and moral consciousness of its citizens. It is a language grounded in a notion of educational struggle and leadership that does not begin with the question of raising test scores or educating students to be experts, but with a moral and political vision of what it means to educate to govern, lead a humane life, and address the social welfare of those less fortunate than themselves. Educated hope points beyond the given by salvaging those dreams that call for educators to develop ethical projects out of the specificity of the contexts and social formations in which they undertake efforts to combat various forms of oppression.[46]

Educators who take on the roles of public intellectuals can also teach students what might be called a language of social criticism and responsibility; a language that refuses to treat knowledge as something to be consumed passively, taken up merely to be tested, or legitimated outside of an engaged normative discourse. Central to such a language is the goal of creating those pedagogical conditions that enable students to develop the discipline, ability, and opportunity to think in oppositional terms, to critically analyze the assumptions and interests that authorize the very questions asked within the authoritative language of the school or classroom. Such criticism cuts across disciplinary boundaries and calls for educators, students, and cultural workers to take on the roles of public critics who can function as historians,

archivists, pundits, social critics, bricoleurs, and activists. Maurice Berger suggests that such forms of criticism create new forms of expression and practice. He writes, "The strongest criticism today—the kind that offers the greatest hope for the vitality and future of the discipline—is capable of engaging, guiding, directing, and influencing culture, even stimulating new forms of practice and expression. The strongest criticism serves as a dynamic, critical force, rather than as an act of boosterism. The strongest criticism uses language and rhetoric not merely for descriptive evaluative purposes but as a means of inspiration, provocation, emotional connection, and experimentation."[47] Berger's notion of criticism affirms a notion of literacy that reveals the bankruptcy of the vocabulary of literacy associated with the discourse of corporate culture and traditional pedagogy. Refusing both a market pragmatism and a literacy rooted in the exclusive confines of the modernist culture of print, "the strongest forms of criticism" emerge out of a pluralized notion of literacy that values both print and visual culture. Moreover, literacy as a critical discourse also provides a more complex accounting of power, identity formation, and the materiality of power while stressing that while literacy itself guarantees nothing, it is an essential precondition for agency, self-representation, and a substantive notion of democratic public life. This suggests a discourse of criticism and literacy that unsettles common sense and engages a variety of cultural texts and public conversations. It is a language that learns how to address social injustices in order to break the tyranny of the present.

Another possible requirement for teachers who assume the position of public intellectuals demands developing new ways to engage history in order to develop a critical watch over the relationship between historical events and the ways in which those events are produced and recalled through the narratives in which they unfold. This suggests that educators reaffirm the pedagogical importance of educating students to be skilled in the language of public memory. Public memory rejects the notion of knowledge as merely an inheritance with transmission as its only form of practice. In its critical form, public memory suggests that history be read not merely as an act of recovery but as a dilemma of uncertainty, a form of address and remembering that links the narratives of the past with the circumstances

of its unfolding and how such an unfolding or retelling is connected to "the present relations of power" and the experience of those engaged in the rewriting of historical narratives.[48] Public memory sees knowledge as a social and historical construction that is always the object of struggle. Rather than be preoccupied with the ordinary, public memory is concerned with what is distinctive and extraordinary; it is concerned not with societies that are quiet, that reduce learning to reverence, procedure, and whispers, but with forms of public life that are noisy, engaged in dialogue and vociferous speech.

In addition, educators as public intellectuals need to expand and apply the principles of diversity, dialogue, compassion, and tolerance in their classrooms to strengthen rather than weaken the relationships between learning and empowerment on one hand and democracy and schooling on the other. Bigotry, not difference, is the enemy of democracy, and it is difficult, if not impossible, for students to believe in democracy without recognizing cultural and political diversity as a primary condition for learning multiple literacies, experiencing the vitality of diverse public cultures, and refusing the comfort of monolithic cultures defined by racist exclusions. Differences in this instance become important not as simply rigid identity markers, but as differences marked by unequal relations of power, sites of contestation, and changing histories, experiences, and possibilities. Difference calls into question the central dynamic of power and in doing so opens up both a space of translation and the conditions for struggling to renegotiate and challenge the ideologies and machineries of power that put some subjects in place while simultaneously denying social agency to others.[49]

In a world marked by increasing poverty, unemployment, and diminished social opportunities, educators must vindicate the crucial connection between culture and politics in defending public and higher education as sites of democratic learning and struggle. Essential to such a task is providing students with the knowledge, skills, and values they will need to address some of the most urgent questions of our time. Educating for critical citizenship and civic courage, in part, means redefining the role of academics as engaged public intellectuals and border crossers who can come together to explore the crucial role that culture plays in revising and strengthening the fabric

of public life. Culture is a strategic pedagogical and political terrain whose force as a "crucial site and weapon of power in the modern world" can be extended to broader public discourses and practices about the meaning of democracy, citizenship, and social justice.[50] One of the most important functions of a vibrant democratic culture is to provide the institutional and symbolic resources necessary for young people and adults to develop their capacity to think critically, to participate in power relations and policy decisions that affect their lives, and to transform those racial, social, and economic inequities that impede democratic social relations.

Schooling and the Politics of Corporate Culture

Corporate Ascendancy is emerging as the universal order of the post-communist world. . . . Our social landscape is now dominated by corporations that are bigger and more powerful than most countries. . . . Our end of the century and the next century loom as the triumphal age of corporations.

—Charles Derber, *Corporation Nation*

CAPITALISM'S FINAL CONQUEST?

A recent full-page advertisement for *Forbes* magazine proclaims, in bold red letters, "Capitalists of the World Unite."[1] Beneath the slogan covering the bottom half of the page is a mass of individuals, representing various countries throughout the world, their arms raised in victory. Instead of workers in the traditional sense, the Forbes professionals (three women in all) are distinctly middle class, dressed in sport jackets and ties, and carrying briefcases or cellular phones. A sea of red flags with their respective national currencies emblazoned

on the front of each waves above their heads. At the bottom of the picture is a text that reads, "All hail the final victory of capitalism." At first glance, the ad appears to be a simple mockery of one of Marxism's most powerful ideals. But as self-conscious as the ad is in parodying the dream of a workers' revolution, it also reflects another ideology made famous in 1989 by Francis Fukuyama, who proclaimed "the end of history," a reference to the end of authoritarian communism in East Central Europe, the former Soviet Union, and the Baltic countries.[2] According to Fukuyama, "the end of history" means that liberal democracy has achieved its ultimate victory and that the twin ideologies of the market and representative democracy now constitute, with a few exceptions, the universal values of the new global village.

The Forbes ad does more than signal the alleged "death" of communism. It also cancels out the tension between market values and those values representative of civil society that cannot be measured in strictly commercial terms but are critical to democracy. I am referring specifically to such values as justice, freedom, equality, health and respect for children, the rights of citizens as equal and free human beings, as well as certain others, including, as Seyla Benhabib lists them, "respect for the rule of law, for individual rights for value pluralism, for constitutional guarantees . . . and democratic politics."[3]

Who are the cheering men (and three women) portrayed in this ad? Certainly not the forty-three million Americans who have lost their jobs in the last fifteen years. Certainly not "the people." The Forbes ad celebrates freedom, but only in the discourse of the unbridled power of the market. There is no recognition here (how could there be?) of either the limits that democracies must place on such power or how corporate culture and its narrow redefinition of freedom as a private good may actually present a threat to democracy equal to if not greater than that imagined under communism or any other totalitarian ideology. Fukuyama, of course, proved to be right about the fall of communism, but quite wrong about "the universalization of Western liberal democracy as the final form of government."[4] Before the ink dried on his triumphant proclamation, ethnic genocide erupted in Bosnia-Herzegovina, Moslem fundamentalism swept Algeria, the Russians launched a bloodbath in Chechnya, Serbs launched genocidal attacks against ethnic Albanians in Kosovo, and parts of Africa

erupted in a bloody civil war accompanied by the horror of tribal genocide. Even in the United States, with the Cold War at an end, the language of democracy seemed to lose its vitality and purpose as an organizing principle for society. As corporations have gained more and more power in the United States, democratic culture becomes corporate culture, the rightful ideological heir to the victory over socialism.[5]

I use the term *corporate culture* to refer to an ensemble of ideological and institutional forces that functions politically and pedagogically to both govern organizational life through senior managerial control and to produce compliant workers, depoliticized consumers, and passive citizens.[6] Within the language and images of corporate culture, citizenship is portrayed as an utterly privatized affair whose aim is to produce competitive self-interested individuals vying for their own material and ideological gains. Reformulating social issues as strictly individual or economic issues, corporate culture functions largely to cancel out the democratic impulses and practices of civil society by either devaluing them or absorbing such impulses within a market logic. No longer a space for political struggle, culture in the corporate model becomes an all-encompassing horizon for producing market identities, values, and practices. The good life, in this discourse, "is construed in terms of our identities as consumers—we are what we buy."[7] Public spheres are replaced by commercial spheres as the substance of critical democracy is emptied out and replaced by a democracy of goods, consumer lifestyles, shopping malls, and the increasing expansion of the cultural and political power of corporations throughout the world.

The broader knowledge, social values and skills necessary for creating substantive democratic participation increasingly seem at odds with and detrimental to such corporate moguls as Bill Gates, Warren Buffett, and Paul Allen—the new cultural heroes of social mobility, wealth, and success. Uncritically celebrated as models of leadership and celebrity icons, billionaires such as Gates personify the emptiness of a corporate culture in which the discourse of profit and moral indifference displace either the discursive possibilities for talking about public life outside of the logic of the market or a discourse capable of defending vital social institutions as public goods. As noncommodified

social spaces and institutions are shut down, Gates is envied in the media for accumulating personal wealth worth ninety billion dollars[8]—"more than the combined bottom 40 percent of the U.S. population, or 100 million Americans"[9]—while little is said about a society that allows such wealth to be accumulated at the same time that over forty million Americans, including twenty million children, live below the poverty line.[10] Within the world of national politics, conservative policy institutions, along with a Republican Congress, incessantly argue that how we think about education, work, and social welfare means substituting the language of the private good for the discourse and values of the public good (note, for example, the central arguments used by conservatives to defeat legislation aimed at curbing the power of the tobacco- and gun-producing industries). At the economic level, the ascendancy of corporate culture has become evident in the growing power of megaconglomerates such as Disney, General Electric, Time Warner, Viacom, and Westinghouse to control both the content and distribution of much of what the American public sees.[11]

Accountable only to the bottom line of profitability, corporate culture and its growing influence in American life has signaled a radical shift in both the notion of public culture and what constitutes the meaning of citizenship and the defense of public goods. For example, the rapid resurgence of corporate power in the last twenty years and the attendant reorientation of culture to the demands of commerce and regulation have substituted the language of personal responsibility and private initiative for the discourses of social responsibility and public service. This can be seen in government policies designed to dismantle state protections for the poor, the environment, working people, and people of color.[12] For example, the 1996 welfare law signed by President Bill Clinton reduces food stamp assistance for millions of children in working families, and a study enacted by the Urban Institute showed that the bill would "move 2.6 million people, including 1.1 million children, into poverty."[13] Other examples include the dismantling of race-based programs such as the California Civil Rights Initiative and the landmark affirmative-action case, Hopwood v. Texas, both designed to eliminate affirmative action in higher education; the reduction of federal monies for urban develop-

ment, such as the Department of Housing and Urban Development's housing program; the weakening of federal legislation to protect the environment; and a massive increase in state funds for building prisons at the expense of funding for public higher education.[14]

As a result of the corporate takeover of public life, the maintenance of democratic public spheres from which to organize the energies of a moral vision loses all relevance. As the power of civil society is reduced in its ability to impose or make corporate power accountable, politics as an expression of democratic struggle is deflated, and it becomes more difficult within the logic of self-help and the bottom line to address pressing social and moral issues in systemic and political terms. This suggests a dangerous turn in American society, one that threatens both the understanding of democracy as fundamental to our freedom and the ways in which we address the meaning and purpose of education.

THE LIMITS OF CORPORATE CULTURE

Politics is the performative register of moral action. It is the mark of a civilized society to prevent justice and compassion from becoming extinguished in each of us, while it is also a call to acknowledge the claims of humanity to eliminate needless suffering while affirming freedom, equality, and hope. Markets don't reward moral behavior, and as corporate culture begins to dominate public life it becomes more difficult for citizens to think critically and act morally. For instance, what opportunities exist, within the logic of privatization and excessive individualism, for citizens to protest the willingness of the United States Congress to serve the needs of corporate interests over pressing social demands? I am not referring simply to the power of individuals and groups to limit government subsidies and bailouts that benefit corporate interests, but to curtail those forms of institutional insanity that have severe consequences for the most vulnerable of our citizens—the young, the aged, and the poor. For instance, with no countervailing powers, norms, or values in place in civil society to challenge corporate power, how can the average citizen protest and stop the willingness of Congress to fund B2 "stealth"

bombers at a cost of $2 billion each, while refusing to allocate $100 million to expand child-nutrition programs? This is a political and moral default that appears all the more shameful given the fact that 26 per cent of children in the United States live in poverty.[15] In a society increasingly governed by profit considerations and the logic of the market, where is the critical language to be developed, nourished, and applied for prioritizing public over private democracy, the social good over those market forces that benefit a very small group of investors, or social justice over rampant greed and individualism?

As the rise of corporate culture reasserts the primacy of privatization and individualism, there is an increasing call for people to surrender or narrow their capacities for engaged politics in exchange for a market-based notion of identity, one that suggests relinquishing our roles as social subjects for the limited role of consuming subjects. Similarly, as corporate culture extends ever deeper into the basic institutions of civil and political society, there is a simultaneous diminishing of noncom-modified public spheres—those institutions engaged in dialogue, education, and learning—that address the relationship of the self to public life on one hand, and social responsibility on the other. Without these critical public spheres corporate power goes unchecked, and politics becomes dull, cynical, and oppressive.

As I have mentioned elsewhere, history has been clear about the dangers of unbridled corporate power.[16] The brutal practices of slavery, the exploitation of child labor, the sanctioning of the cruelest working conditions in the factories, mines, and sweatshops of America and abroad, and the destruction of the environment have all been fueled by the law of maximizing profits while minimizing costs, especially when there has been no countervailing power from civil society to hold such powers in check. This is not to suggest that capitalism is the enemy of democracy, but that in the absence of a strong civil society and the imperatives of a strong democracy, the power of corporate culture when left on its own appears to respect few boundaries based on self-restraint and those noncommodified, broader human values that are central to a democratic civic culture. John Dewey was right in arguing that democracy requires work, but that work is not synonymous with democracy.[17]

Struggling for democracy is both a political and educational task. Fundamental to the rise of a vibrant democratic culture is the recogni-

tion that education must be treated as a civil asset and not merely as a site for commercial investment or for affirming a notion of the private good based exclusively on the fulfillment of individual needs. Reducing higher education to the handmaiden of corporate culture works against the critical social imperative of educating citizens who can sustain and develop inclusive democratic public spheres. There is a long tradition extending from Thomas Jefferson to C. Wright Mills that extols the importance of education as essential for a democratic public life. This legacy of public discourse appears to have faded as educational consultants all over America from Robert Zemsky of Stanford University to Chester Finn of the Hudson Institute call for educational institutions to "advise their clients in the name of efficiency to act like corporations selling products and seek 'market niches' to save themselves" and meet the challenges of the new world order.[18] Within this corporatized discourse, management models of decision making align human initiative and learning with business interests, relegating issues of social responsibility and public accountability irrelevant as the goals of higher education are increasingly fashioned in the language of debits and credits, cost analyses, and the bottom line.[19]

In what follows, I want to address the fundamental shift in society regarding how we think about the relationship between corporate culture and democracy.[20] Specifically, I want to argue that one of the most important indications of such a change can be seen in the ways in which we are currently being asked to rethink the role of higher education. Underlying this analysis is the assumption that the struggle to reclaim higher education must be seen as part of a broader battle over the defense of democratic public spheres, and that at the heart of such a struggle is the need to challenge the ever-growing discourse and influence of corporate culture, power, and politics. I will conclude by offering some suggestions as to what educators can do to reassert the primacy of higher education as an essential sphere for expanding and deepening the processes of democracy and civil society.

CORPORATE MANAGERS IN HIGHER EDUCATION

In a recent issue of the *Chronicle of Higher Education*, Katherine S. Mangan reported that there are a growing number of presidential searches

"looking for leaders who can bridge business and academe."[21] According to Mangan, this has resulted in a large number of business-school deans being offered jobs as college or university presidents. The rationale for such actions appears to be that business deans "are often in a strong position to cultivate corporate contacts [and are] better at translating the academic environment to the outside world."[22] Mangan's article makes clear that what was once part of the hidden curriculum of higher education—the increasing vocational-ization and subordination of learning to the dictates of the market— has become an open and defining principle of education at all levels of learning.

According to Stanley Aronowitz, many colleges and universities are experiencing financial hardship brought on by the end of the Cold War and the dwindling of government-financed defense projects coupled with a sharp reduction of state aid to higher education. As a result, they are all too happy to allow corporate leaders to run their institutions, form business partnerships, establish cushy relationships with business-oriented legislators, and develop curricula programs tailored to the needs of corporate interests.[23] Stories predominate in the national press about the changing face of leadership in higher ed-ucation as more and more schools turn away from hiring scholars to fill administrative positions, relying instead on business leaders who can assume the roles of innovative budget cutters. One recent example is the hiring of John A. Fry, a former business consultant who never worked for a university, as an executive vice president at the University of Pennsylvania. According to one report, Fry "embodies the new, corporatized Penn: tactical, innovative, not tied to tradition, and with an ever-sharp pencil."[24] Fry has instituted reviews of all services at the university in order to determine which can be outsourced to the private sector. Thus far he has saved the school over $50 million while eliminating over five hundred jobs, many of them from em-ployees who had been with the university for decades. Fry's response to the plight of such workers is instructive. He claims that under his corporatized model, with its threat to traditional forms of job secu-rity, employees are now more efficient. He claims, "They are taking less for granted in terms of their employment status. . . . I feel we do the institution a disservice if we all allow inefficiency to perpetuate

because we don't want to rock the boat, or we don't want to deprive these poor people who have been working here for five decades from their jobs. I don't consider it cold-hearted, I consider it an absolute responsibility."[25] Fry frames the issue of responsibility exclusively within the logic of the market and, as one University of Pennsylvania faculty member puts it, he seems entirely indifferent to the traditional role of higher education as a "humanizing force in society, where the value of people is always a priority."[26] The effect of the new leadership at the university is disheartening. Elsa R. Ramsden, the chairman of the school's chapter of the American Association of University Professors, reports that many faculty are demoralized by the new leadership, and they have retreated to their classrooms, unwilling to get involved in the political process because they fear losing their jobs, not getting tenure, or having their salaries frozen. Fry's single-minded devotion to management-driven efficiency appears to legitimate such fears. According to Fry, "I tend to be very impatient. Sometimes that serves us well, sometimes not. I have a foot-on-the-gas mentality. I don't always want to listen to reason. I just want to get results."[27] Fry's vocabulary reveals the low priority placed on critical thought and ethical responsibility as defining features of corporate culture, especially as it becomes entangled with institutions that serve a broader conception of public service and citizenship. The notion that higher education should be defended as centers of critical scholarship, social responsibility, and enlightened teaching in order to expand the scope of freedom and democracy appears irrelevant if not dangerous in this discourse.

The vocationalizing of the university has many consequences. In some cases, it has meant that universities like the Massachusetts Institute of Technology (MIT) and the University of California at Irvine have cut deals with corporations by offering to do product research and cede to their corporate backers the patents for such inventions and discoveries in return for ample research money.

Further evidence of the vocationalization of higher education can be found in the increasing willingness on the part of legislators, government representatives, and school officials to rely on corporate leaders to establish the terms of the debate in the media regarding the meaning and purpose of higher education. One typical example can

be found in the highly publicized pronouncements of Louis Gerstner Jr., who is the chairman and CEO of IBM. In an editorial in *USA Today*, Gerstner argues that schools should be treated like businesses because "U.S. businesses were faced with a stark choice: change or close. They changed. They began to invest in substantial transformation, new methods of production, new kinds of worker training. Most importantly, they continually benchmarked performance against one another and against international competition. . . . And it worked."[28] For Gerstner and many other CEOs, the current success of the capitalist economy is the direct result of the leadership exercised by corporate America. The lesson to be drawn is simple: "Schools are oddly insulated from marketplace forces and the discipline that drives constant adaptation, self-renewal and a relentless push for excellence."[29] Gerstner's argument is instructive because it is so typical, primarily about issues of efficiency, accountability, and restructuring. Corporate organizations such as the Committee for Economic Development, an organization of executives from approximately 250 corporations, have been more blunt about their interest in education. Not only has the group argued that social goals and services get in the way of learning basic skills, but that many employers in the business community feel dissatisfied because "a large majority of their new hires lack adequate writing and problem-solving skills."[30]

Given the narrow nature of corporate concerns, it is not surprising that when matters of accountability become part of the language of school reform, they are divorced from broader considerations of ethics, equity, and justice. This type of corporate discourse not only lacks a vision beyond its own pragmatic interests, it also lacks a self-critical inventory about its own ideology and its effects on society. But, of course, one would not expect such concerns to emerge within corporations, where questions of consequence begin and end with the bottom line. Questions about the effects of downsizing, deindustrialization, and, as the *New York Times* has noted, the "trend toward more low-paid, temporary, benefit-free, blue- and white-collar jobs and fewer decent permanent factory and office jobs" caused by the reforms implemented by companies such as IBM must come from those democratic arenas that business seeks to restructure.[31] Megacorporations will say nothing about their profound role in promoting

the flight of capital abroad, the widening gap among intellectual, technical, and manual labor and the growing class of permanently underemployed in a mass of "deskilled" jobs, the growing inequality between the rich and the poor, or the scandalous use of child labor in third world countries. The onus of responsibility is placed on educated citizens to recognize that corporate principles of efficiency, accountability, and profit maximization have not created new jobs but in most cases have eliminated them.[32] My point, of course, is that such absences in public discourse constitute a defining principle of corporate ideology, which refuses to address—and must be made to address—the scarcity of moral vision that inspires such calls for school reform modeled after corporate reforms implemented in the last decade.

But the modeling of higher education after corporate principles and the partnerships they create with the business community do more than reorient the purpose and meaning of higher education. Such reforms also instrumentalize the curricula and narrow what it means to extend knowledge to broader social concerns. Business/ university partnerships provide just one concrete example of the willingness of both educators and corporate executives to acknowledge the effects such mergers have on the production and dissemination of knowledge in the interest of the public good. Lost in the willingness of schools such as MIT to sell part of their curricula to the corporations is the ethical consequence of ignoring basic science research that benefits humanity as a whole because such research offers little as a profit-maximizing venture. In a recent speech broadcast on C-Span, Ralph Nader indicated that one result of such transactions is that the universities are doing far too little to develop malaria and tuberculosis vaccines at a time when these diseases are once again killing large numbers of people in third world countries; such interventions are viewed as nonprofitable investments.[33] Research guided only by the controlling yardstick of profit undermines the role of the university as a public sphere dedicated to addressing the most serious social problems a society faces. Moreover, the corporate model of research instrumentalizes knowledge and undermines forms of theorizing, pedagogy, and meaning that define higher education as a social asset rather than private good.

Missing from much of the corporate discourse on schooling is any analysis of how power works in shaping knowledge, how the teaching of broader social values provide safeguards against turning citizen skills into simply training skills for the workplace, or how schooling can help students reconcile the seemingly opposing needs of freedom and solidarity in order to forge a new conception of civic courage and democratic public life. Knowledge as capital in the corporate model is privileged as a form of investment in the economy, but appears to have little value when linked to the power of self-definition, social responsibility, or the capacities of individuals to expand the scope of freedom, justice, and the operations of democracy.[34] Knowledge stripped of ethical and political considerations offers limited, if any, insights into how schools should educate students to push against the oppressive boundaries of gender, class, race, and age domination. Nor does such a language provide the pedagogical conditions for students to critically engage knowledge as an ideology deeply implicated in issues and struggles concerning the production of identities, culture, power, and history. Education is a moral and political practice and always presupposes an introduction to and preparation for specific forms of social life, a particular rendering of the notion of community, and what the future might hold.

If pedagogy is, in part, about the production of identities, then curricula modeled after corporate culture have been enormously successful in preparing students for low-skilled service work in a society that has little to offer in the way of meaningful employment for the vast majority of its graduates. If CEOs are going to provide some insight into how education should be reformed, they will have to reverse their tendency to collapse the boundaries between corporate culture and civic culture, between a society that defines itself through the interests of corporate power and one that defines itself through more democratic considerations regarding what constitutes substantive citizenship and social responsibility. Moreover, they will have to recognize that the problems in American schools cannot be reduced to matters of accountability or cost-effectiveness. Nor can the solution to such problems be reduced to the spheres of management and economics. The problems of higher education and public schooling must be addressed in the realms of values and politics, while engag-

ing critically the most fundamental beliefs Americans have as a nation regarding the meaning and purpose of education and its relationship to democracy.

CORPORATE CULTURE AND THE POLITICS OF SCHOOLING

As universities increasingly model themselves after corporations, it becomes crucial to understand how the principles of corporate culture intersect with the meaning and purpose of the university, the role of knowledge production for the twenty-first century, and the social practices inscribed within teacher-student relationships. The signs are not encouraging.

In many ways, the cost accounting principles of efficiency, calculability, predictability, and control of the corporate order have restructured the meaning and purpose of education. As I have mentioned previously, many deans are now given the title of CEO, academic programs are streamlined to cut costs, and in many colleges new presidents are actively pursuing ways to establish closer ties between their respective colleges and the business community. For example, the *New York Times* reports, in what has become a typical story, that at George Mason University, a business-oriented president has emphasized technology training in order to "boost the university's financing (by the state legislature) by as much as $25-million a year, provided that George Mason cultivates stronger ties with northern Virginia's booming technology industry."[35] In other quarters of higher education, the results of the emergence of the corporate university appear even more ominous. One such example comes from James Carlin, a multimillionaire and successful insurance executive who until recently served as the chairman of the Massachusetts State Board of Education. In a speech given before the Greater Boston Chamber of Commerce, he outlined what the structure of the corporate university would look like in the next century. Carlin argued that colleges need to be downsized, just as businesses have in the past decade; that tenure should be eliminated; and that faculty have too much power in shaping decisions in the university. Carlin's conclusion: "At least 50 percent of all

non-hard sciences research on American campuses is a lot of foolish-
ness" and should be banned.[36] Pointing to the rising costs of higher
education, he further predicted that "there's going to be a revolution
in higher education. Whether you like it or not, it's going to be bro-
ken apart and put back together differently. It won't be the same.
Why should it be? Why should everything change except for higher
education?"[37] Carlin's version of the "revolution" was recently
spelled out in more detail in a "Point of View" piece for the Chronicle of
Higher Education.[38] Carlin contends that higher education requires a
model of management and leadership that places more power and
authority in the hands of university presidents. Astonishingly, Carlin's
ideal is John Silber, the former president of Boston University, who
he claims represents "one of the few presidents who had real control
over a college or university."[39] What Carlin conveniently ignores,
though it has become a matter of public record, is both Silber's
demonstrated contempt for faculty and student governance, espe-
cially those structures that challenged his power and his disdain for
the principles of academic freedom so fundamental to higher educa-
tion in America. The subject of endless controversy, Silber's three-
decade rule at Boston University was punctuated by his ongoing
attacks on scholarship produced by feminists, Marxists, multicultural-
ists, and others who did not pass his ideological litmus test. More-
over, as Silber's critics have pointed out, he did more than belittle
such scholarship. He actually refused to grant tenure to many faculty
who did not share his conservative views. Silber's presidency became
synonymous in the popular imagination with a rigid, top-to-bottom
management style that undermined the university as a democratic
public sphere characterized by a range of scholarship, diverse forms
of teaching, and vigorous debate and deliberation. In using Silber as
his model of university leadership, the ex-CEO predictably celebrates
the imperatives of the bottom line and tight management while sell-
ing out academic freedom and intellectual diversity.

Carlin believes that higher education, like the corporations, should
be subject to reorganization and accountability schemes, a strategy
that quickly translates into a series of flawed policies designed to
cripple the intellectual and economic freedom of faculty. Shared gov-
ernance is not on Carlin's reform agenda. Nor does Carlin exhibit

anything but scorn for reforms that would improve opportunities for faculty to teach smaller classes, work within a time frame that allows for creative research, and improve classroom teaching as a result of reduced workloads. Carlin actually opposes all of these reforms. In his eagerness to rebuild universities in the mirror image of the megacorporation, with faculty as hostile workers and students as consumers, Carlin argues for scrapping remediation programs for students, expanding the workload of professors to four three-credit courses a semester, increasing student-teacher ratios, abolishing tenure, eliminating "public service" projects, and eradicating teacher unions. In this discourse, the university becomes an adjunct of the corporation, and its historic function as an autonomous sphere for the development of a critical and productive democratic citizenry is vanquished.

It would be reassuring to view Carlin's approach to higher education as either an isolated or idiosyncratic example of an administrator who is outspoken but largely ignorant of the problems and possibilities of higher education. Unfortunately, this is not the case. The current attacks against tenure, models of shared governance, critical scholarship, and equity-related issues in higher education are more than an outgrowth of the one-dimensional conception of democracy and civil society that corporate culture supports. Carlin's position exemplifies the ever-expanding influence of corporate ideology on institutions of higher learning as well as the concerted effort on the part of conservative ideologues to dismantle the gains of the welfare state, eliminate public entitlements, and abolish all those public spheres that subordinate civic considerations and noncommercial values to the dictates of an allegedly "free" market.

There is more at stake in university reform than the realities and harsh principles of cost cutting. Corporate culture in its reincarnation in the 1980s and 1990s appears to have little patience with noncommodified knowledge, or with the more lofty ideals that have defined higher education as a public service. Carlin's anti-intellectualism and animosity toward educators and students alike signal that as higher education comes under the influence of corporate ideologies, universities will be largely refashioned in the image of the new multiconglomerate landscape. As Carlin suggests, one consequence will be an attempt on the part of universities to curtail academic freedom and

tenure. As one business-oriented administrator admitted in a conversation about tenure with Bill Tierney, "We have to focus on the priorities of the . . . school and not the individual. We must industrialize the school, and tenure—academic freedom—isn't part of that model."[40] Missing from this model of leadership is the recognition that academic freedom implies that knowledge has a critical function, that intellectual inquiry that is unpopular and critical should be safeguarded and treated as an important social asset, and that public intellectuals are more than merely functionaries of the corporate order. Such ideals are at odds with the vocational function that corporate culture wants to assign to higher education.

While the appeal to downsizing higher education appears to have caught the public's imagination at the moment, it belies the fact that such "reorganization" has been going on for some time. In fact, more professors are working part-time and at two-year community colleges than at any other time in the country's recent history. Alison Schneider recently pointed out in the *Chronicle of Higher Education* that "in 1970, only 22 per cent of the professorate worked part-time. By 1995, that proportion had nearly doubled to 41 percent."[41] Creating a permanent underclass of part-time professional workers in higher education is not only demoralizing and exploitative for many faculty who inhabit such jobs, but such policies increasingly deskill both partial and full-time faculty by increasing the amount of work they have to do while simultaneously shifting power away from the faculty to the managerial sectors of the university. But the corporatizing of the university, along with its refusal to recognize higher education as a vital public good, has also had a detrimental effect on graduate students. Increasingly as the forces of downsizing, outsourcing, and part-timing bear down on academic labor, teaching assistants are given larger workloads, are deprived of health benefits, and are paid a slave wage while taking on the responsibility of teaching greater numbers of undergraduates. With little or no control over the conditions of their labor, graduate students have become the new underclass of higher education. At the same time, corporate culture has invested heavily in leadership from the top as evidenced by the huge salaries many CEOs get in this country. Stanford Weill, CEO for Citigroup, was paid $141.6 million in 1998, while L. Dennis Kozlowski, the CEO of Tyco International, received an annual

salary of $74.4 million the same year.[42] Michael Eisner, the CEO of Walt Disney Inc., is estimated to have received over $1 billion since he arrived at Disney fourteen years ago.[43] Yet the price paid for such a model of leadership appears not only to widen the gap between management and workers in the private sector, but also to undermine the image of the university as a public space for creating democratic values, critical teaching communities, and equitable work relations. This is especially true since more and more leadership positions in academia draw from the world and values of big business.

Held up to the profit standard, universities and colleges will increasingly calibrate supply to fit demand, and the results look ominous with regard to what forms of knowledge and research will be rewarded and legitimated. In addition, it appears that populations marked by class and racial subordination will have less access to higher education. As globalization and corporate mergers increase, technologies develop, and cost-effective practices expand, there will be fewer jobs for certain professionals, resulting in the inevitable elevation of admission standards, the restriction of student loans, and the reduction of student access to higher education. Stanley Aronowitz argues that the changing nature of intellectual labor, knowledge production, and the emerging glut of professionals on a global scale undermine mass education as the answer to the growing underemployment of the professional classes. He writes,

> Although the media hypes that millions of new jobs require specialized, advanced knowledge and credentials, the bare truth is that technological change, globalization, and relatively slow growth have reduced the demand for certain professionals. . . . And despite the boom of the middle 1990s, chronic shortages of physicians, accountants and attorneys have all but disappeared. In fact, the globalization of intellectual labor is beginning to effect knowledge industries, with Indian and Chinese engineers and computer designers performing work that was once almost exclusively done in North America and western Europe. And do nonscientists really need credentials signifying they have completed a prescribed program to perform most intellectual labor? If jobs are the intended outcome of a credential, there are few arguments for mass higher education.[44]

Fewer jobs in higher education means fewer students will be enrolled or have access, but it also means that the processes of vocationalization—fueled by corporate values that mimic "flexibility," "competition," or "lean production" and rationalized through the application of accounting principles—pose the threat of gutting many academic departments and programs that cannot translate their subject matter into commercial gains. Programs and courses that focus on areas such as critical theory, literature, feminism, ethics, environmentalism, postcolonialism, philosophy, and sociology suggest an intellectual cosmopolitanism or a concern with social issues that will be either eliminated or technicized because their role in the market will be judged as ornamental. Similarly, those working conditions that allow professors and graduate assistants to comment extensively on student work, provide small seminars for classes, spend time advising students, conduct independent studies, and do collaborative research with both faculty colleagues and students do not appear consistent with the imperatives of downsizing, efficiency, and cost accounting.[45]

SCHOOLING AND DEMOCRACY

I want to return to an issue I raised in the beginning of this chapter in which I argued that corporations have been given too much power in this society, and hence the need for educators and others to address the threat this poses to all facets of public life organized around the noncommodified principles of justice, freedom, and equality. Challenging the encroachment of corporate power is essential if democracy is to remain a defining principle of education and everyday life. Part of such a challenge necessitates that educators and others create organizations capable of mobilizing civic dialogue, provide an alternative conception of the meaning and purpose of higher education, and develop political organizations that can influence legislation to challenge corporate power's ascendancy over the institutions and mechanisms of civil society. This project requires that educators, students, and others provide the rationale and mobilize the possibility for creating enclaves of resistance, new public cultures for collective development, and institutional spaces that highlight, nourish, and evaluate the tension be-

tween civil society and corporate power while simultaneously struggling to prioritize citizen rights over consumer rights.

In strategic terms, revitalizing public dialogue suggests that educators need to take seriously the importance of defending higher education as an institution of civic culture whose purpose is to educate students for active and critical citizenship.[46] Situated within a broader context of issues concerned with social responsibility, politics, and the dignity of human life, schooling should be defended as a site that offers students the opportunity to involve themselves in the deepest problems of society, to acquire the knowledge, skills, and ethical vocabulary necessary for learning how to both participate in and shape public life.[47] Educators, parents, legislators, students, and social movements need to come together to defend higher education institutions as public goods, rather than simply as training centers, because they are among the few public spaces left where students can learn the power of and engage in the experience of democracy. In the face of corporate takeovers, the ongoing commodification of the curriculum, and the transformation of students into consumers, such a project requires educators to mount a collective struggle to reassert the crucial importance of higher education in offering students the skills they need for learning how to govern and take risks, while developing the knowledge necessary for deliberation, reasoned arguments, and social action. At issue here is providing students with an education that allows them to recognize the dream and promise of a substantive democracy, particularly the idea that as citizens they are, as Robin Kelley points out, "entitled to public services, decent housing, safety, security, support during hard times, and most importantly [sic], some power over decision making."[48]

But more is needed than defending higher education as a vital space in which to develop and nourish the proper balance between democratic public spheres and commercial power, between identities founded on democratic principles and identities steeped in forms of competitive, self-interested individualism that celebrate their own material and ideological advantages. Given the current assault on educators at all levels of schooling, it is politically crucial that educators at all levels of involvement in the academy be defended as oppositional public intellectuals who provide an indispensable service to the

nation. Such an appeal cannot be made merely in the name of professionalism but in terms of the civic duty such intellectuals provide. Intellectuals who inhabit our nation's universities represent the conscience of a society not only because they shape the conditions under which future generations learn about themselves and their relations to others and the world, but also because they engage pedagogical practices that are by their very nature moral and political, rather than simply technical. And at their best, such pedagogical practices bear witness to the ethical and political dilemmas that animate the broader social landscape. The appeal here is not merely ethical; it is also an appeal that addresses the materiality of power, resources, access, and politics. As oppositional public intellectuals, educators would take as the object of their pedagogical work the need to link learning to the possibilities of social transformation and political change. This means educators would both demonstrate and provide the opportunities and resources for students to engage in a public conversation about the conditions, sites, and struggles that define important political, economic, and cultural issues. This suggests teaching students how to undertake critique and participate in and shape public conversations across a variety of sites that range from academic journals and public media, on one hand, to town hall meetings and the Internet on the other. Being an oppositional public intellectual means that one works out of a political project, speaks to multiple audiences, links institutional reform to issues of access, and learns a language of critique and possibility that is broadly conceived and capable of addressing a variety of related social and cultural issues.

Organizing against the corporate takeover of schools also suggests—especially within higher education—fighting to protect the jobs of full-time faculty, turning adjunct jobs into full-time positions, expanding benefits to part-time workers, and putting power into the hands of faculty and students. Moreover, such a struggle must address the exploitative conditions many graduate students work under, constituting a de facto army of service workers who are underpaid, overworked, and shorn of any real power or benefits.[48] Similarly, programs in many universities that offer remedial programs, affirmative action, and other crucial pedagogical resources are under massive

assault, often by conservative trustees who want to eliminate from the university any attempt to address the deep inequities in the society while simultaneously denying a decent education to minorities of color and class. Hence, both teachers and students increasingly bear the burden of overcrowded classes, limited resources, and hostile legislators. Such educators and students need to join with community people and social movements around a common platform that resists the corporatizing of schools, the rollback in basic services, and the exploitation of teaching assistants and adjunct faculty.

In the face of the growing corporatization of schools, progressive educators at all levels of education should also organize to establish a bill of rights identifying and outlining the range of noncommercial relations that can be used as mediation between higher education and the business world. If the forces of corporate culture are to be challenged, progressive educators must also enlist the help of diverse communities, local and federal governments, and other political forces to ensure that public institutions of higher learning are adequately funded so that they will not have to rely on corporate sponsorship and advertising revenues. How our colleges and universities educate youth for the future will determine the meaning and substance of democracy itself; such a responsibility necessitates prioritizing democratic community, citizen rights, and the public good over market relations, narrow consumer demands, and corporate interests.

The corporatizing of higher education in the U.S. reflects a crisis of vision regarding the meaning and purpose of democracy at a time when, as Cornel West has said, "market cultures, market moralities, market mentalities [are] shattering community, eroding civic society, [and] undermining the nurturing system for children."[50] Yet such a crisis also represents a unique opportunity for progressive educators to expand and deepen the meaning of democracy—radically defined as a struggle to combine the distribution of wealth, income, and knowledge with a recognition and positive valorizing of cultural diversity—by reasserting the primacy of politics, power, and struggle as a pedagogical task.[51] At stake is not simply the future of higher education, but the nature of critical democracy itself. Democracy is not synonymous with capitalism, and critical citizenship is not limited to

being a literate consumer. Educators need to confront the march of corporate power by resurrecting a noble tradition, extending from the acts of Horace Mann to those of Martin Luther King Jr., in which education is affirmed as a political project that encourages people to expand the range of their capacities in order to assert the primacy of the public good over corporate interests and to reclaim democracy as more than a spectacle of market culture.

The Limits
of Academic
Multiculturalism

There are people who will not be disturbed about the existence of evil because they have a theory that accounts for it. Here, I am also thinking of some . . . who, in the face of wretchedness, quickly proceed to show why it exists. Even comprehension can be too quick.

—Max Horkheimer, *Dawn and Decline: Notes 1926–1931 and 1950–1969*

INTRODUCTION

For more than a decade, critical multiculturalists have made a strong case for rethinking the political and pedagogical possibilities of multiculturalism within higher education.[1] Signaling a new understanding of how the mechanisms of domination and exclusion work to reproduce and legitimate the entrenched nature of class, race, gender, and sexual hierarchies in higher education, critical multiculturalists often combine the study of symbolic forms and signifying practices with a reinvigorated and necessary study of the relations between

culture and politics.[2] For many critical multiculturalists, the process of schooling becomes a terrain of struggle over the meaning and purpose of the humanities, the value of disciplinarity, the regulatory function of culture, the relationship between knowledge and authority, and the related issue of who has ownership over the conditions for the production of knowledge.[3] Critical multiculturalists have also called into question the foundational categories that establish the canons of great works, the "high" and "low" culture divide, and the allegedly "objective" scholarship that mark the exclusions within and between various disciplines.[4] Similarly, they have fought bitter battles to establish academic programs that address the interests of various groups, including women's studies, Latino studies, and gay and lesbian programs.[5] In addition to challenging the content of curricula, they have successfully confronted the institutional distribution of power in higher education, in part by expanding, through affirmative action and other programs, the opportunities for minority students to gain access to colleges and universities.

Critical multiculturalism has scored some of its greatest successes by significantly adding to the sum of public discourses available within the university that provide students with a range of pedagogical options in which they can invest, act, and speak in order to expand their capacities for creating a stronger democratic society. Within progressive notions of multiculturalism, old disciplinary and cultural boundaries have given way to new ones, and the grip of monoculturalism has been significantly eased through a sustained emphasis on pluralized cultures in which various groups can now lay claim to the particularized identities and histories that inform and shape diverse cultural experiences.[6]

Arguing that cultural texts are inextricably related to broader social processes, critical multiculturalists have enhanced our understanding of how culture functions within higher education to construct knowledge, produce different social identities, and legitimate particular maps of meaning. Such insights have furthered our notion of cultural politics and the opportunity to make the pedagogical more political by linking the reading and writing of cultural texts to the acquisition of those skills and knowledges necessary to become critical readers and social actors. Drawing upon various theories of deconstruction, poststructuralism,

and postmodernism, academic multiculturalists have appropriated the critical turn toward language, particularly the emphasis on strategies of indeterminacy, uncertainty, and polyvocal meanings, in order to challenge Western logocentrism and reveal the racial codes that discursively construct "whiteness" as a mode of oppression and domination. Texts are now seen not only as objects of struggle in challenging dominant modes of racial and colonial authority but also as pedagogical resources for rewriting the possibilities for new narratives, identities, and cultural spaces.[7] Focusing on the politics of representation to call attention to the ways in which texts mobilize meanings in order to suppress, silence, and contain marginalized histories, voices, and experiences, critical multiculturalists have reasserted the power of the symbolic as a pedagogical force in securing authority and as a pedagogical strategy for producing particular forms of contestation and resistance.

Subjectivity and representation constitute the core determinants in shaping cultural politics in the liberal and radical discourses of academic multiculturalism, and serve to foreground pedagogical strategies that privilege the reading of texts and the related struggle over the control and production of identities.[8] Although critical and radical multiculturalists have been attentive to the relationship between culture and systemic relations of power within the university, they have largely focused their efforts pedagogically on matters of language, negotiation, and cultural identity. Within such approaches, the political as a form of ideology critique defines literacy largely as the pedagogical imperative to read texts differently; to "draw attention to discursive ambivalence";[9] to recognize different logics of signification; and to unsettle the consensus of common sense that constitutes dominant public values, national identity, and the meaning of citizenship. Academic multiculturalism in its more radical manifestations has emphasized going beyond opening texts to a multiplicity of interpretations, to the contruction of an in-between space of translation where subaltern knowledge can be represented and heard. It has also insisted on the need for dominant intellectuals to work against the grain of their own embedded interests and privileges while, as John Beverly sees it, "undoing the authority of the academy and knowledge centers at the same time that [they] con-

tinue to participate fully in them and to deploy their authority as teachers, researches, planners and theorists."[10]

At its best, critical multiculturalism has reinvigorated the debate over the role the humanities and the university might play in creating a pluralized public culture essential for animating the basic precepts of democratic public life. It has also worked to provide an institution-alized space for generating new bodies of knowledge, critical meth-ods, and social relationships alongside the old, traditional, and familiar.[11] Critical multiculturalism has provided new discourses for contesting oppressive power within the university in order to produce the formation of new publics of difference. In pluralizing literacy, mul-ticulturalism has redefined the pedagogical possibilities for teachers and students to engage their own historical locations and hybridized identities as formative rather than static, as part of a process of border crossing and a mode of becoming in which the production of cultural differences is both ongoing and an invaluable asset to democratic pub-lic life.[12]

Yet in spite of the contributions that critical multiculturalists have made in terms of democratizing higher education, their work has spawned serious debate and reprisal over the relationship between culture and politics. In what follows, I want to engage a number of the more vociferous charges that have surfaced against critical multi-culturalism. While many of these criticisms are important for the construction of a viable notion of cultural politics, I want to go be-yond these to argue that critical multiculturalism must overcome its insularity and reliance on textual strategies and address a cultural pol-itics of difference that takes seriously the relationship between cul-ture and power, and the implications the latter has for connecting work within the university to broader struggles in the larger society.

Since the strengths and limitations of critical multiculturalism can only be understood as part of the outcome of a broader struggle over issues of culture, identity, and power, I begin by addressing the most pervasive forms of multiculturalism in the academy, which consist of centrist models of diversity management and liberal attempts to de-velop a politics of recognition. I then focus on the emergence of one dominant strain of critical multiculturalism, which has developed in opposition to these forms of multiculturalism, and analyze the detour

it has taken primarily through literary studies, with its concerted focus on the politics and pedagogy of textuality. I then address briefly the conservative attack on all forms of academic multiculturalism and the role conservatives play in opposing multiculturalism as a form of radical cultural politics in the university. The paradoxical role that conservatives have played here demands some elaboration. Not only have conservatives engaged in a form of "cultural politics" that defines itself against politics even as it increasingly sets the agenda for how culture and power regulate questions of identity and difference within higher education; they have also presented a serious challenge to their counterparts on the left who theorize and strategize the relationship among culture, power, and politics by focusing almost exclusively on questions of meaning and textuality.

MANAGING DIVERSITY AND THE POLITICS OF RECOGNITION

Academic multiculturalism in its corporate and liberal versions has come under considerable attack recently, not only from a diverse number of conservatives but increasingly from critics on the left. Refusing to link cultural differences to relations of power, multiculturalists representing multinational corporate interests and centrist views of the academy have been rightly criticized for attempting to manage diversity through policies designed to incorporate resistance by, as David Theo Goldberg sees it, "paying lip service to the celebration of cultural distinctions."[13] Such strategies simultaneously undermine challenges waged by minority students against the misdistribution of power and resources in higher education. In this version of multiculturalism, race and difference are neutralized within the inclusive but homogeneous logic of assimilation or the power-insensitive discourse of pluralism.[14] Depoliticized and domesticated, culture is now racially cleansed and immune from the conflicts and exclusions that constitute its historical legacy.[15]

In fact, left critics have argued recently that within the mainstream appropriation of multiculturalism, management has become the organizing principle for regulating differences, often treating racism as

simply a pathology and prejudice rather than the systematic and his-
torically informed legacy of white supremacy.[16] For instance, Angela
Davis has argued, "Diversity management is precisely a means of pre-
serving and fortifying power relations based on class, gender, and race
[and that] such disciplining of diversity is, in fact, a strategy for more
exhaustive control of the working-class."[17] In addition, radical critics
such as David Bennett have also criticized liberal versions of diversity
management based on the call for group tolerance and a politics of
equal respect for the "other."[18] These approaches to academic multi-
culturalism focus on racial difference "as a question of identity rather
than of history and politics."[19] According to Bennett, the diversity-
management model of multiculturalism is organized around a notion
of pluralism that actually refuses the politics of difference among cul-
turally diverse groups while focusing on "consensus, rather than any
overarching structures of power, privilege and inequality, that defines
a group as a 'community.' "[20] Avery Gordon and Christopher Newfield
claim that there is no language in liberal multiculturalism for either
acknowledging the structural determinants of inequality within the
university or for challenging the "most lethal cultural aspect of white
rule — assimilation — which allows the mere presence of white peo-
ple to be a form of control."[21]

Some progressives argue that cultural politics in this discourse be-
comes ossified and wrongly celebrates political identities in their own
right rather than mobilizing social identities in the interests of a
broader counterhegemonic political project. Moreover, they charge
that the politics of recognition and diversity management is rooted in
a form of essentialism that assumes that individuals inhabit different
but unsullied, preconstituted cultural memories, locations, and expe-
riences.[22] Politics in this paradigm is about recognizing diversity and
forming consensus, rather than addressing inequality, the abuses of
power, and white supremacy.[23] Homi Bhabha sums up the impor-
tance of this critique by redefining cultural difference as a product of
power and politics, rather than preconstituted positions of difference
as suggested in liberal discourses such as Charles Taylor's more cele-
brated politics of respect. Bhabha writes,

> The notion that cultural diversity is a problem because there are al-
> ready many different cultures is not the reason why you have cultural

difference. Cultural difference is a particular constructed discourse at a time when something is being challenged about power or authority. . . . Cultural difference is not difficult, if you like, because there are many diverse cultures; it is because there is some particular issue about the redistribution of goods between cultures, or the funding of cultures, or the emergence of minorities or immigrants in a situation of re-sources—where resource allocation has to go—or the construction of schools and the decision about whether the school should be bilin-gual or trilingual or whatever. It is at that point that the problem of cultural difference is produced. So, it's really an argument against the naturalization of the notion of culture.[24]

As important as the politics of recognition might be in criticizing forms of racial privilege or calling for educators to make their own authority problematic and democratic, it generally has little to say about what it is in opposition to or what broader political project in-forms its own discourse of critique.[25] In light of such absences, crit-ics such as Gayatri Chakravorty Spivak, Chandra Mohanty, Ella Shohat, and Robert Stam have argued that academic multiculturalists of the diversity-management variety have not only failed to link difference to issues of power, parity, and equality, they have also failed to chal-lenge the Eurocentric biases that figure in their notions of history, marginality, modernity, gender, and transformation.[26]

PROFESSIONALIZED THEORY AND THE POLITICS OF TEXTUALITY

The legacies of corporate and colonial ideology can also be found in critical multiculturalism's obsession with a Western-oriented formal-ist criticism that often abstracts theory from concrete problems and the dynamics of power. Theory in this sense is reduced to a form of theoreticism, an indulgence in which the production of theoretical discourse becomes an end in itself, an expression of language largely removed from the possibility of challenging strategies of domina-tion. Rather than performing the bridging work between public and intellectual debates or implementing a political project that merges strategies of understanding and social engagement, theory becomes

less a means for social amelioration than an end for professional advancement. Cut off from concrete struggles and broader public debates, theory assumes an enervating role in privileging rhetorical mastery, playfulness, and cleverness over the politically responsible task of challenging the inertia of commonsense understandings of the world, opening up possibilities for new approaches to social reform, or addressing the most pressing social problems transforming the emergence of a transnational, multicultural democracy.[27]

At the core of the critical debate surrounding the political viability of critical multiculturalism is the emphasis on the politics of representation and textuality. It is widely recognized that critical multiculturalism's emphasis on textuality has provided an important theoretical service. Such work has opened up institutional spaces that enable teachers and students to interrogate different readings of cultural texts and address critically the signifying power of such texts to create and affirm particular social identities. Yet, this work has often resulted in reductive pedagogical and political practices. Removed from broader public discourses and analyzed outside of an assemblage of other cultural formations, texts become either the reified markers of a narrow version of identity politics or pedagogical resources for uncovering the attributes of specific identities.

Critical multiculturalists, especially those that inhabit literary theory programs, often focus inordinate attention on texts, signs, and disciplinary turfs. Herman Gray, in response to the textualization of politics within the academy, argues that "by privileging cultural texts over practice as the site of the social and political, the social and historical contexts that shape, situate, and structure cultural texts/products are largely ignored."[28] David Theo Goldberg reinforces Gray's criticism by arguing that cultural politics is not simply a signifying scheme through which identities are produced, but also a "mobilization around material resources regarding education, employment conditions, and political power."[29] Both of these theorists are correct in assuming that the textualization of multiculturalism, with its emphasis on expanding the curricula, its uncritical endorsement of multiple readings, and its use of texts to recover and affirm maginalized identities offers a narrow version of cultural politics. The politics of textuality has little to say about the underlying political and economic forces that keep various social groups marginalized; nor does it know

how to address the often subtle ways in which cultural practices both deploy power and are deployed in material relations of power.[30] Within many liberal and critical approaches to multiculturalism, the politics of meaning becomes relevant only to the degree that it is separated from a broader politics of engagement. Reading texts becomes a hermetic process removed from larger social and political contexts, and questions of power are engaged exclusively within a politics of representation. Such readings largely function to celebrate a textuality that has been diminished to a bloodless formalism and the nonthreatening, if not accommodating, affirmation of indeterminacy as a transgressive aesthetic. Lost here is any semblance of a radical political project that, as George Lipsitz sees it, "grounds itself in the study of concrete cultural practices and . . . understands that struggles over meaning are inevitably struggles over resources."[31] By failing to connect the study of texts, identity politics, and the politics of difference to specific social contexts, many academic multiculturalists conceive of politics as largely representational and abstractly theoretical.[32] In doing so, they erroneously believe that the politics of difference and the broader culture of politics can only be imagined or talked about as a form of discourse rather than understood as a set of effects marked by specific social relations, spatial practices, and institutional conditions produced within unequal relations of power. By addressing discourse in terms of both usage and effects, it becomes possible for educators to connect the discursive nature of their work to political and historical analyses that extend into wider public conversations and social issues. Such connections offer multicultural academics ample opportunities to connect their institutional subcultures within the university to broader struggles and social movements that build upon radical projects such as expanding the goals of the civil rights movement, campaigns designed to end attacks against the poor and immigrants, organized efforts to eliminate child poverty, and ongoing struggles to end sexism, racism, and environmental abuse.

CONSERVATIVE ATTACKS ON MULTICULTURALISM

A much different mode of critical analyses of multiculturalism and cultural politics has emerged from a number of conservatives who

argue that racism no longer undermines the ability of marginal groups to get ahead and that identity concerns over race, gender, and sexual orientation represent in large part the rantings of special-interest groups whose primary purpose is to undermine the traditions of Western culture and the basic principles of excellence that shape university life. The conservative attack is too well known to be repeated in detail, but includes a range of positions extending from the liberal assimilationist arguments of Arthur Schlesinger Jr., to the centrist conservative arguments of such authors as Shelby Steele and Stephan and Abigail Thernstrom, to the ideological extremism of Richard J. Herrnstein and Charles Murray, Dinesh D'Souza, and Robert Bork.[33] But in spite of their differences, all of these authors argue that racism no longer exists as a major problem for American society and that "blacks now have an unfair advantage in almost everything—jobs, education, housing, and incomes."[34] In its more mean-spirited version, this argument is often used to legitimate the more popular assumption that the black underclass and the poor are responsible for their own suffering and plight. In this strangely twisted argument it is no longer racism that poses a problem, but those who experience its effects.[35]

The resurgence of such arguments and bitter racial attacks have become widespread and gained a new urgency since the Reagan and Bush era. In part this has happened because of a growing and organized campaign against racial justice and equality that is largely funded by right-wing institutes like the John M. Olin Foundation, the Manhattan Institute, and the Smith Richardson Foundation. All of the previously mentioned best-selling authors have been sponsored in one way or another by right-wing think tanks and foundations, and all of them exhibit a pronounced belief that immigrants, multiculturalism in the schools, affirmative action, civil rights legislation, and the black underclass represent a growing threat to national identity, unity, and what it means to be an American.[36] Stanley Fish argues that in spite of their differences, conservative critics all share elements of a demagogic monoculturalism and "generally tell the same story about the formation of American character, the necessity of preserving it, and the threat it faces from ethnic upsurges: a story that continues in every respect, from words and phrases to large arguments, a

progress has not been sustained. This is particularly evident in the dramatic increase in black prisoners and the growth of the prison-industrial complex; crumbling city infrastructures; segregated housing; soaring black and Latino unemployment; exorbitant school dropout rates among black and Latino youth, coupled with the more general realities of failing schools; and deepening inequalities of incomes and wealth between blacks and whites.[50] Pushing against the grain of civil rights reform and racial justice are reactionary and moderate positions ranging from the extremism of right-wing skinheads and Jesse Helms conservatives to the moderate "color-blind" positions of liberals like Randall Kennedy.[51]

Crucial to the reemergence of this "new" racism is a cultural politics that plays a determining role in how race shapes our popular unconscious. This is evident in the widespread articles, reviews, and commentaries in the dominant media that give inordinate amounts of time and space to mainstream conservative authors, filmmakers, and critics who rail against affirmative action, black welfare mothers, and the alleged threats black youth and rap artists pose to middle-class existence. Rather than dismiss such rampant conservatism as either indifferent to the realities of racism or deconstruct its racialized codes to see where such language falls in on itself, educators can engage these commentaries more constructively by analyzing how they function as public discourses, how their privileged meanings work intertextually to resonate with ideologies produced in other sites, and how they serve largely to construct and legitimate racially exclusive practices, policies, and social relations. Central to such a project is the need to engage a multicultural politics that offers students and teachers opportunities to critically examine how certain racialized meanings carried in cultural texts gain the force of common sense in light of how racialized discourses are legitimated in other public spheres and institutionalized sites.

In order to deepen the cultural politics of multiculturalism, educators can address questions of culture, power, identity, and representation as part of a broader discourse about public pedagogy and social policy. In this pedagogical approach, power becomes central to the study of cultural texts and practices, and socially relevant problems can be explored through theoretical engagements with wider institutional

contexts and public spaces in which multicultural discourses gain their political and economic force. If teaching students to interrogate, challenge, and transform those cultural practices that sustain racism is a central objective of multicultural education, such a pedagogy must be addressed in ways that link cultural texts to the major social problems that animate public life. Texts in this instance would be analyzed as part of a "social vocabulary of culture" that points to how power names, shapes, defines, and constrains relationships between the self and the other; constructs and disseminates what counts as knowledge; and produces representations that provide the context for identity formation.[52] Within this type of pedagogical approach, multiculturalism must find ways to acknowledge the political character of culture through strategies of understanding and engagement that link an antiracist and radically democratic rhetoric with strategies to transform racist institutionalized structures within and outside of the university.

At its best, critical multiculturalism should forge a connection between reading texts and reading public discourses in order to link the struggle for inclusion with relations of power in the broader society. It is precisely within the realm of a cultural politics that teachers and students develop pedagogical practices that close the gap between intellectual debate and public life not simply as a matter of relevance, but as a process through which students can learn the skills and knowledge to develop informed opinions, make critical choices, and function as citizen activists. Robin D. G. Kelley provides one direction such a project might take. He insightfully argues,

> [Multiculturalism cannot ignore] how segregation strips communities of resources and reproduces inequality. The decline of decent-paying jobs and city services, erosion of public space, deterioration of housing stock and property values, and stark inequalities in education and health care are manifestations of investment strategies under de facto segregation. . . . [Progressives must address] dismantling racism, bringing oppressed populations into power and moving beyond a black/white binary that renders invisible the struggles of Latino, Asian-Americans, Native Americans and other survivors of racist exclusion and exploitation.[53]

tradition of jingoism, racism and cultural imperialism."[37] While con-
servatives respond to multiculturalism by privileging American history
as a public sphere inhabited largely by whites while reproducing at all
levels of schooling the legacy and racially coded discourse of Anglo-Eu-
ropean colonialism, they have not limited their battles to struggles over
texts and meaning. In fact, they have utilized the enormous power of
their capital, both material and symbolic, to shape educational policy
around issues of access, knowledge production, and retention, promo-
tion, and tenure. Moreover, conservatives have not limited their strug-
gles over cultural politics to the schools; they have also developed
alliances between conservative academics and state legislators, promi-
nent think tanks, and other sources of conservative funding. In doing
so, they have exercised a powerful influence on private and govern-
mental institutions that produce legislation, influence the media, and
distribute resources, especially as part of a broader attempt to liquidate,
as Pierre Bourdieu has noted, "the gains of the welfare state . . . as the
guardian of the public interest."[38] Conservatives have made it clear
through their discourse and actions that the politics of culture is not
limited to the politics of representation and that such struggles are not
confined within the isolated sphere of higher education.

CONNECTING CULTURE AND POLITICS

In light of the conservative offensive against multicultural education,
immigrants, civil rights legislation, and the welfare state, a number of
critical theorists have recently made a strong case for rethinking the po-
litical and pedagogical possibilities of a radical multiculturalism within
higher education.[39] In fact, many of these theorists share Wahneema
Lubiano's argument that higher education should not be abandoned as
a site of political and cultural struggle.[40] Lubiano and others are right
in suggesting that progressives should resist surrendering to the imper-
atives of professionalism, or retreat under pressure from right-wing
border patrol groups such as the National Association of Scholars who
routinely police the Western canon against racial impurities and disci-
plinary border crossings. Instead, such progressives ought to consider

new collective strategies for organizing engaged public intellectuals within and outside of the university to challenge the state's attempt to appropriate multiculturalism as both a corporate strategy and a set of empty slogans while limiting the intellectual and material resources available to marginalized groups. At the same time, such intellectuals can play an important role by not only challenging-state sanctioned uses of culture to reproduce and regulate racial, class, and gender-based hierarchies and inequalities, but also by producing new spaces in which teachers and students can reimagine their senses of self and their relationships to others within a more radical democratic social order where racial injustices lose their determining force as the "fundamental category for the distribution of power, material resources and privilege."[41]

But if the academy is to assume a central role in contesting racial injustice, class hierarchies, and the politics of exclusion, progressive academics will have to challenge those poststructuralist and postmodern versions of multicultural textualism that reduce culture to the logic of signification. As Lawrence Grossberg points out, culture must not be equated with the domain of meaning and representation, but rather addressed as "both a form of discursive practice and an analysis of institutional conditions."[42] Equally important to politically viable academic work is the recognition that the struggle over culture is not a substitute for some kind of "real" or "concrete" form of politics. Rather, as Grossberg sees it, culture is a crucial "site of the production and struggle over power—where power is understood not necessarily in the form of domination," but as a productive and mediating force for the making and remaking of diverse and interconnected social, political, and economic contexts that make up daily life.[43]

As citizenship becomes more privatized and students are increasingly educated to become consuming subjects rather than critical social subjects, it becomes all the more imperative for educators to rethink how the educational force of the culture works to both secure and resist particular identities and values. This is especially important as the force of dominant culture is defined through its submission to the values of the economy with its emphasis on privatization and the gospel of self-help, all of which works to both undermine notions of the public good and collective responsibility and place the blame for

injustice and oppression entirely on the shoulders of those who are the victims of social misfortune. In opposition to such critics as Harold Bloom, Alan Sokal, and Todd Gitlin, progressive educators can foreground the importance of critical work in higher education as part of a broader radical democratic project to recover and rethink the ways in which culture is related to power and how and where it functions both symbolically and institutionally as an educational, political, and economic force that refuses to live with difference, democracy, and social justice.

As more and more young people face a world of increasing poverty, unemployment, and diminished social opportunities, those of us in education can struggle to vindicate the crucial connection between culture and politics in defending higher education as an essential democratic public sphere dedicated to providing students with the knowledge, skills, and values they will need to address some of the most urgent questions of our time. Yet if addressing multiculturalism as a form of cultural politics within the university is to become a meaningful pedagogical practice, academics will have to reevaluate the relationship between culture and power as a starting point for bearing witness to the ethical and political dilemmas that connect the university to other spheres within the broader social landscape. In doing so, progressive educators need to become more attentive to how multicultural politics gets worked out in urban spaces and public spheres currently experiencing the full force of the right-wing attack on culture and racial difference. It is no longer possible for academics to make a claim for a radical politics of multiculturalism by defining it merely as a set of intellectual options and curriculum imperatives. Academic multiculturalism must also examine actual struggles taking place in the name of cultural difference within institutional sites and cultural formations that bear the brunt of dominant machineries of power designed to exclude, contain, or disadvantage the oppressed. The institutional and cultural spheres bearing the brunt of the racialization of the social order are increasingly located in the public schools, in the criminal justice system, in retrograde anti-immigrant policy legislation, and in the state's ongoing attempts to force welfare recipients into workfare programs.[44]

I am not suggesting that we redefine multiculturalism by moving away from issues of representation or that we shift our pedagogical

efforts in the interests of a democratic politics of difference away from the university. On the contrary, as progressive educators we need to vitalize our efforts within the university by connecting the intellectual work we do there with a greater attentiveness to broader pressing public problems and social responsibilities. A radical approach to multiculturalism must address how material relations of power work to sustain structures of inequality and exploitation in the current racialization of the social order. It must ask specific questions about the forms racial domination and subordination take within the broader public culture and how their organization, operation, and effects both implicate and affect the meaning and purpose of higher education. At stake here is the need for critical educators to give meaning to the belief that academic work matters in its relationship to broader public conversation practices, and policies; and that such work holds the possibility for understanding not just how power operates in particular contexts, but also how, according to Lawrence Grossberg, such knowledge "will better enable people to change the context and hence the relations of power"[45] that inform the inequalities that undermine any viable notion of multiculturalism within spheres as crucial to democracy as the public schools and higher education.

In short, I want to insist that multiculturalism is not simply an educational problem. At its roots it is about the relationship between politics and power; it's about a historical past and a living present in which racist exclusions appear "calculated, brutally rational, and profitable."[46] Embedded within a systemic history of black restriction, subjugation, and white privilege, the politics of multiculturalism is still, as Supreme Court justice Ruth Bader Ginsburg puts it, "evident in our workplaces, markets and neighborhoods."[47] David Shipler argues powerfully that race and class are the two most powerful determinants shaping American society. Based on interviews with hundreds of people over a five-year period, Shipler's book A Country of Strangers bears witness to a racism that "is a bit subtler in expression, more cleverly coded in public, but essentially unchanged as one of the 'deep abiding currents' in everyday life, in both the simplest and the most complex interactions of whites and blacks."[48]

Although there can be little doubt that racial progress has been achieved in many areas in the last fifty years,[49] it is also true that such

Implicit in Kelley's call for action is the recognition that any viable pedagogy and politics of representation needs to address the realities of historical processes, the actuality of economic power, and the range of public spaces and institutions that constitute the embattled terrain of racial difference and struggle. This suggests developing a critical vocabulary for viewing texts not only in relation to other modes of discourse, but also, as Randall Johnson notes, "in relationship to contemporaneous social institutions and non-discursive practices."[54] Within this approach, cultural texts cannot be isolated from the social and political conditions of their production. Nor can the final explanation of such texts be found within the texts themselves. On the contrary, such texts become meaningful when viewed both in relation to other discursive practices and in terms of "the objective social field from which [they] derive."[55] Pedagogically, this suggests addressing how cultural texts in the classroom construct themselves in response to broader institutional arrangements, contexts of power, and the social relations that they both legitimate and help to sustain.

In what follows, I demonstrate the theoretical relevance for developing a multicultural pedagogical practice in which issues of representation and social transformation mutually inform each other. In doing so I want to focus on a recent Hollywood blockbuster, 187, to illustrate how pedagogy might be taken up as a public project designed to integrate representations of cultural and racial difference with material relations of power that animate racially exclusive practices and policies. Hollywood is one of many sites that often appear too far removed from the privileged security of the university to be included in the discourse of critical multiculturalism.

RACIAL CODING IN THE HOLLYWOOD TEXT

During the last five years, a number of Hollywood films, such as *Dangerous Minds* (1995), *The Substitute* (1996), and *High School High* (1996), have cashed in on the prevailing racially coded popular "wisdom" that public schools are out of control, largely inhabited by illiterate, unmotivated, and violent urban youth who are economically and racially marginalized. This increasingly familiar script suggests a

correlation between urban public space and rampant drug use, daily assaults, broken teachers, and schools that do nothing more than contain deviants who are a threat to themselves and everybody else. The film 187 is a recent addition to this genre, but takes the pathologizing of poor, urban students of color to extremes so far beyond existing cinematic conventions that it stands out as a public testimony to broader social and cultural formations within American society that make the very existence of this blatantly racist film possible.

Directed by Kevin Reynolds and written by Scott Yagemann, a former schoolteacher, 187 narrates the story of Trevor Garfield (Samuel L. Jackson), a science teacher who rides to work on a bike in order to teach at a high school in the Bedford-Stuyvesant section of Brooklyn. Garfield is portrayed as an idealistic teacher who, against all odds, is trying to make his classes interesting and do his best to battle daily against the ignorance, chaos, and indifference that characterize the urban public school in the Hollywood imagination. Yet the film quickly turns away from a call for educational reform and a defense of those teachers who face a Sisyphean task in trying to improve the lives of urban youth and rapidly degenerates into a rationale for abandoning urban public schools and the black and brown students who inhabit their hallways and classrooms.

In the film's opening scenes, students move through metal detectors under the watchful eyes of security guards—props that have become all too familiar in urban high school settings. Clearly, the students in 187 are far removed from the squeaky clean, high-tech classrooms of white suburbia: the school looks more like a prison, and the students, with their rap music blaring in the background, look more like inmates being herded into their cells. The threat of violence is palpable in this school, and Garfield confronts it as soon as he enters his classroom and picks up his textbook, which has the figure 187 scrawled all over it. Recognizing that the number is the police code for homicide, Garfield goes to the principal to report what he believes is a threat on his life. The principal tells Garfield he is overreacting, dismissing him with, "You know what your problem is? On one hand, you think someone is going to kill you, and on the other hand, you actually think kids are paying attention in your class." Garfield hasn't yet left the office before the principal reveals

that he has told a student in Garfield's class that he has flunked the course. Not only has the principal violated Garfield's student-teacher relationship, but the student who he has flunked is on probation and as a result of the failing grade will now be sent back to prison. The threat of violence and administrative ineptitude set the stage for a hazardous series of confrontations between Garfield and the public school system. Garfield leaves the principal's office terrified and walks back to his classroom. Each black male student he now sees appears menacing and poised to attack; shot in slow motion, the scene is genuinely disturbing. And before Garfield reaches his classroom, he is viciously and repeatedly stabbed with a nine-inch nail in the hallway by the black male student he has flunked.

Fifteen months later Garfield has relocated and finds a job as a substitute teacher at John Quincy Adams High School in Los Angeles. The students in this school are mostly Latino. They wear oversized pants and torn shirts, carry boom boxes blaring rap music, and appear as menacing as the African-American students Garfield taught in Brooklyn. As the camera pans their bodies and expressions, it becomes clear that what unites these inner-city students of color is a culture that is dangerous, crime-ridden, and violent. Assigned to teach his class in a bungalow, Garfield's first day is a nightmare as students taunt him, throw paper wads at him, and call him "bitch." Garfield has moved from New York to California only to find himself in a public high school setting that has the look and feel of hell. Heat rising from the pavement, pulsating rap music, graffiti, and oversized shadows of gang members playing basketball filter through the classroom window to paint an ominous picture of what Garfield can hope to experience.

But Garfield has to face more than dangerous students. His new principal prides himself on never having been a teacher, refers to the students as "clients," and makes it clear that his primary concern is to avoid potential lawsuits. Hollywood's message in this case is clear: public schools are filled with administrators who would rather cater to a liberal discourse about the civil rights of students—who clearly don't deserve any—than protect the welfare of teachers who face the threat of daily violence.

Garfield's fellow teachers are no better. The first teacher he meets, Dave Childress (John Heard), is an alcoholic burnout who stashes a

.357 Magnum in his desk drawer, thoroughly hates his students, and, we later learn, has had sexual relations with a very young, emotionally shaken Latina student. Hanging on for the paycheck, Childress serves as a reminder of what such schools do to teachers. Robbed of his passion, he regards every kid as a social menace or macho punk, waiting to kill or be killed.

Garfield eventually strikes up a friendship and romance with Ellen Henry (Kelly Rowan), a perky, blond computer-science teacher, but it soon turns sour as the bleak and dangerous environment in which they find themselves eventually pushes Garfield over the edge. Ellen tries to draw close to Garfield, but he is too battered and isolated, telling Ellen at one point that when he was assaulted in New York, it robbed him of his "passion, my spark, my unguarded self—I miss them."

Garfield's descent into madness begins when his bungalow is completely trashed by the gang members in his class. He becomes edgy, living in a shadow of fear heightened by his past. Ellen then tells Garfield that Benny, a particularly vicious gang member in his class, has threatened to hurt her, and that she doesn't know what to do. Benny soon disappears, but Ellen's troubles are not over, as Benny's sidekick Cesar and his friends kill her dog. As a result, Cesar becomes the object of vigilante justice. Roaming drunk near an L.A. freeway, he is stalked, shot with a spiked arrow, and, while unconscious, has his finger cut off. The tension mounts as Ellen finds Benny's rosary beads in Garfield's apartment and confronts him with the evidence that he might be the killer. Garfield is immune to her reproach, arguing that someone has to take responsibility since the system will not protect "us" from "them." Ellen tells Garfield she doesn't know him anymore, and Garfield replies, "I am a teacher just like you." As the word circulates that Garfield may be the vigilante killer and assailant, the principal moves fast to protect the school from a lawsuit and fires him. Garfield, now completely broken, goes home and is soon visited by Cesar and his gang, who, inspired by the film The Deer Hunter, force Garfield into a game of Russian roulette. With little to lose, Garfield accuses Cesar of not being a real man, and ups the stakes of the game by taking Cesar's turn. Garfield pulls the trigger and kills himself. Forced into questioning his own manhood, Cesar decides to take his turn, puts the gun to his head, and fatally shoots himself as well. In

the final scene of the film, a student is reading a graduation speech about how teachers rarely get any respect. The shot switches to Ellen, who is in her classroom. Ellen takes her framed teaching certificate off the wall, throws it into the wastebasket, and walks out of the school.

ACCESSING A PEDAGOGY OF THE CULTURAL OBJECT

Pedagogically, films like 187 can be interrogated by analyzing both the commonsense assumptions that inform them as well as absences and exclusions that limit the range of meanings and information available to audiences. Analyzing such films as public discourses also provides pedagogical opportunities to engage complex institutional frameworks that create the conditions for the construction, legitimation, and meaning of such cultural texts. As public discourses, these cultural texts can be addressed in terms of how they are constituted as objects that gain their relevance through their relationship to other social institutions, resources, and nondiscursive practices. In this instance, 187 would be taken up as a discursive practice whose effects might be addressed in relation to issues of race in related contexts where struggles for meaning and representation are connected to struggles for power, social agency, and material resources. Some of these issues are illustrated below.

The film 187 provides ample representations of students of color as the pathological other, and public schools as not only dysfunctional but also as an imminent threat to the dominant society. Represented as a criminalized underclass, black and brown students in 187 are viewed as dangerous, and public schools as holding centers that contain such students through the heavy-handed use of high-tech monitoring systems and military-style authority. Reinforcing such stereotypes is a decontextualized and depoliticized cinematic narrative that erases the conditions that produce such denigrating images of inner-city public schools—poverty, family turmoil, highly segregated neighborhoods, unemployment, crumbling school buildings, lack of material resources, or inequities within local and national tax structures. In this instance, 187 represents more than a text that portrays a

particularly offensive image of urban schools and minority students; it also participates as a public pedagogy in enabling, legitimizing, and reinforcing discursive practices whose effect is to condemn the children of the urban poor to public schools increasingly subject to electronic surveillance, private police forces, padlocks, and alarms suggestive of prisons or war zones.[56]

Clearly, if the dominant codes at work in such a film are to be questioned, it is imperative for students to address how the absences in such a film tie it to prevailing discourses about public education, multiculturalism, and the ongoing assault on minorities of class and color in- and outside public schooling. Marking such absences is crucial to understanding such a film—the refusal to point to the need for smaller class sizes, inspiring teachers, visionary administrators, and ample learning resources—but such absences become meaningful when understood within a broader struggle over issues of racial identity, power, representation, and everyday life.

Films like 187 carry the logic of racial stereotyping to a new level and represent one of the most egregious examples of how popular cultural texts can be used to demonize black and Latino youth while reproducing a consensus of common sense that legitimates racist policies of either containment or abandonment in the inner cities. But such instances of racial coding cannot reside merely within the boundaries of the text to be fully understood as part of the broader landscape of racial injustice. Depictions of urban youth as dangerous, pathological, and violent must be located in terms of where different possibilities of uses and effects of such representations may ultimately reside in contexts of everyday life that are at the forefront of multicultural struggles. For example, the depictions of youth in 187 resonate powerfully with the growth of a highly visible criminal justice system whose get-tough policies fall disproportionately on poor black and brown youth. What is the pedagogical potential of a film such as 187 in addressing the political, racial, and economic conditions that promote a specious (yet celebrated) "war on drugs," a war whose policies threaten to wipe out a whole generation of young black men who are increasingly incarcerated in prisons and jails? The figures are disturbing, as the number of black men incarcerated is

growing at the rate of about 7 percent a year, and annual prison costs are now higher than $30 million?[57]

As statistics show, "between 1983 and 1998 the number of prisoners in the U.S. increased from 650,000 to more than 1.7 million. About 60 percent of that number are African-Americans and Latinos. More than one-third of all young black men in their 20s are currently in jail, on probation or parole, or awaiting trial. We are now adding 1,200 new inmates to U.S. jails and prisons each week, and adding about 260 new prison beds each day."[58]

This state of affairs is compounded by the disturbing fact that as a result of serving time nearly half of the next generation of black men will forfeit their right to vote in several states. How might a cultural text such as 187 be used to address the relationship between the increase in prison growth and the plight caused by industrial downsizing and rising unemployment among young black men across America's inner cities in the 1990s? What might it mean for students to address their own responses to the moral panics concerning crime and race that have swept across the middle classes in the last decade, made manifest in strong electoral support for harsh crime laws and massive increases in prison growth?

At the very least, educators can address 187 not merely in terms of what such a text might mean but how it functions within a set of complex social relations that create the conditions of which it is a part and from which it stems. Lawrence Grossberg insightfully argues that such a pedagogy would "involve the broader exploration of the way in which discursive practices construct and participate in the machinery by which the way people live their lives are themselves produced and controlled. Rather than looking for the 'said' or trying to derive the saying from the said, rather than asking what texts mean or what people do with texts, [a critical pedagogy] would be concerned with what discursive practices do in the world."[59]

Engaging the potential discursive effects of films like 187 might mean discussing the implication of this Hollywood film's appropriating the name of the controversial California proposition to deny mostly nonwhite students access to public schools. Or it might mean discussing how the film contributes to a public discourse that rationalizes

both the demonization of minority youth and the defunding of public and higher education at a time when, in states such as California, "approximately 22,555 African Americans attend a four-year public university . . . while 44,792 (almost twice as many) African Americans are in prison [and] this figure does not include all the African Americans who are in county jails or the California Youth Authority or those on probation or parole."[60]

Hollywood films like 187 must be addressed and understood within a broader set of policy debates about education and crime that often serve to legitimate policies that disempower poor and racially marginalized youth. For example, state spending for corrections has increased 95 percent over the last decade, while spending on higher education has decreased 6 percent. Similarly, in the last ten years, the rate of increase in the number of correctional officers is four times that of the increase in public higher education faculty. Again, it is not surprising that the chosen setting for 187 is primarily California, a state that now, the Justice Policy Institute notes, "spends more on corrections (9.4 percent of the General Fund) than on higher education."[61] While it would be absurd to suggest to students that films like 187 are responsible for recent government spending allocations, they do take part in a public pedagogy and representational politics that cannot be separated from a growing racial panic over and fear of minorities, the urban poor, and immigrants.

As public discourses, films like 187, *The Substitute*, *Dangerous Minds*, and *Belly* fail to rupture the racial stereotypes that support harsh, discriminatory crime policies and growing incidents of police brutality. (Recent examples include the New York Police Department's highly publicized torture of Abner Louima, or its shooting of Amadou Diallo by four patrolmen who riddled his body and an apartment building vestibule with forty-one bullets in spite of the fact that the victim was unarmed.) Such films also have little to say about police assaults on poor black neighborhoods, such as those conducted by former police Chief Daryl Gates in South Central Los Angeles. Exploiting the race-based moral panics that fuel popular antagonism toward affirmative action, immigrants, bilingual education, the inner city, and the unmarried "welfare queen," films such as 187 capitalize on modes of exclusion through what Jimmie Reeves and Richard Campbell call the

"discourse of discrimination" and the "spectacle of stigmatization."
Within this discourse, the urban black or brown youth is depicted as
"the pathological Other—a delinquent beyond rehabilitation."[62]

What is unique about 187 is that it explores cinematically what the
logical conclusion might be in dealing with urban youth for whom
reform is no longer on the national agenda, and for whom contain-
ment or the militarization of school space seem both inadequate and
too compromising. Carried to the extreme, 187 flirts with the ulti-
mate white supremacist logic, that is, the extermination and genocide
of those "others" deemed beyond the pale of social reform, deemed
inhuman and despicable. The film capitalizes on the popular media
conception that public education is not safe for white, middle-class
children, that racial violence is rampant in the public schools, that
minority students have turned classroom discipline into a joke, that
administrators are paralyzed by insensitive bureaucracies, and that the
only thing that teachers and students share is the desire to survive the
day. Yet repititious cultural texts such as 187 become meaningful not
just as strategies for understanding and critical engagement that raise
questions about related discourses, texts, and social issues; they also
become meaningful in probing what it might mean to move beyond
the sutured institutional space of the classroom to address social is-
sues in related spheres marked by racial injustices and unequal rela-
tions of power.

The popularity of such films as 187 in the heyday of academic mul-
ticulturalism points to the need, in light of such representations, for
educators to expand their understanding of politics as part of a
broader project designed to address major social issues in the name
of a multiracial democracy. This suggests getting beyond reducing
multiculturalism to the simple study of texts or discourse, and ad-
dressing multicultural politics as part of the struggles for power and
resources in a variety of public spheres. This may mean endeavoring
to change how, as Michael Bérubé notes, the "economics of school
funding and school policy [work to] sustain segregation in American
public education [through] inhuman fiscal policies that have ensured
the continuous impoverishment of schools attended wholly by black
or Hispanic schoolchildren."[63] It may require students to engage in a
politics of multiculturalism aimed at reforming a criminal justice sys-

tem that disproportionately incarcerates and punishes minorities of class and color. Issues of representation and identity in this case offer the opportunity for multicultural educators to explore and challenge both the strengths and limits of cultural texts. This suggests developing a pedagogy that promotes a social vocabulary of cultural difference that links strategies of understanding to strategies of engagement; that recognizes the limits of the university as a site for social engagement; and that refuses to reduce politics to matters of language and meaning, erasing broader issues of systemic political power, institutional control, economic ownership, and the distribution of cultural and intellectual resources in a wide range of public spaces. I recognize that academics cannot become public intellectuals by the mere force of will, given the professional and institutional constraints under which they operate. But at the same time, if multiculturalism is not going to abandon the world of public politics and take seriously the link between culture and power, progressive educators will have to rethink collectively what it means to link the struggle for change within the university to struggles for change in the broader society. Combining theoretical rigor with social relevance may be risky politically and pedagogically, but the promise of a multicultural democracy far outweighs the security and benefits that accompany a retreat into academic irrelevance and color-blind professionalism.

Teaching the
Political with
Homi Bhabha

Henry A. Giroux and
Susan Searls Giroux

INTRODUCTION

As I have suggested throughout this book, the relationship among
culture, politics, and pedagogy is the subject of heated debate for so-
cial theorists, political pundits, and educators, and the controversy
cuts across ideological lines. Much of the animus is unsurprising—
the detritus of the conservative recoil from difference—though it
has taken on a new urgency as part of the broader backlash against
women, minorities of color, youth, and the welfare state itself. The
more familiar lines of attack can be summarized as follows: cultural
politics is repudiated in the interests of a new—actually old—or-
thodoxy of anachronistic materialism, or it is simply dismissed as a
corrupting influence on the universal values of truth, beauty, and
reason. Caught between the modalities of a timeless universal aes-
thetic or a narrowly defined economism, factions on both the right
and left mark culture's proliferation of differences as profoundly
dangerous. Removing culture from the play of power and politics,
educators and critics across the political spectrum thwart the possi-

bility for understanding how learning is linked to social change. Moreover, such an erasure mystifies how the struggle over identities, meanings, values, and desires that takes place across the whole field of social practices is wielded to make it difficult for subaltern groups to participate in such struggles in ways that carry any legitimacy. Yet some of the criticism provides a welcome opportunity for rethinking the relationship between cultural politics and politics in general, between cultural politics and the politics of literacy, and between pedagogy and agency.

In what follows, we will continue an important theme of this book—defending culture as an important site of political struggle, and pedagogy as a crucial component of cultural politics. In doing so, we want to first analyze some recent public conversations about university educators in general and the nature of pedagogy in particular. Increasingly, pedagogy has either been dismissed as an unviable element of education and cultural politics or rendered politically obsolete by reducing it to a method and set of instrumental prescriptions and teaching tips. We spend some time on these examples, because they are characteristic of how pedagogy is being depoliticized as part of a broader attack on higher education and the culture of politics itself. In opposition to these attacks, we attempt to make a case for the relationship between the politics of culture and the culture of politics—and for the primacy of the pedagogical as a constitutive force in the resuscitation of a democratically informed political culture that links the struggle over identities and meaning to the wider struggle over material relations of power.[1] In doing so, we turn to the work of Homi Bhabha as an example of critical pedagogical practice concerned with the relationships among culture, power, and politics, on one hand, and literacy, pedagogy, and social change on the other. Bhabha's work is important for rethinking pedagogy as a mode of cultural inquiry that is essential for questioning the conditions under which knowledge and identifications are produced and subject positions are taken up or refused. Bhabha also raises important questions regarding how we think about politics—that is, how we understand the dynamics of culture within the shifting terrain of the discursive—and the implications it has for theorizing the pedagogical conditions that make social agency possible.

ERASING THE POLITICS OF PEDAGOGY

Conservative theories of education generally begin with the premise that knowledge is the fulfillment of (Western) tradition and that pedagogy is a technical practice primarily concerned with the process of transmission. Although it seems reasonable to assume that there is a relationship between what we know and how we act, it does not follow (although it often does in conservative educational discourse and theory) that what we learn and how we learn can be measured solely by the content of an established discipline. This is a fatally flawed argument with respect to its refusal to engage the particular discursive and institutional conditions under which we learn and act. Removed from such perspectives are crucial questions regarding how knowledge relates to power and how language shapes experience under specific conditions of learning. On one hand, the ideological nature of knowledge production, legitimation, and circulation is often subsumed by appeals for excellence and standards, and on the other hand, the productive character of pedagogy as a moral and political practice is either dismissed as the imposition of bias and an obstacle to learning or is relegated to a grab bag of depoliticized methods and defined almost exclusively in technical and instrumental terms. The first position can be found in the work of Leon Botstein, the outspoken president of Bard College, and the second is evident in the scholarship on pedagogy undertaken by Elaine Showalter, the former president of the Modern Language Association.[2]

Though occupying seemingly different positions on the role of education and the value of pedagogy, both theorists represent examples of so-called progressive educational reforms that deny the political nature of education and the transformative possibilities of pedagogy itself. In a recent editorial in the New York Times, Botstein suggests that the root cause of the failure of education in the United States is largely due to the inadequate preparation of teachers. Taking aim at education programs in universities nationally, Botstein argues that prospective teachers are taught pedagogy at the expense of formal training in their subject matter and, consequently, are inadequately prepared to teach students even the fundamentals of the basic subject disciplines, contributing both to the lowering of academic standards

and the failure of students to learn. The solution, according to Botstein, is to "disband the education schools and integrate teacher education into the core of the university."[3] In short, Botstein argues that schools of education do prospective teachers a great disservice by focusing on the social, historical, and philosophical trajectories of education's own disciplinary traditions at the expense of learning subject matter taught by professionals in the liberal arts.

For Botstein, the key to educational reform lies in raising academic standards, particularly through the mastering of discipline-based subject matter. Missing from Botstein's short-sighted and simplistic appeal is any attempt to engage broader questions of what public schools or higher education should accomplish in a democracy, and why they fail. His facile appeal to academic content cannot engage the relationship between schools and democracy, because it has been depoliticized within the discourse of disciplinary purity. Botstein does not have anything to say about how knowledge is related to the power of self-definition and self-determination. Rather, pedagogy is generally assumed to be about processing received knowledge rather than actually transforming it in the interest of the public good. Botstein appears to be utterly indifferent—if not ignorant of—not only questions regarding the purpose and meaning of schooling, which actually set the context for understanding the relationship between knowledge and power, but also to the fact that the real crisis in schools is not simply whether students are learning subject matter but whether students are capable of meeting important educational goals (i.e., learning to think critically about the knowledge they gain, engaging larger social issues, and developing a sense of social responsibility). Botstein's appeal to standards ignores what it means to educate prospective teachers about the roles they might play as public intellectuals informed about how power works both within and outside the classroom. What the role of education should be in a democratic society, how the conditions of teaching affect how students learn, what it might mean to educate students to discern between academic norms and critical intellectual work, or what it might mean to educate students to use knowledge critically in the service of shaping democratic identities and institutional arrangements are questions entirely missing from Botstein's analysis. Knowledge for Botstein is an end in itself

as opposed to an ongoing process of struggle and negotiation, and the conditions of its production or the limits it embodies in its institutionalized and disciplinary forms appear irrelevant to him.

Botstein's inclusive emphasis on teaching disciplinary knowledge in opposition to any serious engagement with pedagogical issues reveals a fundamental incapacity to address what it might mean to create the conditions to make knowledge meaningful in the first place before it can become either critical or transformative. Botstein aside, knowledge doesn't speak for itself; and unless the pedagogical conditions exist to connect forms of knowledge to the lived experiences, histories, and cultures of the students we engage, such knowledge is not only reified, but "deposited" in the Freirian sense through transmission models that both ignore the living context in which knowledge is produced and silence as much as they deaden student interest. Moreover, the emphasis on teaching as knowledge production has little to say about teaching as self-production. In this discourse, it becomes almost impossible to use pedagogy as a way of making teachers attentive to their own identifications, values, and ideologies as they work through and shape what and how they teach. In other words, Botstein's exclusive emphasis on disciplinary knowledge offers no theoretical language for helping prospective educators register and interrogate their own personal and social complicities in what, how, and why they teach and learn within particular institutional and cultural formations.

In short, Botstein's emphasis on the virtues of disciplinary knowledge as a way of discrediting both pedagogy and colleges of education ignores the crucial importance of pedagogy for raising a number of serious questions. Moreover, it denies the obvious fact that education has its own disciplinary body of knowledge worthy of investigation, ironically reinforcing the necessity of schools of education. There is a long tradition, for instance, of educational knowledge extending from John Dewey and Paulo Freire to Samuel Bowles and Herbert Gintis to Maxine Greene that analyzes the relationships between democracy and schooling, theory and practice, formal and hidden curricula as well as examining the ethical, social, political, and historical foundations of schooling. Such knowledge is crucial both for contextualizing and engaging the ways in which academic

knowledge has been mobilized to define the race-, gender-, and class-specific purposes of public and higher education. Similarly, the history of education provides a rich and expansive literature for analyzing pedagogy as a moral and political practice through which knowledge, values, and social relations are deployed within unequal relations of power in order to produce particular notions of citizenship, subject positions, and forms of national identity. Botstein depoliticizes knowledge and pedagogy in his analysis, and in doing so renders mute the need to understand how they mutually inform each other and what their complicated interaction suggests for addressing both the teaching of prospective educators and teaching itself as a deeply ethical and political issue. For Botstein, education is about the management of knowledge divorced from questions of power, place, ideology, self-management, and politics. In this context, Botstein provides a model of education unaware of its own pedagogical assumptions and deeply indebted to a theory of learning that is indifferent to either how power works in education or how teachers and students alike might employ education in the service of democratic struggles.

In opposition to Botstein, Elaine Showalter, in a recent commentary in the *Chronicle of Higher Education*, recognizes the importance of sound pedagogical practice, particularly the responsibility of faculty in preparing their graduate students to teach undergraduate courses. Showalter rejects the popular attitude among her professional colleagues that any "interest in pedagogy [be seen] as the last refuge of a scoundrel."[4] For Showalter, such derision is unfounded and simply perpetuates the general complaint that teaching assistants don't know how to teach and that faculty are unwilling to do anything about it. Born out of a general impatience with the lack of will and effort to address the problem of pedagogy, Showalter brought together in 1998 a number of graduate students in a noncredit course on teaching in order to take up the problem of pedagogy. The first challenge for Showalter was to locate materials on teaching in order to "find out what other people are doing behind their closed classroom doors."[5] Conducting an intensive search on the Internet, Showalter surprised herself and her students by how many books she was able to find on teaching, and argues that most books on university teaching fall into four general categories: personal memoirs, spiritual and ethical reflec-

tions, practical guidebooks, and reports on education research. Un-
fortunately, Showalter's search left her and her students unaware of a
long tradition of critical theoretical work on pedagogy, schooling,
and society. The result is that teaching ends up being reduced to a
matter of methods, exclusively and reductively concerned with prac-
tical and technical issues; hence her enthusiasm for books that "pro-
vide lots of pointers on subjects as varied as choosing textbooks and
getting feedback from students and colleagues" or books that help
"instructors make the most effective use of the lecture/discussion
mode."[6] Even those books that Showalter claims deal with ethical and
spiritual issues become significant to the degree that they "can offer
both inspiration and some surprisingly concrete advice."[7] In the end,
Showalter recommends a number of books, such as Wilbert J. Mc-
Keachie's *McKeachie's Teaching Tips* and Joseph Lowman's *Mastering the Tech-
niques of Teaching* because they "offer practical, concrete advice about
learning to ask students good questions and encouraging them to
participate."[8]

Showalter ignores an entire generation of scholarship in critical
pedagogy that addresses teaching as a moral and political practice, as
a deliberate attempt to influence how and what knowledge and iden-
tities are produced within particular relations of power.[9] In doing so,
she abstracts pedagogical practices from the ethicopolitical visions
that inform them, and has little to say about how pedagogy relates the
self to public life, social responsibility, or the demands of critical citi-
zenship. Showalter has no pedagogical language for dealing with so-
cial, racial, and class inequalities. Nor does she offer her students
guidance on matters of justice, equality, liberty, and fairness that
should be at the core of pedagogical practices designed to enable stu-
dents to recognize social problems and injustices in a society founded
on deep inequalities. Even basic pedagogical issues regarding how
teacher authority can manifest itself without being inimical to the
practice of freedom are ignored in Showalter's discourse. By defining
pedagogy as an a priori discourse that simply needs to be uncovered
and deployed, Showalter has nothing to say about pedagogy as the
outcome of specific struggles between diverse groups to name his-
tory, experience, knowledge, and the meaning of everyday life in
one's own terms. Unfortunately, Showalter offers up a depoliticized

pedagogy of "tips" that is effectively silent on matters of how knowledge, values, desire, and social relations are always implicated in power and broader institutional practices. One wonders what Showalter's stripped-down version of pedagogy has to say about the increasing corporatization of the university and the ongoing deskilling of teachers, or the role that pedagogy plays in educating students about what public and higher education should accomplish in a democracy and why the institutions often fail.

If Botstein depoliticizes and instrumentalizes questions concerning the production of knowledge and reduces pedagogy to the logic of transmission, Showalter similarly reifies pedagogy by stripping it of its political and ethical referents and transforming it into a grab bag of practical methods and techniques. Neither theorist has anything to say about the productive character of pedagogy as a political and moral discourse. Hence, both are silent about the institutional conditions that bear down on the ability of teachers to link conception with execution, and what it means to develop a better understanding of pedagogy as a struggle over the shaping of particular identities. Nor can they raise questions about education as a form of political intervention that cannot elude its role in creating potentially empowering or disempowering spaces for students, critically interrogate the role of teacher authority, or engage the limits of established academic subjects in sustaining critical dialogues about educational aims and practices. These questions barely scratch the surface of issues that are often excluded when education is linked solely to the teaching of content, and pedagogy is instrumentalized to the point of irrelevance.

In opposition to these increasingly dominant views, we draw upon the timely and provocative work of Homi Bhabha. Bhabha's recent work is particularly suited for this task because it refuses a politics with guarantees while relentlessly questioning what it means to live within notions of agency, commitment, and education that address important social issues but do not make a claim to a full understanding of contexts, texts, and the unfolding of events. For Bhabha, culture is the sphere of provisional meaning, indeterminacy, and uncertainty, and it is precisely this emphasis on the conditioned, contingent, and contextual that offers that in-between space where identities are

formed, agency develops, and pedagogy is manifest in the ethical for-
mation of the self in history.[10]

MAKING THE PEDAGOGICAL MORE POLITICAL IN THE WORK OF HOMI BHABHA

The current debate over the viability of cultural politics and critical
pedagogy provides an important opportunity for assessing the
strengths and limitations of Homi Bhabha's theoretical analysis of the
relationships between culture and pedagogy, knowledge and power,
and meaning and investment. For Bhabha, culture is the terrain of
politics, a site where power is produced and struggled over, deployed
and contested, and understood not merely in terms of domination,
but of negotiation.[11] Culture is, in this sense, a performative space, a
complex site that "opens up narrative strategy for the emergence of
negotiation" and incites us to think beyond the limits of theory and
"turn pedagogy into the exploration of its own limits."[12] Culture also
provides the constitutive framework for making the pedagogical
more political—by investigating how educators can make learning
meaningful in order to open up its discursive possibilities and plea-
sures as part of a broader strategy of self- and social formation. At a
time when the social function of the university is frequently derided
by cultural critics as either the handmaiden of an ever-evolving and
encroaching corporatism or an "always already" bastion of support
for the status quo, Bhabha's attentiveness to the relationships among
writing, agency, and self- and social transformation provides educa-
tors with a much-needed reminder of the potential importance of
their work in the university. Bhabha refuses to reduce literacy to the
pedagogical imperatives of method or the ethnocentric appeal to rei-
fied notions of knowledge embodied in Western conceptions of the
canon. At the same time, he is careful to assert that we must not
fetishize literacy as a de facto socially ameliorative or democratic
force; he claims, in one of the most insightful and sobering moments
of a recent interview, that the leading ideology of most literate peo-
ple is racism.[13] That caution having been made, Bhabha explores what
a postcolonial criticism has to offer, pedagogically, to the student at all

levels of education. What might it mean, he poses, to approach theory "by doing a certain kind of writing," and to develop ideas that "also shape [and] enact the rhetoric"?[14]

In contrast to Showalter's pedagogy-as-method, Bhabha links questions of teaching, writing, and literacy to issues of self-representation, and what it might mean for students to function as agents within a wider democratic culture. For students marginalized by their race, class, or gender, who cannot find themselves "within the sentence," Bhabha proposes a strategy that Ranajit Guha calls "writing in reverse."[15] Such an intervention does not simply articulate the absences of marginalized histories and narratives, but also reads dominant narratives against themselves in order to understand the moment of disruption that is, for Bhabha, the quintessential postcolonial moment. Exposing students to the discourse of "sententiousness," educating them to think "outside of the sentence," and insisting that they "occupy" the fissures, gaps, and hesitations in declaratives that they take for granted are for Bhabha a means of opening up a liminal or middle space for critical and potentially revisionary—or revolutionary—engagement with what he calls the "consensus of common sense."[16] Pedagogy for Bhabha becomes a performative act, a mediation rather than simply a medium, that reveals in its narrative ambivalence an "unsettling tension between where the sign emerges and where it ends up."[17] Such ambivalence not only offers a political space for challenging the ideological aspects of a narrative cultural pedagogy— "what we think we see without really looking"[18]—but also draws attention to the disrupted borders and fissures within dominant social formations, strategies, and practices. Of course, such strategies run the risk of reversing while maintaining the operative binaries, but Bhabha's work is well-known for refusing such a construction. On the contrary, Bhabha problematizes the very act of enunciation and address to make both its object and subject a site for negotiation, dialogue, and critical pedagogical engagement. As important as the marginalized discourses of race, gender, and sexual orientation are to any progressive pedagogy, they must also be understood as antiessentialist and open to interrogating the very nature of authority that gives such discourses political and ethical valence.

Bhabha's pedagogical imperative is not simply about refining one's capacities for rational and rhetorical argument, for identifying and exploding contradictions within a highly and historically racialized society. Bhabha provides an additional theoretical service for educators by complicating the process of becoming critically literate by invoking the role that affect and emotion play in the formation of individual identities and social collectivities. In an attempt to understand how education as a productive force works in the creation and re-creation of particular subject positions and contexts, Bhabha makes the pedagogical more political by taking seriously those maps of meaning, affective investments, and sedimented desires that enable students to connect their own lives and everyday experiences to what they learn. Pedagogy in this sense becomes more than a mere transfer of received knowledge, an inscription of a unified and static identity, or a rigid methodology; it presupposes that students are moved by their passions and motivated, in part, by the affective investments they bring to the learning process. This suggests, as Paulo Freire points out, the need for a theory of pedagogy willing to develop a "critical comprehension of the value of sentiments, emotions, and desire as part of the learning process."[19] The relationships among pedagogical praxis, critical literacy, and identity in this context are always seen as part of an ongoing struggle over what constitutes the social, and how identities are shaped within a culture of movement and indeterminacy that allows for a proliferation of discourses, languages, and questions.[20]

Bhabha's politics and pedagogy of indeterminacy, partiality, and movement refuse the traditional modernist narratives of certainty, control, and mastery that mark transition theories of education. And it is in Bhabha's call for educators to "take responsibility for the un-spoken . . . to provide a strangeness for framing" that they might recognize forms of temporal distancing and negotiation that offer them the possibility to develop pedagogical practices that allow them to argue a position while refusing the arrogance of theoretical certainty.[21] Within Bhabha's discourse there is no room for grand oppositions of the sort embraced by conservatives. Identities, like culture itself, are fashioned performatively in those border crossings, fissures, and

negotiations that connect the public and private, the psyche and the social sphere.[22] But there is more at work in Bhabha's theory of difference, identity, and literacy than the production of subjects. There is also the reworking of the nature of politics itself. Bhabha is instructive on this issue, commenting, "Politics is as much a process of the ambivalent production of subjects and psychic identifications—sexuality, guilt, dependency—as it is a more 'casual' discourse of governmental objects and objectives—alienated labor, wage differentials, affirmative legislative action."[23] To his credit, Bhabha problematizes the contemporary scholarly affinity for what he calls the "mantras of multiculturalism" by redefining cultural difference as "a particular constructed discourse at a time when something is being challenged about power or authority" rather than "a natural emanation of the fact that there are different cultures in the world."[24] To this end, his theory of hybridity both challenges essentialist claims to an authentic identity and emphasizes the necessity of negotiation between texts and cultures in situations of iniquitous power relations through "strategies of appropriation, revision and iteration."[25]

In the section that follows, we hope to build on Bhabha's timely and insightful work by further investigating the dynamics of writing, literacy, and social change while raising questions about the relationships among what we call strategies of understanding, strategies of engagement, and strategies of transformation, as well as the mediating roles of affect and desire. Here we attempt to think at the limit regarding theories of cultural difference and hybridity and identity formation while understanding their centrality to issues of agency, power, politics, and pedagogy. In short, we want to extend Bhabha's insightful attempts to make the political more pedagogical where we recognize his profound challenge to the increasingly anti-intellectual and politically reckless interventions in the public debate over education in general and pedagogy in particular. In Bhabha's terms, this means rethinking the tension between the pedagogical and the performative by asking how the performative functions pedagogically. To this end, we ask the following: To what degree do Bhabha's strategies of negotiation in and of themselves actually challenge iniquitous power relations? In other words, what other conditions—beyond the capacity to identify and inhabit the gaps and fissures of dominant discourses—

must be realized for the subject of reading/writing to experience herself as an agent of social change?

Clearly Bhabha does not ignore institutional power, but his emphasis on exploring and exploiting discursive ambivalence at times underemphasizes the reach and gravity of such forces. To what degree does his pedagogical theory of reading and writing "outside" or "beyond the sentence" rely on an already critically engaged and willing inquisitor of commonsense assumptions? What role do affect and desire play in one's decision to critically engage—or disengage from— the process of learning, and what are the implications of this for educators?[26] And finally, what are the limitations of a politics of identity/difference for theorizing strategies of pedagogical and social transformation that demand not only individual but also collective intervention? How might a politics of identity/difference expand the meaning of citizenship as a principle of action that develops a notion of the common good but leaves room for dissent?

FREDERICK DOUGLASS AND THE SUBALTERN

We would like to work through the density and complexity of these issues by means of a brief historical illustration. There is an extensive history in African-American letters of exploring the relationships among critical literacy, the acquisition of agency, and self- and social transformation. In what follows, we attempt a theoretical response to the preceding questions by turning to the celebrated work of another subaltern intellectual whose dedication to the emancipatory possibilities of rhetoric and writing bear a striking resemblance to Bhabha's. Although Frederick Douglass's work on race and rhetoric derives from a very different historical context—engaging four hundred years of enslavement—we find that a careful translation of Douglass's work offers much insight for theorizing the pedagogy and politics of critical literacy in relation to the gross inequalities of present-day social relations. When one considers a whole range of new social relations from the privatization of the prison-industrial complex to the conditions of workers in an ever-growing international sex trade, "slavery" may well prove an apt metaphor.

In his second autobiography, *My Bondage and My Freedom*, Frederick Douglass relates his first encounter with the power of rhetoric in the pursuit of self-representation and self-determination and at the same time dramatically rewrites the scene as it appeared in his first, much-celebrated autobiography. When young Douglass's tutelage by his mistress in Baltimore was cut short by his master's outrage at the idea of a literate slave, it was already too late. Douglass rightly assented to his master's proposition that "if you teach that nigger . . . how to read the Bible, there will be no keeping him . . . it would forever unfit him for the duties of the slave."[27] In doing so, Douglass discovers what had been for him a painful mystery to dispel: "to wit, the white man's power to perpetuate the enslavement of the black."[28] His master's comments not only provided Douglass with a special revelation of the power of literacy to transform his life, it also fed his desire to read and learn, even under the threat of severe punishment by law. At a point in his life when he had secreted away enough money, Douglass recounts his first purchase: a then-popular school rhetoric, *The Columbian Orator*. The reader contained, among others, one essay of particular interest to Douglass that describes a dialogue between a master and his slave; he summarizes it at length in his autobiography.

It seems that a slave has been captured after his second attempt to run away, and the dialogue opens with a severe upbraiding by the master. Having been charged with the high crime of ingratitude, the slave is asked to account for himself. Knowing that nothing he has to say will be of any avail, he simply replies, "I submit to my fate." The master is touched by the slave's answer and gives him permission to speak on his behalf. Invited to debate, the slave makes a spirited defense of himself and an unimpeachable argument against slavery. Hence, the master is "vanquished at every turn in the argument; and seeing himself to be thus vanquished, he generously and meekly emancipates the slave. . . ."[29] Douglass recalls that speeches such as these not only added to his "limited stock of language," but armed him with "a bold and powerful denunciation of oppression, and a most brilliant vindication of the rights of man."[30]

Shortly after, however, Douglass writes that he himself has been confronted with the same opportunity to defend himself as the fortunate ex-slave and refuses it. Aware that his mistress wants an explana-

tion for his dramatic change in temperament, he withholds, stating, "Could I have freely made her acquainted with the real state of my mind, and given her reasons therefor[sic], it might have been well for both of us. . . . [But]—*such is the relation of master and slave*—I could not tell her. . . . My interests were in a direction opposite to hers, and we both had our private thoughts and plans. She aimed to keep me ignorant; and I resolved to know."[31] We find that what Frederick Douglass appropriates from the lessons of his rhetorical self-training is instructive on a number of levels for engaging both the strengths and limitations of Bhabha's theory of hybridity and agency. Douglass strategically replays the master/slave encounter in the context of his own life with a crucial difference that begs the simple question, Why does he refuse altogether the invitation to "appropriate" and "revise" dominant discourses about the immorality of oppression and the rights of man that he so carefully studied in *The Columbian Orator?*

On a literal level, Douglass makes clear that one cannot engage the evils of slavery from the subject position of slave—*such is the relation of master and slave*. It seems that finding oneself in a liminal or hybrid space—no longer subject to a slave mentality and not yet free—does little here to alter relations of power and oppression. It is only after Douglass has successfully managed to escape captivity that he engages his former master on the necessity of abolition. Douglass's decision to waive his defense suggests that the strategies of negotiation that Bhabha proposes must take into account questions of location and power; they must consider, as Douglass makes clear, where and how the subaltern can speak in a way that carries authority and meaning. But the capacity to alter one's location is crucially tied to questions of one's mobility and access to resources. Here, Lawrence Grossberg tells us, agency "is not simply a matter of places but is more a matter of the spatial relations of places and spaces and the distribution of people within them. . . . It is a matter of the structured mobility by which people are given access to particular kinds of places (and resources), and to the paths that allow one to move to and from such places."[32]

Moreover, Douglass's critical repetition of the master/slave narrative suggests to us that rhetorical strategies of appropriation and revision do not adequately address the material dimension of discourse. In other words, the politics of culture cannot be reduced to the politics of

meaning, while issues of material organization and consequences of life disappear.[33] Douglass's autobiography everywhere emphasizes the relationship between the discursive rationalization for slavery and its concrete material and spatial effects. For example, the sanctioning discourse of paternalism suggests that slave owners are responsible for their slaves' material and spiritual needs and that slaves in return owe them their work and their undying gratitude. Such logic translates for Douglass into the denial of those material resources and opportunities for decision making that might enable any independence of action, any semblance of self-determination. Aware that a language of resistance may have dire material consequences in a slave state, Douglass must wait several long years before he can effect his escape and combat the institution of slavery from a position of authority disengaged from the discursive and material limitations of the "peculiar institution."

COMBATING OFFICIAL DISCOURSES

As this example makes clear, combating official discourses demands being attentive, as Stuart Hall points out, to "both what is said and done." For Hall, the importance of the idea of the discursive is to "resist the notion that there is a materialism which is outside meaning. Everything is within the discursive, but nothing is only discourse or only discursive."[34] Discourse does not deny the existence of material reality, but makes problematic how it is given meaning and how such meaning often translates into discernible material effects. Unfortunately, according to Hall, what frequently disappears in most appropriations of Foucault's notion of the discursive is the role that social forces play. The upshot is thinking about discourses—like ideologies—as merely ideational rather than as fully concretized in the structures of daily life. Hence, a pedagogy and politics of critical literacy must not only push students to rhetorically challenge and rewrite the "consensus of common sense," as Bhabha insightfully argues, but also to think about and engage the ways that common sense becomes embedded in the material structures and machineries of power that frame their daily experiences. It is one thing to challenge

the logic of racism in our classrooms and quite another to confront the way its historical legacy has structured the still largely segregated experience of schooling—and daily life. To view the crisis of racism as merely a crisis of representation is to engage in a social mythology that erases the material reality of power and negates the need to link the language of critique to the practical politics of intervention and social change.

Bhabha's astute observation that racism remains the leading ideology of most literate people poses another interesting problem in relation to his pedagogical strategies of negotiation and translation. Douglass's narrative makes problematic from the start the assumption that his oppressor is unaware of the contradictions at the heart of the rationality of enslavement. Historically, the institution of slavery drew upon myriad forms of knowledge—scientific, philosophical, religious, aesthetic, legalistic, and economic—for its legitimacy and sanction, largely by "proving" the gross racial "inferiority" of the enslaved. Such discourses confirmed that the master race was rational, civilized, dispassionate, capable of moral judgment, and hence, capable of self-determination; they also imparted the "knowledge" that subject races were the antithesis of the master race: irrational, savage, sexually lascivious, morally bankrupt, and completely incapable of self-determination. So why the legal prohibition of literacy for the enslaved, if by virtue of their biological race they were incapable of rational judgment and moral outrage? Why does Hugh Auld, Douglass's former master, astutely argue that reading leads to freedom if a slave by definition can't think or act in his own behalf? Nor was Douglass unaware of the contradictions that constituted the slave system. Even as a boy, he struggled less with the veracity of how the white world constructed "reality"—with the insidiousness of the role that it cast for him and for itself—than with what it meant to fight the seeming historical inertia of its racist discourses, the sheer historical weight of them. He does not submit to the crippling logic that another discourse can't emerge and be heard; but he is careful not to equate the force of such narratives with his own counternarrative.

Naming the truth in this instance has its limits. Clearly, much more is at stake in developing the possibilities for political agency than being able to challenge and revise, however skillfully, the gaps

and contradictions in the logic of oppression. "The subaltern is not a social category," argues Rosalind O'Hanlon, "but a statement of power."[35] As Lawrence Grossberg notes, this has implications not only for the question of agency in terms of addressing how interests, investments, and participation "as a structure of belonging" get "distributed with particular structured terrains" but also for thinking of agency beyond questions of cultural identity and how such identities are produced and taken up through practices of representation.[36] In other words, we begin to see the limitations of Bhabha's commitment to the politics of representation, to what he sees as a recent shift in "the very nature of what can be construed as political, of what could be the representational objects and objectives of social transformation."[37]

That racism exists among literate people suggests that more is at work than their ignorance of its untenable and contradictory logic. Negotiating the terrain of racist ideologies pedagogically necessitates strategies of understanding, engagement, and transformation. Not only do students need to understand the economic and political interests that shape and legitimate racist discourses, they must also address the strong emotional investments they may bring to such beliefs. For Shoshana Felman, educators must think about the role of desire in both ignorance and learning. "Teaching," she explains, "has to deal not so much with lack of knowledge as with resistances to knowledge. Ignorance, suggests [Jacques] Lacan, is a 'passion.' Inasmuch as traditional pedagogy postulated a desire for knowledge, an analytically informed pedagogy has to reckon with the passion for ignorance."[38] Felman elaborates further on the productive nature of ignorance, arguing, "Ignorance is nothing other than a desire to ignore: its nature is less cognitive than performative . . . it is not a simple lack of information but the incapacity — or the refusal — to acknowledge one's own implication in the information."[39] If students are to move beyond the issue of understanding to an engagement with the deeper affective investments that make them complicitous with racist ideologies or other oppressive ideologies, they must be positioned to address and formulate strategies of transformation through which their individualized beliefs can be articulated with broader public discourses that extend the imperatives of democratic public life. An unsettling pedagogy in this instance would engage their identities from

unexpected vantage points and articulate how they connect to exist-
ing material relations of power. At stake here is not only a pedagogi-
cal practice that recalls how knowledge, identifications, and subject
positions are produced, unfolded, and remembered but also how
they become part of an ongoing process, more strategic so to speak,
in mediating/accommodating/challenging existing relations of
power. This is not to suggest that Bhabha's strategies of appropria-
tion, revision, or iteration are not useful, but that such strategies are
not equipped in and of themselves to bridge the gap between desire,
knowledge, and transformation. What they do provide is an ethical
referent for living in a democratic and multicultural—that is, an-
tiracist—society that is entirely missing from dominant educational
discourses like Leon Botstein's and Elaine Showalter's.

Moreover, Bhabha's attempt to theorize the relationship between
critical literacy and the politics of difference supports a notion of
"public pedagogy" that is interdisciplinary in its theoretical and poetic
reach, transgressive in its challenge to authority and power, and inter-
textual in its attempt to link the local with the national and interna-
tional. The project underlying Bhabha's pedagogy is rooted in issues of
compassion and social responsibility aimed at deepening and expand-
ing the possibilities for critical agency, racial justice, and democratic
life. Rigorous, theoretical, and playfully and purposefully ambivalent,
Bhabha's work refuses easy answers to the most central, urgent, and
disturbing questions of our time. Yet it is in his attempt to make hope
the basis for freedom and to make social justice the foundation of his
cultural politics and pedagogy that frames his project as open-ended
and self-reflexive. Bhabha's writing both instructs and disrupts,
opens a critical dialogue but refuses the "arrogance of theory" or a
politics with guarantees.

Bhabha's work has always refused to limit the sites of pedagogy
and politics to those privileged by the advocates of "realpolitik." He
has urged educators and others to take up the challenge of critical lit-
eracy and political agency from within dominant institutions, while
challenging their authority and cultural practices. For Bhabha, the
context of such work demands confronting a major paradox in capi-
talist societies—that of using the very authority vested in institutions
such as higher education to push against the grain. Such action is not

a retreat from politics, as Todd Gitlin and others have argued,[40] but an extension of the possibility of politics to make visible and challenge the work of dominant intellectuals and institutions that largely function to incapacitate the intersection of critical pedagogy, cultural politics, and political agency. At the same time, cultural workers, educators, and others need to rethink the relationship between the politics of identity and the possibilities of self- and social transformation. At stake here is the need for a critical vocabulary that recognizes the need to combine multiple and shifting cultures in a way that defends their particularity but does so within a broader defense of social and democratic public life. Ernesto Laclau rightfully suggests that the politics of pure difference is the route to self-apartheid and will have no consequences at the wider levels of society. As Lacan points out, identity politics cannot be limited so as to prevent the specific nature of its struggles from entering into "relations of solidarity with other groups and engaging in wider struggles at the level of society."[41] If agency involves "the possibilities of action as interventions into the processes by which reality is continually being transformed and power enacted," as Lawrence Grossberg argues, "then agency must not be conflated with cultural identity or epistemological issues" but with questions of how access, affective investments, and interests are distributed within specific contexts regulated within established structures of power.[42] Agency in this case becomes more than the struggle over identifications, or a representational politics that unsettles and disrupts common sense; it is also a performative act grounded in the spaces and practices that connect people's everyday lives and concerns with the reality of material relations of values and power. At stake here is a cultural politics and public pedagogy rooted in the necessity of critical understanding and the possibility of social change.

Teaching the
Cultural with
Disney

There is nothing innocuous left. The little pleasures, expressions of life that seemed exempt from the responsibility of thought, not only have an element of deviant silliness, of callous refusal to see, but directly serve their diametrical opposite.

—Theodor Adorno, *Minima Moralia*

INTRODUCTION

Theodor Adorno's insights seem particularly appropriate at a time when multinational corporations have become the driving force behind media culture, making it increasingly difficult to maintain what has always been a problematic position—that the entertainment industry provides people with the moments of pleasure and escape that they desire. That corporate culture is rewriting the nature of children's culture becomes clear as the boundaries once maintained between spheres of formal education and entertainment collapse into each other. To be convinced of this, one only has to consider a few

107

telling events from the growing corporate interest in schools as profit-making ventures, the production of curricular materials by toy companies, or the increasing use of school space for the advertising of consumer goods.

The organization and regulation of culture by large media corporations such as Disney profoundly influence children's culture and increasingly dominate public discourse. The concentration of control over the means of producing, circulating, and exchanging information has been matched by the emergence of new technologies that have transformed culture, especially popular culture, into the primary educational site in which youth learn about themselves, their relationship to others, and the larger world. The Hollywood film industry, television, satellite broadcasting technologies, the Internet, posters, magazines, billboards, newspapers, videos, and other media forms and technologies have transformed culture into a pivotal force for, as Stuart Hall sees it, "shaping human meaning and behavior and regulat[ing] our social practices at every turn."[1] Although the endlessly proliferating sites of media production promise unlimited access to vast stores of information, such sites are increasingly controlled by a handful of multinational corporations. The Disney corporation's share of the communication industry represents a case in point. Disney's numerous holdings include a controlling interest in twenty television stations that reach 25 percent of all U.S. households, and ownership of over twenty-one radio stations and the largest radio network in the United States, serving 3,400 stations and covering 24 percent of all households in the country. In addition, Disney owns three music studios, the ABC network, and five motion picture studios. Other holdings include, but are not limited to, television and cable channels, book publishing companies, sports teams (the Atlanta Braves, Atlanta Hawks, and World Championship Wrestling), theme parks, insurance companies, magazines, and multimedia productions.[2]

Mass-produced images fill our daily lives and condition our most intimate perceptions and desires. At issue for parents, educators, and others is how culture, particularly media culture, has become a substantive, if not the primary, educational force in regulating the meanings, values, and tastes that set the norms and conventions that offer up and legitimate particular subject positions. In other words, media

culture influences what it means to claim an identity as male, female, white, black, citizen, or noncitizen as well as defining the meaning of childhood, the national past, beauty, truth, and social agency.[3] The scope and impact of new electronic technologies as teaching machines can be seen in some rather astounding statistics. It is estimated that "the average American spends more than four hours a day watching television. Four hours a day, 28 hours a week, 1456 hours a year."[4] Don Hazen and Julie Winokur report, citing American Medical Association statistics, that the "number of hours spent in front of a television or video screen is the single biggest chunk of time in the waking life of an American child."[5]

Such statistics warrant grave concern given that the pedagogical messages often provided through such programming are shaped largely by a $130-billion-a-year advertising industry, which not only sells its products but also values, images, and identities that are largely aimed at teaching young people to be consumers. Alarmed by the growing influence of the media on young children, the American Academy of Pediatrics released a report in 1999 claiming that the influence of television viewing among the young constituted a public health issue. The report urged parents not to allow children under two years old to watch television, and recommended that older children not be allowed televisions in their bedrooms.[6] It would be reductionistic not to recognize that there is also some excellent programming that is provided to audiences, but by and large much of what is produced on television and in the big Hollywood studios panders to the lowest common denominator, defines freedom as consumer choice, and debases public discourse by reducing it to a spectacle.[7]

Nothing appears to be out of bounds for the megacorporations and their counterparts in the advertising industry when it comes to transforming childhood dreams into potential profits. For example, soon after the U.S. women's soccer team won the World Cup in July of 1999, the dominant media reported that one of the first things the team did to relax after its World Cup victory was to visit Disney World. Within this discourse, the long struggle for women to gain some parity in American sports was transformed into simply another high-profile advertisement for Disney. Similarly, two days after Mark McGwire had belted out home run number sixty-two, thus breaking

Roger Maris's record, a television ad ran on all the major networks in which McGwire appeared hitting the home run, jogging around the bases, and picking up his son in celebration of his record-breaking event. A camera zoomed in on McGwire, hero to millions of kids, holding his son in his arms, and a voice asked, "What are you going to do now?" McGwire smiled, looked directly at the camera, and replied, "I am going to take my son to Disneyland."

Following the McGwire ad, the dominant media, including the three major television network news programs, announced that the groundskeeper who had picked up McGwire's record-setting baseball would give it back to him and that this generous deed would be rewarded with a free round-trip ticket to Disney World. Once again, Disney managed to appropriate a celebrated American image and turn it into an advertisement for corporate America.

Yet such commercialism is not limited to appropriating events deeply associated in the national imagination with the efforts of famous sports events or heroic sports figures such as Mark McGwire, or even appropriating celebrities such as New York Knicks "bad boy" superstar Latrell Sprewell (currently considering a project with Disney).[8] No identity, desire, or need appears to escape the advertiser's grip. For instance, Disney Magazine recently ran an ad for the Baby Mickey porcelain doll. The ad features a baby wearing a cap with the logo Disney Babies on it. The baby's pajama top also has a Mickey Mouse logo on it, and just in case the reader has missed the point, the baby is holding a Baby Mickey doll, with Baby Mickey emblazoned on its bib. The caption for the ad reads, "He drifts off to dreamland with Baby Mickey to cuddle nearby!"[9] The doll is part of the Ashton-Drake Galleries collection offered to adults who can rewrite their own memories of being a child in Disney's terms while simultaneously indulging a commodified view of innocence that they can use to introduce their own infants to Disney's version of childhood. The ad appeals to innocence as it appropriates it at one of its most seductive and vulnerable moments.

In this case, innocence is emptied of any substantive content so that it can be commodified and exploited. Disney disingenuously presents innocence as that untouched psychic space in which the brutal world is forgotten, and, as Ernest Larsen notes, "the fullness of fantasy reliably, if pathetically compensates for the emptiness of reality."[10] Larsen

argues that one of Walt Disney's greatest insights was that he "knew that we all believe ourselves to be like unto children. And he knew how to exploit the pathos and comedy—but especially the pathos— of that universal delusion of innocence."[11]

The Disney commercial fantasy machine uses innocence as a representational image to infantilize the very adults at whom it is aimed. The appeal to fantasy in Disney's perfectly scripted world functions to disable rather than liberate the imagination. Nothing is out of place in Disney's landscape, and under the rubric of community Disney purposely "confuses the personal and the corporate."[12] Within this context critical agency is replaced by corporate planning, allowing Disney to edit out conflict, politics, and contradictions, thus relieving adults and children of having to make any choices beyond those that allow them to indulge in the fantasy of unfettered consumerism. Of course, the larger issue is that the commercialization of the media and the culture, in general, limits the choices that children and adults can make in extending their sense of agency beyond a commercial culture that enshrines an intensely myopic, narcissistic, and conservative sense of self and society. Reflecting on his own study of Disney's new town, Celebration, Florida, Andrew Ross ponders this very issue, insightfully pointing out, "The rage for privatization that has swept the country, and much of the developed world, routinely sacrifices justice and accountability at the altar of efficiency."[13]

Beyond this notion of fantasy and entertainment that supports a loss of faith in public institutions and participatory democratic politics is a pedagogical model that suggests that those engaged with Disney culture become "quiet" citizens just as cast members in Disney's theme-park labor force are required to become utterly compliant and obsequious. Jane Kuenz captures this sentiment in the response of one of the Disney's "cast members" at Disney World, who explains, "You've got to keep your mouth shut. You can't tell them your opinion. You have to do everything they say. The Disney Way. Never say anything negative. Everything's positive. There's never a no. You never say I don't know. If you don't know something you find out fast, even on your own after work."[14] Within this type of model of cultural and moral regulation, Disney's image of innocence is completely nullified next to the power it exercises in dominating public

discourse and undermining the social and political capacities necessary for individuals to sustain even the most basic institutions of democracy. The discourse of innocence in Disney's worldview is both performative and strategic. Not only does it offer up subject positions free of conflict, politics, and contradictions, it also offers a rationale for abstracting corporate culture from the realms of power, politics, and ideology. Against this Disney dreamworld, one has to ask what price the public pays by simply focusing on the pleasure and fun that culture industries such as Disney provide while excluding the growing influence they have in shaping so many other facets of national and global life.

Consider the enormous control that a handful of transnational corporations have over the diverse properties that shape popular and media culture. Joshua Karliner has noted that "51 of the largest 100 economies in the world are corporations."[15] Moreover, the United States media is dominated by fewer than ten conglomerates, whose annual sales range from $10 to $27 billion. These include major corporations such as Time Warner, General Electric, Disney, Viacom, TCI, and Westinghouse. Not only are these firms major producers of much of the entertainment, news, culture, and information that permeates our daily lives, they also produce media software and have networks for distribution that include television and cable channels as well as retail stores.[16] Similarly, the heads of these corporations have amassed enormous amounts of personal wealth, further contributing to the shameless disparity of income between company CEOs and factory workers, on the one hand, and the new global elite and the rest of the world's population on the other. For instance, in 1997 Disney CEO Michael Eisner was paid more than $575 million. Russell Mokhiber and Rubert Weissman explain that, in addition to his $750,000 salary, Eisner claimed a $9.9 million bonus and cashed in on $565 million in stock options.[17] CEOs like Michael Eisner, Bill Gates, Warren Buffett, and others are part of an exclusive club of 358 global billionaires whose collective income, explains Zygmunt Bauman, "equals the combined incomes of [the] 2.3 billion poorest people (45 percent of the world's population)."[18] Much of what young people learn today is brought to them by a handful of corporate elite, including Eisner, Rupert Murdoch, and others, who have

little regard for what kids learn beyond what it means for them to become consumers.

The recognition that this global elite and the corporations they own and control are involved in every aspect of cultural production—ranging from the production of identities, representations, and texts to control over the production, circulation, and distribution of cultural goods—is not a new insight to theorists of cultural studies. What has been missing from such work is an analysis of the educational role that such corporations play in promoting a public pedagogy that uses, as Raymond Williams has pointed out, the educational force of all of its institutions, resources, and relationships to actively and profoundly teach an utterly privatized notion of citizenship.[19] All too often within the parameters of such a public pedagogy, consumption is the only form of citizenship being offered to children, and democracy is privatized through an emphasis on egoistic individualism, low levels of participation in political life, and a diminishing of the importance of noncommodified public spheres. In what follows, I want to point to some theoretical and political implications for focusing on corporations as "teaching machines" engaged in a particular form of public pedagogy. In doing so, I will focus specifically on the Disney corporation and what I will call its discourse of innocence as a defining principle in structuring its public pedagogy of commercialism within children's culture.

DISNEY AND THE POLITICS OF INNOCENCE

Within the last decade, the rise of corporate power and its expansion into all aspects of everyday life has grown by leaps and bounds.[20] One of the most visible examples of such growth can be seen in the expanding role that the Walt Disney Company plays in shaping popular culture and daily life in the United States and abroad. The Disney Company is an exemplary model of the new face of corporate power at the beginning of the twenty-first century. Like many other megacorporations, its focus is on popular culture, and it continually expands its reach to include not only theme parks but television networks, motion pictures, cruise lines, baseball and hockey teams,

Broadway theater, and a children's radio program. What is unique about Disney is that, unlike Time Warner or Westinghouse, its brand name is synonymous with the notion of childhood innocence. As an icon of American culture and middle-class family values, Disney actively appeals to both parental concerns and children's fantasies as it works hard to transform every child into a lifetime consumer of Disney products and ideas. In this scenario, a contradiction emerges between the company's cutthroat commercial ethos and a Disney culture that presents itself as the paragon of virtue and childlike innocence.

Disney has built its reputation on both profitability and wholesome entertainment. Largely removing itself from issues of power, politics, and ideology, it embraces a pristine self-image associated with the magic of pixie dust and Main Street USA. Yet this is merely the calculating rhetoric of a corporate giant whose annual revenues in 1997 and 1998 exceeded $22 billion as a result of its ability to manufacture, sell, and distribute culture on a global scale, making it the world's most powerful leisure icon.[21] Michael Ovitz, a former Disney executive, touches on the enormous power Disney wields, claiming, "Disney isn't a company as much as it is a nation-state with its own ideas and attitudes, and you have to adjust to them."[22]

The image of Disney as a political and economic power promoting a specific culture and ideology appears at odds with a public relations image that portrays the company as one that offers young people the promise of making their dreams come true through the pleasures of wholesome entertainment. The contradiction between the politics at work in shaping Disney culture and the appeal the company puts forth in order to construct and influence children's culture is disturbing and problematic. Yet making Disney accountable for the ways in which it shapes children's desires and identities becomes all the more important as the Disney corporation increasingly presents itself not only as a purveyor of entertainment and fun, but also as a political force in developing models of education that influence how young people are educated in public schools, spheres traditionally understood to offer children the space for critical and intellectual development uninhibited by the relentless fascinations of consumer culture.

Disney has given new meaning to the politics of innocence as a narrative for shaping public memory and for producing a "general

body of identifications" that promote a packaged and sanitized version of American history.[23] Innocence also serves as a rhetorical device that cleanses the Disney image of the messy influence of commerce, ideology, and power. In other words, Disney's strategic association with childhood, a world cleansed of contradictions and free of politics, represents not just the basic appeal of its theme parks and movies, but also provides a model for defining corporate culture separate from the influence of corporate power. Hence, Michael Eisner, as president and CEO of the Walt Disney Company, is caught in a contradiction when he repeats the company line that Disney only gives children what they want, or when he panders to the rhetoric of innocence by arguing that his own role as CEO is comparable to being in charge of a giant toy store.[24] Such comments are more than simple disingenuousness; witness the recent legal battle between Michael Eisner and former employee Jeffrey Katzenberg. Not only did Eisner appear mean-spirited and inflexible in dealing with colleagues like Katzenberg, whom he once referred to as "the little midget," but documented court records suggested that "Disney was systematically underreporting revenue and overreporting expenses to its creative partners" in the movie and television industries.[25] Given the public airing of corporate greed and mudslinging, Disney's appeal to the kinder and gentler values associated with old Walt appear to be simply dishonest. It gets worse: behind the rhetoric of innocence is the reality of a company that, Charles Kernaghan of the National Labor Committee argues, uses subcontractors to produce Disney clothing and toys in countries not only connected to military dictatorships but also actively engaged in child labor. The myth of innocence and fun seems all the more insidious given the fact, according to Russell Mokhiber and Robert Weissman, that in recent years Disney has outsourced production of its "clothing and toys to sweatshops in Haiti, Burma, Vietnam, China and elsewhere."[26] For example, one Disney subcontractor pays approximately one thousand factory workers in Vietnam "six to eight cents an hour, far below the subsistence wage estimated at 32 cents an hour."[27] In Haiti, workers produce Mickey Mouse pajamas; Pocahontas, Donald Duck, and Lion King T-shirts; and Hunchback of Notre Dame sweatshirts while being paid an hourly wage of 38 cents, or $3.30 a day.[28]

These contradictions became all the more glaring to me as I walked, on a hot day in the summer of 1999, into a Disney Store in Chicago, located on the famed Magnificent Mile on Michigan Avenue. A recent addition to Disney's arsenal of retail stores, the store exterior was covered with more than 180 pairs of mouse ears, seemingly inspired by the designs of the famed Chicago architect Louis Sullivan. Soon after the store opened, Blair Kamin, the *Chicago Tribune* architecture critic, argued that "The Disney Store . . . is a small but telling example of the way America is turning into a landscape of studied fakes that devalue the very history they pretend to honor."[29] As I entered the store I was surrounded by well-dressed middle-class types, many of whom wore Disney clothing, almost all of them carrying a shopping bag displaying a Disney cartoon character. Surrounded by some of the most expensive department and fashion stores in America, The Disney Store greets potential consumers with a motto carved into white, polished stone near the entrance. The motto, originally from Walt Disney himself, reads, "The things that we have in common far outnumber and outweigh those that divide us." I am not sure what Walt had in mind, but the unifying principle at work in the store, attempting to provide a common focus for its inhabitants, is the logic of consumerism. Every space, advertisement, item, and symbol in The Disney Store exhorts its inhabitants to buy something, including wine glasses, mugs, watches, and tables etched with the Mickey Mouse logo. The clothing, stuffed animals, photo albums, and every other largely useless item in the store, including Winnie-the-Pooh tricolor pasta, is overpriced in comparison to the labor that went into producing such goods. Donald Duck shirts sell for thirty-six dollars, which amounts to a one-week salary for the Haitian workers who made them. Yet who would wear a Disney shirt without accessories? In this case, the Haitian workers would have to consider giving up seven weeks of their salary in order to buy a standard accessory such as a Mickey Mouse watch, which sells for two hundred dollars. Maybe the prices will drop, or the workers will be paid even less since Disney's retail stores have been losing money since 1998,[30] though there is no evidence of that in the Disney Michigan Avenue store.

Eisner's toy-store promotional image is sullied by more than the company's use of sweatshops, child labor, and the commercial carpet

bombing of children. It is also tarnished by Disney's often hostile and demeaning labor practices endured by its American workers—work relations scripted from beginning to end and supervised, in part, by hired spies and informants (known as shoppers) who contribute to an enforced "culture of mutually generating suspicion and dependence."[31] Eisner also willfully refuses to acknowledge responsibility for the role that Disney plays in harnessing children's identities and desires to an ever-expanding sphere of consumption; for editing public memory to reconstruct an American past in its own image; and for setting limits on democratic public life by virtue of its controlling influence on the media and its increasing presence in the schools. Education is never innocent, because it always presupposes a particular view of citizenship, culture, and society, and yet it is this very appeal to innocence, bleached of any semblance of politics and commerce that has become a defining feature of Disney culture and pedagogy.

The Walt Disney Company's attachment to the appeal of innocence provides a rationale for Disney to both reaffirm its commitment to children's pleasure and to downplay any critical assessments of the role Disney plays as a benevolent corporate power in sentimentalizing childhood innocence as it simultaneously commodifies it. Stripped of the historical and social constructions that give it meaning, innocence in the Disney universe becomes an atemporal, ahistorical, apolitical, and atheoretical space where children share a common bond free of the problems and conflicts of adult society. Disney both markets this ideal and presents itself as a corporate parent who safeguards this protective space for children by magically supplying the fantasies that nourish it and keep it alive. Michael Eisner not only recognizes the primacy of innocence for Disney's success, he reaffirms the company's long-standing public relations position that innocence somehow exists outside of the reach of adult society, and that Disney alone provides the psychic economy through which kids can express their childlike fantasies. As he has said, "The specific appeal of Disneyland, Disney films and products—family entertainment—comes from the contagious appeal of innocence. . . . Obviously, Disney characters strike a universal chord with children, all of whom share an innocence and openness *before* they become completely molded by their respective societies."[32] Eisner's claim is important because it now

suggests that Disney culture reflects rather than shapes a particular version of childhood innocence and subjectivity. There is little to insinuate in Eisner's comments that Disney has always viewed children as an enormously productive market to fuel company profits, and that Walt Disney clearly understood the appeal to innocence as a universal mechanism for exploiting the realm of childhood fantasies in what Mike Wallace has referred to as a "relentless quest for new images to sell."[33] Old Walt may have had the best of intentions when it comes to making kids happy, but he had few doubts about the enormous commercial potential of youth.

Innocence plays a complex role in the Disney Company's attempt to market its self-image to the American public. Not only does it register Disney's association with a sentimentalized notion of childhood fantasy, but innocence also functions as the principal concept of moral regulation and as part of a politics of historical erasure. Further elaborating this dual strategy reveals that in Disney's moral order innocence is presented as the deepest of truths,[34] which when unproblematized can be used with great force and influence to legitimate the spectacle of entertainment as escapist fantasy. In addition, innocence becomes the ideological and educational yardstick through which Disney promotes a conservative set of ideas and values as the normative and taken-for-granted "premises of a particular and historical form of social order."[35] Recognizing that Disney has a political stake in creating a particular moral order favorable to its commercial interests raises fundamental questions about what it teaches to produce the meanings, desires, and dreams through which it attempts to inscribe both young people and adults within the Disney worldview.

MAKING THE POLITICAL MORE PEDAGOGICAL

Although my focus is on Disney because of its particular attempt to mystify its corporate agenda with appeals to fun, innocence, and purity, the seriousness of the threat to a vibrant democracy that Disney and other corporations present through their ownership of the media and their control over information cannot be underestimated. I don't mean to suggest that Disney is engaged in a conspiracy to undermine

American youth or democracy around the world. Nor do I want to suggest that Disney is part of an evil empire incapable of providing joy and pleasure to the millions of kids and adults who visit its theme parks, watch its videos and movies, or buy products from its toy stores. On the contrary, the main issue here is that such entertainment now takes place under conditions in which, Toby Miller points out, the media "becomes a critical site for the articulation of a major intellectual shift in the ground of public discourse . . . in which pricing systems are now brought to bear on any problem, anytime, anywhere."[36] In other words, media conglomerates such as Disney are not merely producing harmless entertainment, disinterested news stories, or unlimited access to the information age; nor are they removed from the realm of power, politics, and ideology. But recognition of the pleasure that Disney provides should not blind us to the realization that it is about more than the production of entertainment and enjoyment.

I also want to avoid suggesting that the effect of Disney films, radio stations, theme parks, magazines, and other products is the same for all those who are exposed to them. Disney is not a self-contained system of unchanging formal conventions. Disney culture, like all cultural formations, is riddled with contradictions; rather than viewing the Disney empire as monolithic, it is important to emphasize that within Disney culture there are also potentially subversive moments and pleasures.

In fact, any approach to studying Disney must address the issue of why so many kids and adults love Disney, and experience its theme parks, plays, and travel opportunities as a counterlogic that allows them to venture beyond the present while laying claim to unrealized dreams and hopes. For adults, Disney's theme parks offer an invitation to adventure, a respite from the drudgery of work, and an opportunity to escape from the alienation and boredom of daily life. As Susan Willis points out, Disney invites adults to construct a new sense of agency founded on joy and happiness and to do so by actively participating in their own pleasures, whether it be a wedding ceremony, a cruise ship adventure, or a weekend at the Disney Institute. Disney's appeal to pleasure and the "child in all of us" is also rooted in a history that encompasses the lives of many baby boomers. These adults

have grown up with Disney culture and often "discover some nostal-
gic connection to [their] childhood" when they enter into the Disney
cultural apparatus. In this sense, Willis notes, Disney can be thought
of as an "immense nostalgia machine whose staging and specific at-
tractions are generationally coded to strike a chord with the various
age categories of its guests."[37] Similarly, Disney's power lies, in part,
in its ability to tap into the lost hopes, abortive dreams, and utopian
potential of popular culture.

Disney's appeal to the relationship between fantasy and dreams be-
comes all the more powerful against a broader American landscape in
which cynicism has become a permanent fixture. Disney's invitation
to a world where "the fun always shines" does more than invoke the
utopian longing and promise of the sun-drenched vacation; it also
offers an acute sense of the extraordinary in the ordinary, a powerful
antidote to even the most radical forms of pessimism. But at the
same time Disney's utopia points beyond the given while remaining
firmly within it. As Ernst Bloch has pointed out, genuine wishes are
felt here at the start but these are often siphoned off within con-
structions of nostalgia, fun, and childhood innocence that undercut
the utopian dream of "something else"—that which extends be-
yond what the market and a commodity-crazed society can offer.[38]
And yet, even in this "swindle of fulfillment," to quote Bloch's
coinage,[39] there are contradictions regarding how adults experience
a Disney culture that reflect a combination of pleasure and irritation,
subordination and resistance, genuine affective involvement and pas-
sive identifications. For example, Disney's invitation to adult couples
to experience the pleasures of the erotic fling, the escape into the al-
leged rekindling of sensual desire and pleasure that is to be found in
a vacation at one of Disney's theme parks, is undermined by the real-
ity of an environment that is utterly septic, overly homogeneous,
and completely regulated and controlled. And yet, this exoticizing of
the Disney landscape does contain a utopian element that exceeds
the reality of the Disney-produced commercialized spaces in which
such desires find their origins as well as their finale in the fraudulent
promise of satisfaction.

There are no passive dupes in this script, and many of Disney's
texts offer opportunities for oppositional readings. But at the same

time, the potential for subversive readings, the recognition of the complex interplay of agency, or the mixture of alienation and pleasure that the culture industry promotes does not cancel out the power of a corporation like Disney to monopolize the media and saturate everyday life with its own ideologies. Although it is true that people mediate what they see, buy, wear, and consume, and bring different meanings to the texts and products that companies like Disney produce, it is crucial that any attempt to deal with the relationship between culture and politics not stop with such a recognition but investigate both its limits and its strengths, particularly in dealing with the three- to eight-year-old crowd.[40] Hence, it is crucial that any rendering and interpretation of Disney culture not be seen as either static or universal but be addressed as a pedagogical attempt to challenge the diverse meanings and commonsense renderings that students and others bring to their encounter with Disney culture in its various manifestations.

Engaging Disney's public pedagogy as a form of cultural politics is meant to offer readers a set of problematics that enable them to inquire into what Disney represents in a way that they might not have thought about and to shatter commonsense assumptions regarding Disney's claim to both promoting fun and games and protecting childhood innocence. In short, the aim of such a project is to both challenge and go beyond the charge that cultural critics who take a critical stand on Disney or argue for a particular interpretation of what its culture represents fail to consider other possible readings of Disney texts, or, as David Buckingham notes, "simply offer self-righteous tirades against an endless litany of 'isms.'"[41] In fact, the real issue may not be one of ideological rigidity on the part of progressive cultural critics or their failure to assign multiple interpretations to Disney's texts, but how to read cultural forms as they articulate with a whole assemblage of other texts, ideologies, and practices. How audiences interpret Disney's texts may not be as significant as how some ideas, meanings, and messages under certain political conditions become more highly rated as representations of reality than others, and how these representations assume the force of ideology by making an appeal to common sense while at the same time shaping political policies and programs that serve very specific interests—

such as the passing of the 1996 Telecommunications Act, or the forging of school-business partnerships.

For some cultural theorists, the strength of Disney's texts lies in the potential they have for pleasure and for the multiple readings—outside of the realm of ideology—they provide for diverse audiences. One can grant that recognizing that reception is itself constitutive of how meaning is produced, and the fact that the work of conferring meaning cannot be specified in advance is an important insight, though not one that by default eliminates the inordinate power of megacorporations such as Disney to control the range of meanings that circulate within society. There is a difference between political formations, which involve a mix of institutional and ideological forces, and reading methods (always attempting to be more rigorous than the positivist-oriented media effects studies) that remind us that the relationship between determinations and effects are problematic. Similarly, Edward Said makes an important point about the relationship between method and politics when he insists that some theorists "have fallen into the trap of believing that method is sovereign and can be systematic without also acknowledging that method is always part of some larger ensemble of relationships headed and moved by authority and power."[42] For Said, the forces of cultural production and reception are not equal; and this suggests dealing very differently with how we actually think about the relationships among politics, power, and pedagogy in linking these two modes of intervention. Focusing on how subjects interpret, mediate, or resist different messages, products, and social practices does not cancel out the concentrated assemblage of power that produces them, nor does it address the broader historical, cultural, and institutional affiliations that often privilege texts with specific intentions and meanings. Nor does such a method suggest that one is actually working out of a project that takes a stand against particular forms of domination while struggling to expand democratic relations and pluralize democratic public spheres. What is the celebration of any method, including audience research (in its various manifestations), actually against? What does it oppose? What is the project that gives it meaning? And how does this appeal to method actually address the growing concentration of political and economic power and the broad spectrum of texts, institu-

tions, and social practices that corporations such as Disney effectively reproduce?

Yet, how people mediate texts, produce different readings of various cultural forms, and allow themselves to experience the pleasure of various aspects of Disney culture cannot be ignored. How viewers use Disney's cultural texts to make sense of their lives, or how such texts mobilize those pleasures, identifications, and fantasies that connect audiences to the broader issues that make up their everyday experiences are crucial issues that need to be addressed in order to understand how the media do their pedagogical work without reducing respondents to passive dupes.[43] However, the ways in which such messages, products, and conventions "work" on audiences is one that must be left open to the investigation of particular ethnographic interventions and/or pedagogical practices. There is no virtue, ideologically or politically, in simply pronouncing what Disney means—as if that is all there is to do. I am suggesting a very different approach to Disney, one that highlights the pedagogical and the contextual by raising questions about Disney—such as what role it plays in shaping childhood identity, public memory, national identity, gender roles, or in suggesting who qualifies as an American or what the role of consumerism is in American life—that expand the scope of inquiry in order to allow people to enter into such a discussion in a way that they ordinarily might not have. Disney needs to be engaged as a public discourse, and doing so means offering an analysis that prompts civic discourse and popular culture to rub up against each other. Such an engagement represents both a pedagogical intervention and a way of recognizing the changing contexts in which any text must be understood and engaged.

Questioning what Disney teaches is part of a much broader inquiry regarding what it is that parents, children, educators and other cultural workers need to know in order to critique and challenge, when necessary, those institutional and cultural forces that have a direct impact on public life. Such inquiry is all the more important at a time when corporations hold such an inordinate amount of power in shaping children's culture into a largely commercial endeavor, using their various cultural technologies as teaching machines to relentlessly commodify and homogenize all aspects of everyday life, and in

this sense posing a potential threat to the real freedoms associated with a substantive democracy. Yet questioning what megacorporations such as Disney teach also means appropriating the most resistant and potentially subversive ideas, practices, and images at work in their various cultural productions.

What Disney teaches cannot be abstracted from a number of important larger issues: What does it mean to make corporations accountable to the public? If dominant media constitute the primary public forum for education and exchange, what is the role of cultural politics in addressing the possible forms that might exist between corporations and public life in the next century? How might cultural-studies theorists link public pedagogy to a critical democratic view of citizenship? How might diverse cultural workers develop forms of critical education that enable young people and adults to become aware of and interrogate the media as a major political, pedagogical, and social force? What role might public schools and higher education play in providing students with the skills, knowledge, and motivation needed to address the threat that commercial culture poses to subordinating democratic values to market values? Where might cultural politics be useful in developing multiple democratic spheres in which children and adults can develop the pedagogies, relations, and discourses for defending vital social institutions as public goods? Put bluntly, how can cultural workers in a variety of fields come together to create visions, values, and social relations removed from the narrow logic of the marketplace? At the very least, such a project suggests that cultural workers give more thought to the importance of public pedagogy as a vital political project, and how such a project might be incorporated as a defining principle of cultural politics in order to offer students and others the opportunity for learning how to use and critically read the new media technologies and their various cultural productions as pedagogical practices designed to secure particular identifications and desires in the service of a privatized notion of citizenship and democracy. Organizing to democratize the media and make it accountable to a participating citizenry also demands engaging in the hard political and pedagogical task of opening up corporations such as Disney to public interrogation and critical dialogue.[44]

Disney's overwhelming presence in the United States and abroad reminds us that the battle over culture is central to the struggle over meaning and institutional power, and that for learning to become meaningful, critical, and emancipatory, it cannot be surrendered either to the dictates of consumer choice or to a prohibition on critically engaging how ideologies work within various social formations and cultural discourses. On the contrary, critical learning must be linked to the empowering demands of social responsibility, public accountability, and critical citizenship precisely as a form of cultural politics.

Performing
Performing
Cultural
Cultural
Studies
Studies

To create a new culture does not only mean to make original discoveries on an individual basis. It also and especially means to critically popularize already discovered truths, make them, so to speak, social, therefore give them the consistency of basis for vital actions, make them coordinating elements of intellectual and social relevance.

—Antonio Gramsci, *Selections from the Prison Notebooks*

INTRODUCTION

Within the last decade, artists and educators have been caught in an ideological crossfire regarding the civic and political responsibilities they assume through their roles as engaged critics and cultural theorists. I want to respond, in part, to this debate by addressing the issue of what roles cultural workers might play as oppositional public intellectuals who refuse to define themselves either through the language of the market or through a discourse that abstracts cultural

politics from the realm of the aesthetic or the sphere of the social. This appropriation of cultural workers as oppositional public intellectuals suggests both a critical analysis of the relationship between the political and the pedagogical, and a redefinition of artists, educators, and other cultural workers as border crossers and intellectuals who engage in intertextual negotiations across different sites of cultural production. The concept of border crossing at work here foregrounds not only the shifting nature of borders and the problems they pose in naming and articulating the locations of identity formation, politics, and struggle; it also draws attention to the kind of cultural work that increasingly takes place in the border space between "high" and popular culture; between the institution and the street; between the public and the private. Intellectual work in this instance becomes both theoretical and performative—that is, it is marked by forms of invention, specificity, and critique as well as an ongoing recognition of the border as partial, fluid, and open to the incessant tensions and contradictions that inform the artist/educator's own location, ideology, and authority in relation to particular communities. At the same time, space and place do not disappear as markers of memory, history, and lived experience; they become more porous and unstable, but still bear the weight of history and the legacies of struggles yet to be fulfilled.

At stake here is not merely the call to link art and other forms of cultural work to practices that are transgressive and oppositional, but to articulate a wider project that connects artists, educators, and other cultural workers to an insurgent cultural politics that challenges the growing incursions of corporate power while simultaneously developing a vibrant democratic public culture and society.

The problem that I want to foreground is how the diverse traditions of critical pedagogy and cultural studies might be engaged to redefine cultural work as acts of insurgent citizenship that help keep alive, as the poet Robert Haas puts it, "the idea of justice, which is going dead in us all the time."[1] In what follows, I try to engage two critical traditions that offer the opportunity to retheorize not just the role that engaged artists might play in keeping justice alive but also the role that other cultural workers might play as public intellectuals who revitalize the dynamics of an ongoing radical cultural politics.

While critical educators and cultural studies scholars have traditionally occupied separate spaces and addressed different audiences, the pedagogical and political nature of their work appears to converge around a number of points. At the risk of overgeneralizing: both cultural-studies theorists and critical educators engage in forms of cultural work that locate politics in the interplay among symbolic representations, everyday life, and material relations of power; both engage cultural politics, as "the site of the production and struggle over power,"[2] and learning as the outcome of diverse struggles rather than as the passive reception of information. In addition, both traditions have emphasized what I call a performative pedagogy reflected in what such theorists as Lawrence Grossberg call "the act of doing,"[3] the importance of understanding theory as the grounded basis for "intervening into contexts and power . . . in order to enable people to act more strategically in ways that may change their context for the better."[4] Moreover, theorists working in both fields have argued for the primacy of the political in their diverse attempts to produce critical public spaces, regardless of how fleeting they may be, in which "popular cultural resistance is explored as a form of political resistance."[5] Yet although both groups share certain pedagogical and ideological practices, they rarely speak to each other, in part because of the disciplinary barriers and institutional borders that atomize, insulate, and prevent diverse cultural workers from collaborating across such boundaries.

THE SEARCH FOR A PROJECT

This subtitle suggests the need to develop elements of a project that might enable cultural-studies theorists and educators to form alliances around pedagogical practices that are not only interdisciplinary, transgressive, and oppositional, but also connected to a broader notion of cultural politics designed to further racial, economic, and political democracy.[6] Within such a project, theory is connected to social change, textual analysis to practical politics, and academic inquiry to public spheres that bear, as Martha Nussbaum sees it, the "texture of social oppression and the harm that it does."[7]

The meaning and primacy of the notion of the project I mention is drawn from a long tradition of political work that extends from Raymond Williams and Stuart Hall to, more recently, Chantal Mouffe, Nancy Fraser, Lawrence Grossberg, Angela McRobbie, and Stanley Aronowitz and refers to strategies of understanding, engagement, and transformation that address the most demanding social problems of our time. Such projects are utopian in that they reject the currently fashionable notion that it is better to adapt to the dominant discourse and conditions of the new global marketplace. But there is more at stake than simply a form of utopianism that is compensatory, that offers up only the great refusal. On the contrary, the utopianism of ongoing democratic projects consists of both criticizing the existing order of things and using the terrain of culture and education to actually intervene in the world, to struggle to change the current configurations of power in society. Utopianism in this sense is both anticipatory and provisional. It refuses to be messianic, but because it cannot predict any final outcome, it does not embrace a politics of despair or cynicism. Rather, as a form of educated hope, it provides the grounds for thinking critically and acting responsibly—pushing against the grain so as to undermine and transform structures of oppression. Similarly, there is nothing abstract about a critically informed utopian project, since it recognizes that progressive educational and political work has to begin at those intersections where people actually live their lives. Such a project uses theory to understand such contexts as lived relations of power while pedagogically fashioning new and imagined possibilities through art and other cultural practices in order to bear witness to the ethical and political dilemmas that animate both the specificity of such contexts and their connection to the larger social landscape. Implicit in this notion of the project is both the public nature of art as a form of cultural politics and the importance of culture as a struggle over meaning, identity, and relations of power—a struggle that is essential to addressing those practices and forms of domination that have resulted in a massive increase in social and economic inequality, a marked resurgence in violence against minorities of color and sexual orientation, a renewed attack on the global environment, and a full-fledged assault on those nonmarket, noncommodified, democratic spaces that provide what Robert

McChesney believes are the public forums "necessary for meaningful participation in decision making."[8]

Within the parameters of such a project, I want to address how cultural studies and critical pedagogy advocates might find common ground in a radical project and practice informed by theoretically rigorous discourses that affirm the critical but refuse the cynical, that confirm hope as central to a critical pedagogical and political practice but eschew a romantic utopianism. Fundamental to such a project is a notion of the performative that expands the political possibilities of the pedagogical by highlighting how education as a critical practice might be used to engage the tension between existing social practices produced in a wide range of shifting and overlapping sites of learning and the moral imperatives of a radical democratic imaginary.

Pedagogy in this context becomes public and performative, in part because it opens a space for disputing conventional academic borders and raising questions "beyond the institutional boundaries of the disciplinary organization of question and answers."[9] Defined through its performative functions, public pedagogy is marked by its attentiveness to the interconnections and struggles that take place over knowledge, language, spatial relations, and history. Public pedagogy represents a moral and political practice rather than merely a technical procedure. At stake here is not only the call to link public pedagogy to practices that are interdisciplinary, transgressive, and oppositional, but also to connect such practices to broader projects designed to further racial, economic, and political democracy, to strike a new balance and expand what Stuart Hall and David Held have called the "individual and social dimensions of citizenship rights."[10]

The performative nature of the pedagogical recognizes the partial breakdown, renegotiation, and repositioning of boundaries as fundamental to understanding how pluralization is linked to the shifting nature of knowledge, identities, and the process of globalization. The performative and pedagogical in this context acknowledge the rise of new spaces and a social vision regarding what it means to live in a world that has been radically altered by global capitalism, transnational corporations, and new electronic technologies. But linking the performative and pedagogical also suggests recognizing that cultural workers need to address how new modes of symbolic and social

practice change the way we think about power and social agency, and what such changes mean for expanding and deepening the processes of democratic education, social relations, and public life.

BEYOND THE POLITICS OF TEXTUALITY

A performative practice in its more orthodox register focuses largely on events as cultural texts and how they are, to use Simon Frith's terms, "presented, 'licensed,' or made 'excessive.'"[11] A growing tendency is appearing within cultural studies, as I mentioned previously, especially as it becomes more popular in North America, of privileging text over context, language over material relations of power, and discursive relations outside of the frameworks "within which their broader political significance can be established."[12] The exclusive emphasis on texts, however, runs the risk of reproducing processes of reification and isolation, as when the performative is framed outside of the context of history, power, and politics. In this instance, texts become trapped within a formalism that often succumbs to viewing such issues as one's commitment to the "other," the ethical duty to decide between what is better and what is worse, and, by extension, human rights as either meaningless, irrelevant, or leftovers from a bygone age.[13] Lewis Gordon argues that in its most reductive moment performativity as a pedagogical practice often falls prey to a one-sided focus on politics as rhetoric in which the political dimension of such practice "is rendered invisible by virtue of being regarded as purely performative. . . . What one performs is rendered immaterial. Whatever 'is' is simply a performance."[14] Progressive cultural-studies theorists recognize that the complex terms of cultural engagement are produced performatively, but unlike Gordon, many believe that the issue is still open as to how the performative can have some purchase in social action or help produce new forms of identity and politics while simultaneously developing a political and ethical vocabulary for creating the conditions of possibility for a politics and pedagogy of economic, social, and racial justice.

I would like to address the possibilities of a politically progressive notion of the performative and its relevance for highlighting the

mutually determining role of theory and practice, on one hand, and the related project of making the political more pedagogical on the other (thus amplifying the chapter on Homi Bhabha in this book). This is especially important as pedagogy becomes more central to shaping the political project(s) that inform the work of educators, artists, and cultural workers in a variety of sites, especially within a present marked by the rise of right-wing politics, a resurgent racism, a full-fledged attack on the public funding for the arts, and punitive attacks on the poor, urban youth, and people of color. The invocation of a wider political context suggests that the intersection of cultural studies and critical pedagogy be analyzed more critically in light of recent interventions by a growing number of progressives and conservatives who attempt to either erase the relationship between power and politics as part of a return to a hermetic view of teaching and the text, or have narrowly defined politics within a dichotomy that pits the alleged "concrete" material issues of class and labor against a fragmenting and marginalizing identity politics on one hand, and a range of diverse, ineffective, side-show battles over culture on the other. Unfortunately, this model not only fails to recognize how issues of race, gender, age, sexual orientation, and class are intertwined, it also refuses to acknowledge the pedagogical function of culture as the site where identities are constructed, desires mobilized, and moral values shaped. Ellen Willis rightly argues that if people "are not ready to defend their right to freedom and equality in their personal relations, they will not fight consistently for their economic interests, either."[15] As I argue in more detail in other chapters in this book, this totalizing model of class functions largely to cancel out how culture as a terrain of struggle shapes our sense of political agency and mediates the relations between material-based protests and structures of power and the contexts of daily struggles.

EDUCATION AS A PERFORMATIVE PRACTICE

Progressives willing to engage the pedagogical as a performative practice that both connects and affirms the most important theoretical and strategic aspects of work in cultural studies and critical peda-

gogy might begin with Raymond Williams's insight that the "deepest impulse [informing cultural politics] is the desire to make learning part of the process of social change itself."[16] For Williams, a cultural pedagogy signals a form of permanent education that acknowledges "the educational force of our whole social and cultural experience . . . [as an apparatus of institutions and relationships that] actively and profoundly teaches."[17] This suggests that educators and others need to rethink the ways in which culture is related to power, and how and where it functions both symbolically and institutionally as an educational, political, and economic force. Culture is the ground of both contestation and accommodation, and as the site where young people and others imagine their relationship to the world; it produces the narratives, metaphors, and images for constructing and exercising a powerful pedagogical force over how people think of themselves and their relationship to others. While it has become a matter of common sense for progressive critics to challenge those liberal and conservative traditions that attempt to purify culture and cultural questions by rendering them essentially apolitical or untainted by politics, many critics have failed to take seriously Antonio Gramsci's insight that "[e]very relationship of 'hegemony' is necessarily an educational relationship"—with its implication that education as a cultural pedagogical practice takes place across multiple sites as it signals how, within diverse contexts, education makes us both subjects of and subject to relations of power.[18]

As a performative practice, the pedagogical opens up a narrative space that affirms the contextual and the specific while simultaneously recognizing the ways in which such spaces are shot through with issues of power. Referencing the ethical and political is central to a performative/pedagogical practice that refuses closure, insists on combining theoretical rigor and social relevance, and embraces commitment as a point of temporary attachment that allows educators and cultural critics to take a position without becoming dogmatic and rigid.[19] The pedagogical as performative also draws upon recent cultural-studies work in which related debates on pedagogy can be understood and addressed within the broader context of social responsibility, civic courage, and the reconstruction of democratic public life. Cary Nelson's insight that cultural studies exhibits a deep

concern for "how objects, discourses, and practices construct possibilities for and constraints on citizenship" provides one important starting point for designating and supporting a project that brings together various educators, academics, and cultural workers within and outside of the academy.[20]

Central to this concern for citizenship as an act of critique and resistance is a notion of border pedagogy that registers a call for developing theoretical tools and social practices that would enable educators and cultural workers to move within and across disciplinary, political, and cultural borders in order to raise new questions, produce diverse contexts in which to organize the energies of a moral vision, and draw upon the intellectual resources needed to understand and transform those institutions and forces that keep "making the lives we live, and the societies we live in, profoundly and deeply antihumane."[21]

Underlying this form of cultural politics is a view of radical pedagogy that locates itself on the dividing lines where the relations between domination and oppression, power and powerlessness continue to be produced and reproduced. For many cultural workers and educators this means listening to and working with the poor and other subordinate groups so that they might speak and act in order to alter oppressive relations of power. But professionalist relegitimation in a troubled time seems to be the order of the day as an increasing number of academics both refuse to recognize the university as a critical public sphere and offer little or no resistance to the ongoing vocationalization of the university, the continuing evisceration of the intellectual labor force, and the current assaults on the poor, the elderly, children, people of color, and working people in this country.[22]

In opposition to such pessimism, educators and other cultural workers can join with a number of cultural-studies theorists in raising questions about how culture is related to power—why and how it operates in both institutional and textual terms—within and through a politics of representation. Yet a performative pedagogy does more than textualize everyday life and reveal dominant machineries of power; it is also, as Lawrence Grossberg points out, "about remaking the context where context is always understood as a structure of power."[23] Pedagogical work in this sense informs and ex-

tends cultural studies's long-standing concern with mobilizing knowledge and desires that may lead to significant changes in minimizing the degree of oppression in people's lives. My call to make the pedagogical a defining feature of cultural studies is meant to accentuate the performative as an act of doing—a work in progress informed by a cultural politics that translates knowledge back into practice, places theory in the political space of the performative, and invigorates the pedagogical as a practice through which collective struggles can be waged to revive and maintain the fabric of democratic institutions. Such a call to reform also suggests redefining the role of academics as oppositional public intellectuals in order to reaffirm the necessity for them to focus on the pedagogical and political dimensions of culture and interrogate cultural texts as public discourses. This suggests expanding the tools of ideology critique to include a range of sites in which the production of knowledge and identities takes place (including but not limited to television, Hollywood films, video games, newspapers, fanzines, popular magazines, and Internet sites). Yet once again, as I have argued throughout this book, it is important to stress that progressive educators and cultural workers must go beyond the primacy of signification over power and focus on how these cultural texts work within the material and institutional contexts that structure everyday life.

PUBLIC INTELLECTUALS AND THE POLITICS OF THE PERFORMATIVE

Envisioning the pedagogical as a performative practice also points to the necessity of rethinking the role that educators and cultural-studies scholars might take up as public intellectuals. Rather than reducing the notion of public intellectual to an academic fashion plate ready for instant consumption by the New York Times and Lingua Franca, a number of critical theorists have reconstituted themselves within the ambivalences and contradictions of their own distinct personal histories while simultaneously recognizing and presenting themselves through their role as social critics. By connecting the biographical, pedagogical, and performative, artists such as Suzanne Lacy, Coco Fusco, Luis

Alfaro, Mierle Ukeles, Peggy Diggs, and Guillermo Gomez-Peña rearticulate the relationship between the personal and the political without collapsing one into the other.[24] As public intellectuals, these cultural workers not only refuse to support the academic professionalization of social criticism, they also take seriously their role of critics as teachers and the potentially oppositional space of all pedagogical sites, including but not restricted to, the academy. Such artists do not respond to the degradation of civic life by apologizing for the incivility of social criticism or capitalize on the crisis of social life by promoting themselves on talk radio and television news circuits. On the contrary, many performance artists take seriously Pierre Bourdieu's admonition, "There is no genuine democracy without genuine opposing critical powers,"[25] and do everything they can to make their voices heard in those public spaces still available for meaningful dissent, social criticism, and political theater. In doing so, many performance artists provide new tools for understanding how culture functions as a pedagogical and political force at the community level, working to bridge relations between different audiences, theories, and forms of culture.

Performance artists like Suzanne Lacy have worked relentlessly during the last three decades to dissolve the differences between artists and participants, aesthetic artifice and social process, demonstrating that art should be a force for information, dialogue, and social change. Her ongoing public work on rape, women's rights, immigration, racism, aging, domestic violence, and urban youth has been used to mobilize various audiences and agencies about the role public services can play in servicing the needs of diverse communities, especially those who are marginalized and oppressed.[26] Her efforts on *Three Weeks in May* in 1977 focused on rape and violence against women and brought together a number of organizations, media outlets, and groups to both raise consciousness and implement policies to protect women from male-inflicted violence. In 1993, she installed a public work entitled *Underground* in which she placed a railroad track across the lawn of Pittsburgh's Point State Park. Three wrecked cars were placed on the tracks, and were painted with statistics about domestic violence, as well as words from its victims. A phone booth and open telephone line were made available for women

to talk to volunteers from various legal and medical services. The installation served as a public space that assisted victims of family violence and educated a larger public about its presence and consequences. It also served to link such victims and the public with a broad network of social agencies. Lacy's most recent work, especially *Code 33*, continues to combine art and social activism through a form of public pedagogy that provides a civic space and form of public outreach to subordinated groups. In this case, Lacy brings together urban youth and the police in Oakland, California, to engage in a public dialogue about police brutality, urban youth violence, and what can be done to address such issues. Educators, academics, and other cultural workers have much to learn from artists like Lacy. George Lipsitz reinforces this point in arguing that academics have much to learn from "artists who are facing up to the things that are killing them and their communities. Important social theory is being generated by cultural creators. Engaged in the hard work of fashioning cultural and political coalitions based on cultural affinities and shared suffering, they have been forced to think clearly about cultural production in contemporary society."[27]

Of course, few of these artists and cultural workers define themselves self-consciously as oppositional public intellectuals. Yet what is so remarkable about their work is the way in which they render the political visible through pedagogical practices that attempt to make a difference in the world rather than simply reflect it. The pedagogical as performative offers cultural workers within and outside education the opportunity to grapple with new questions and, as Peggy Phelan puts it, ways of "mis/understanding" how demanding social issues are "framed/acknowledged/and erased" within dominant and resistant ideologies.[28] The pedagogical as performative in this work does not merely provide a set of representations/texts that imparts knowledge to others; it also becomes a form of cultural production in which one's own identity is constantly being rewritten, but always with an attentiveness to how culture functions as both a site of production and a site of contestation over power. In this instance, cultural politics and the authority to which it makes a claim are always rendered suspect and provisional—not to elude the burden of judgment, meaning, or commitment, but to enable teachers and students

alike to address what Stuart Hall calls "the central, urgent, and disturbing questions of a society and a culture in the most rigorous intellectual way . . . available."[29]

Refusing to reduce politics to the discursive or representational, performative interpretation suggests reclaiming the political as a pedagogical intervention that links cultural texts to the institutional contexts in which they are read, and the material grounding of power to the historical conditions that give meaning to the places people actually inhabit in their attempts to live out the futures they desire. Within this notion of pedagogical practice, the performative becomes a site of memory work, a location and critical enactment of the stories we tell in assuming our roles as oppositional public intellectuals willing to make visible and challenge the grotesque inequalities and intolerable oppression of the present moment.

A cultural politics that makes the performative pedagogical engages ideas of how power operates within and across particular cultural spheres so as to make some representations, images, and symbols under certain political conditions more valuable as representations of reality than others. At issue here is the attempt to develop a theory of articulation in which the meanings produced within texts are understood in terms of how they resonate with other public discourses within other cultural sites and locations. There is an important distinction here between the attempt to simply read a text and make claims for it, and to read it in light of a whole assemblage of social relations in order to understand how some meanings resonate as ideologies by being able to define the terms of reality with a greater power than other meanings. In this instance, texts and events cannot be analyzed in isolation from their place within the material contexts of everyday life. Texts in this instance become objects of pedagogical inquiry as well as pedagogical events through which educators and others might analyze the mechanisms that inform how a politics of representation operates within dominant regimes of meaning so as to produce and legitimate knowledge about gender, youth, race, sexuality, work, public intellectuals, pedagogy, and other issues. Making the political more pedagogical means raising questions about how domination and resistance actually operate, are lived out and mobilized, and how they both deploy power and are themselves the expression of power.

CAN EDUCATION BE POLITICAL?

Critical pedagogy as a theory and practice should not legitimate a ro-
manticized notion of the cultural worker who can only function on the
margins of society, nor should it legitimate notions of teaching wedded
to an infatuation with method, formalism, and technique. When
viewed as both a moral and political practice, pedagogy becomes both a
site of struggle and the outcome of struggles informed by social rela-
tions that always presuppose some vision of the future, some notion of
what it means to be a citizen participating in public life. Pedagogy and
other cultural practices whose aim is to inform and empower are often
dismissed as being either doctrinaire or impositional.[30] Unfortunately,
the conservative and liberal dismissal of appropriating the pedagogical
as political often fails to make a distinction between what can be called
a *political education* and that which is a *politicizing education*. *Political educa-
tion* means recognizing that education is political because it is directive,
and addresses itself to the unfinished nature of what it means to be
human, to intervene in the world because human agency is condi-
tioned and not determined. It also suggests recognizing that schools
and other cultural sites cannot abstract themselves from the sociocul-
tural and economic conditions of their students, families, and commu-
nities.[31] Political education also means teaching students to take risks,
ask questions, challenge those with power, honor critical traditions,
and be reflexive about how authority is used in the classroom and other
pedagogical sites. A political education provides the opportunity for
students not merely to express themselves critically, but to alter the
structure of participation and the horizon of debate through which
their identities, values, and desires are shaped. A political education
constructs pedagogical conditions in order to enable students to under-
stand how power works *on* them, *through* them, and *for* them in the ser-
vice of constructing and expanding their roles as critical citizens.
Central to such a discourse is the recognition that citizenship is not an
outcome of technical efficiency but is instead a result of pedagogical
struggles that link knowing, imagination, and resistance, that, as bell
hooks has put it, disrupt "conventional ways of thinking about the
imagination and imaginative work, offering fictions that demand care-
ful scrutiny, that resist passive readership."[32]

Moreover, a politicizing education refuses to address its own political agenda, and often silences through an appeal to a specious methodology, objectivity, or notion of balance, or through an appeal to professionalism. Politicizing education polices the boundaries of the disciplines, often refuses to name or problematize its own cultural authority, and generally ignores the broader political, economic, and social forces that legitimate pedagogical practices consistent with existing forms of institutional power. Politicizing education appears indifferent to opening up the questions about the intersection of knowledge, power, ideology, and struggle that are fundamental to the teaching/learning process. In politicizing education, the language of objectivity, methodology, or the rigors of institutional process often ignores the systems of inclusion and exclusion at work in pedagogical spaces; similarly, the appeal to method and rigor too often undercuts any critical attempts to interrogate the normative basis of teaching and the political responsibility of educators, including issues regarding how they might help students identify, engage, and transform relations of power that generate the material conditions of racism, sexism, poverty, and other oppressive conditions.[33] Ignored in politicizing education is the crucial issue of how pedagogy puts into place and legitimates certain forms of identification and subject positions: student as consumer, worker, citizen, and so on. Politicizing education also rarely address how pedagogy might function to close down opportunities for students to critically engage the conditions under which knowledge is produced, circulated, and legitimated, and how particular pedagogical practices work to shape particular narratives about the past, present, and future—thus forfeiting any claim to neutrality. Lacking a political project, the role of the public school and university intellectuals is reduced to that of a technician engaged in formalistic rituals or professional boosterism, largely unconcerned with the disturbing and urgent problems that confront the wider society.

CONCLUSION

I would like to argue that pedagogy as a critical and performative practice be considered a defining principle among all cultural workers—

journalists, performance artists, lawyers, academics, representatives of the media, social workers, teachers, and others—who work in popular culture, composition, literary studies, architecture, and related fields. In part, this suggests the necessity for academics and other cultural workers to develop dynamic, vibrant, politically engaged, and socially relevant projects in which the traditional binarisms of margin/center, unity/difference, local/national, and public/ private can be reconstituted through more complex representations of identification, belonging, and community. Paul Gilroy has suggested that progressive cultural workers need a discourse of ruptures, shifts, flows, and unsettlement, one that functions not only as a politics of transgression but also as part of a concerted effort to construct a broader vision of political commitment and democratic struggle.[34] This implies a fundamental redefinition of the meaning of educators and cultural-studies workers as oppositional public intellectuals. And as oppositional public intellectuals, we might consider defining ourselves not as marginal, avant-garde figures, professionals, or academics acting alone, but as critical citizens whose collective knowledge and actions presuppose specific visions of public life, community, and moral accountability.

Crucial to this project is a conception of the political that is open yet committed, respects specificity and place without erasing global considerations, and provides new spaces for collaborative work engaged in productive social change. Such a project can begin to enable educators and other cultural-studies scholars to rethink how pedagogy as a performative practice can be expressed by, as Suzanne Lacy deems it, an "integrative critical language through which values, ethics, and social responsibility" are fundamental to creating shared critical public spaces that engage, translate, and transform the most vexing social problems we now face nationally and internationally.[35] Given the current corporate and right-wing assaults on public and higher education, coupled with the emergence of a moral and political climate that has shifted towards a new social Darwinism, it is crucial for educators, artists, and other cultural workers to begin to find ways to join together to both defend and reconstruct those cultural sites and public spheres that are essential to reformulate the relationship between cultural studies and critical pedagogy—not as a new academic fad but as a broader effort to revitalize democratic public life.[36]

notes

INTRODUCTION

1. For three excellent sources on this issue, see Edward Herman and Robert W. McChesney, *The Global Media* (Washington, D.C.: Cassell, 1997); Charles Derber, *Corporation Nation* (New York: St. Martin's Press, 1998); Noam Chomsky, *Profit Over People* (New York: Seven Stories Press, 1999).

2. Herbert Marcuse, "Some Social Implications of Modern Technology," in *Technology, War, and Fascism: Collected Papers of Herbert Marcuse*, ed. Doug Kellner (New York: Routledge, 1998), p. 41.

3. See, in this regard, the important comments of Roberto Mangabeira Unger and Cornel West, *The Future of American Progressivism* (Boston: Beacon Press, 1998); see also Stanley Aronowitz's more sustained and theoretically informed work: Stanley Aronowitz, *The Death and Rebirth of American Radicalism* (New York: Routledge, 1996).

4. Russell Jacoby, *The End of Utopia: Politics and Culture in an Age of Apathy* (New York: Basic Books, 1999), p. xi.

5. On this issue, see Nina Eliasoph, *Avoiding Politics: How Americans Produce Apathy in Everyday Life* (New York: Cambridge University Press, 1998); Unger and West, *The Future of American Progressivism*.

6. Robert W. McChesney, introduction to Noam Chomsky, *Profit Over People*, p. 11.

7. See, for instance, the stories following the suppression of dissent on Disney-owned ABC, or the increasing corporatization of the university: Robert W. McChesney, *Corporate Media and the Threat to Democracy* (New York: Seven Stories Press, 1997); Henry A. Giroux, *The Mouse That Roared: Disney and the End of Innocence* (Lanham, Md.: Rowman and Littlefield, 1999); Russell Mokhiber and Robert Weissman, *Corporate Predators: The Hunt for Mega-Profits and the Attack on Democracy* (Monroe, Maine: Common Courage Press, 1999); Chomsky, *Profit Over People*.

8. This position becomes almost caricature when it is applied to cultural studies by some conservatives. One typical example can be found in Edward Rothstein, "Trolling 'Low' Culture for High-Flying Ideas: A Sport of Intellectuals," *New York Times*, Sunday, March 28, 1999, p. A33. The sixties as the source of most contemporary

problems has become a fundamental tenet of right-wing ideology, and includes the work of such academics as Harold Bloom and Getrude Himmelfarb, and the strident commentaries of former house majority leader Newt Gingrich.

9. David Williams, "Mr. DeLay Had It Right; Absolutism and Relativism Were at the Heart of the Clinton Matter," *Washington Post*, March 7, 1999, p. B2.

10. Anthony Lewis, "Self-Inflicted Wound," *New York Times*, Tuesday, February 9, 1999, p. A31.

11. This position can be found in the work of Neil Postman. See, for example, his *Technopoly: The Surrender of Culture to Technology* (New York: Knopf, 1992).

12. Two typical examples include Todd Gitlin, *The Twilight of Common Dreams: Why America Is Wracked by Culture Wars* (New York: Metropolitan Books, 1995); and Alan Sokal and Jean Bricmont, *Fashionable Nonsense: Postmodern Intellectuals' Abuse of Science* (New York: Picador, 1998).

13. For a brilliant critique of this issue, see Stanley Aronowitz, *The Crisis of Historical Materialism* (Westport, Conn.: Bergin and Garvey, 1981). As Judith Butler insightfully points out, the left's call for unity around class "prioritizes a notion of the common" that is not only purified of race and gender considerations, but also "forgets" that those social movements that organized around various forms of identity politics emerged, in part, in opposition to the principles of exclusion in which such calls for class unity were constructed. See Judith Butler, "Merely Cultural," *Social Text* 15:3–4 (Fall/Winter 1997), p. 268.

14. On this issue, see Lawrence Grossberg, "Identity and Cultural Studies: Is That All There Is?" in Stuart Hall and Paul Du Gay, eds., *Questions of Cultural Identity* (Thousand Oaks, Calif.: Sage, 1996), pp. 87–107.

15. Elizabeth Long, "Introduction: Engaging Sociology and Cultural Studies: Disciplinarity and Social Change," in Elizabeth Long, ed., *From Sociology to Cultural Studies* (Malden, Mass.: Basil Blackwell, 1997), p. 17.

16. Sygmunt Bauman, *Globalization: The Human Consequences* (New York: Columbia University Press, 1998).

17. Stuart Hall, "The Centrality of Culture: Notes on the Cultural Revolutions of Our Time," in Kenneth Thompson, ed., *Media and Cultural Regulation* (Thousand Oaks, Calif.: Sage, 1997), p. 209.

18. Grossberg, "Identity and Cultural Studies: Is That All There Is?" pp. 99–100.

19. Henry A. Giroux, *Border Crossings: Cultural Workers and the Politics of Education* (New York: Routledge, 1992).

20. James Young, "The Holocaust as Vicarious Past: Art Spiegelman's *Maus* and the Afterimages of History," *Critical Inquiry* 24 (Spring 1998), p. 673.

21. On the issues of pedagogy, hope, and historical contingency, see Paulo Freire, *Pedagogy of Freedom* (Lanham, Md.: Rowman and Littlefield, 1998); Richard Johnson, "Teaching Without Guarantees: Cultural Studies, Pedagogy, and Identity," in Joyce Canaan and Debbie Epstein, eds., *A Question of Discipline* (Boulder: Westview Press, 1997), pp. 42–77; Alan O' Shea, "A Special Relationship? Cultural Studies, Academia, and Pedagogy," *Cultural Studies* 12:4 (1998), pp. 512–27.

22. Michel Foucault, "Polemics, Politics, and Problematizations: An Interview with Michel Foucault" in Paul Rabinow, ed., *Ethics, Subjectivity and Truth: The Essential Works of Michel Foucault 1954–1984* (New York: The New Press, 1994), pp. 111–19.

23. Lost from this discourse is any attempt to engage, guide, direct, and stimulate new forms of practice and expression. Rather than being a dynamic, critical force, such

discourse becomes a kind of pretense for interviewing oneself, a form of self-aggrandizement. On this issue, see Maurice Berger, "Introduction: The Crisis of Criticism," in Maurice Berger, ed., *The Crisis of Criticism* (New York: The New Press, 1998), pp. 1–14.

24. In this regard, see the brilliant and chilling analysis in Jeffrey Wallen, *Closed Encounters in Literary Politics and Public Culture* (Minneapolis: University of Minnesota Press, 1998).

25. Chantal Mouffe, cited in Lynn Worsham and Gary A. Olson, "Rethinking Political Community: Chantal Mouffe's Liberal Socialism," *Journal of Composition Theory* 19:2 (1999), pp. 180–81

26. For an excellent summary of this movement, see Richard Apelbaum and Peter Dreier, "The Campus Anti-Sweatshop Movement," *The American Prospect* 46 (September/October 1999), pp. 71–78; For a report on the strike at the University of California-Berkeley and its resolution, see June Jordan, "Good News of Our Own," *The Progressive*, August 1999, pp. 18–19.

27. Pierre Bourdieu, *Acts of Resistance* (New York: New Press, 1999), pp. 8–9.

CHAPTER 1

1. Andrew Ross, *Real Love: In Pursuit of Cultural Justice* (New York: New York University Press, 1998), p. 3.

2. Harold Bloom, "They Have the Numbers; We Have the Heights," *Boston Review* 23:2 (April/May 1998), p. 27.

3. Harold Bloom, *The Western Canon* (New York: Riverhead Books, 1994), p. 29. Bloom's position is rooted in a nostalgia for the good old days when universities taught the select few who qualified as talented writers and readers willing to carry on an aesthetic tradition purged of the contamination of politics, ideology, and power. Unfortunately for Bloom, the universities are now filled with the stars of the "School of Resentment," who debase themselves by teaching social selflessness.

4. Bloom, "They Have the Numbers; We Have the Heights," p. 28.

5. Ibid.

6. Cheney, "Scholars and Society," *American Council of Learned Societies Newsletter* 1 (Summer 1988), p. 6.

7. Ellen Messer-Davidow, "Whither Cultural Studies?" in Elizabeth Long, ed., *From Sociology to Cultural Studies* (Malden, Mass.: Basil Blackwell, 1997), p. 491.

8. Michael Bérubé, *The Employment of English: Theory, Jobs, and the Future* (New York: New York University Press, 1998), p. 181.

9. John Silber, quoted in Jamin Raskin, "The Great PC Cover-Up," *California Lawyer*, February 1994, p. 69.

10. Richard Rorty, "The Inspirational Value of Great Works of Literature," *Raritan* 16:1 (1996), p. 13.

11. Lindsay Waters, "Dreaming with Tears in My Eyes," *Transition* 7:2 (1998), p. 86.

12. Richard Rorty, "The Dark Side of the American Left," *The Chronicle of Higher Education*, April 3, 1998, p. B5.

13. Waters, "Dreaming with Tears in My Eyes," p. 85.

14. Homi Bhabha, "The White Stuff," *Artforum*, May 1998, p. 22.

15. Rorty, "The Dark Side of the American Left," p. B6. This argument is repeated in greater detail in Rorty's *Achieving Our Country: Leftist Thought in 20th-Century America* (Cambridge, Mass.: Harvard University Press, 1998).

16. Richard Rorty, "First Projects, Then Principles," *The Nation*, December 22, 1997, p. 19.

17. For a brilliant rejoinder to this type of historical amnesia, see Robin D. G. Kelley, *Yo' Mama's Disfunktional! Fighting the Culture Wars in America* (Boston: Beacon Press, 1997).

18. Kuan-Hsing Chen, "The Formation of a Diasporic Intellectual: An Interview with Stuart Hall," in David Morley and Kuan-Hsing Chen, eds., *Stuart Hall: Critical Dialogues in Cultural Studies* (New York: Routledge, 1996), pp. 484–503.

19. See Todd Gitlin, *The Twilight of Our Common Dreams: Why America Is Wracked by Culture Wars* (New York: Metropolitan Books, 1995); Michael Tomasky, *Left for Dead: The Life, Death and Possible Resurrection of Progressive Politics in America* (New York: The Free Press, 1996); Jim Sleeper, *The Closest of Strangers* (New York: W. W. Norton, 1990). For an insightful critique of Tomasky, and a brilliant defense of cultural politics, see Ellen Willis, *Don't Think, Smile! Notes on a Decade of Denial* (Boston: Beacon Press, 1999). See also various critiques of cultural studies in Majorie Ferguson and Peter Golding, eds., *Cultural Studies in Question* (Thousand Oaks, Calif.: Sage, 1997), which includes a chapter by Gitlin. One of the most strident attacks on cultural politics and cultural studies can be found in Alan Sokal and Jean Bricmont, *Fashionable Nonsense: Postmodern Intellectuals' Abuse of Science* (New York: Picador, 1998). For a sustained critique of Sokal's and Bricmont's position, see Ted Striphas, "Cultural Studies, 'So-Called'," *Review of Education/Pedagogy/Cultural Studies*, forthcoming.

20. Gitlin's most sustained development of this argument can be found in his *The Twilight of Our Common Dreams*.

21. Judith Butler, "Merely Cultural," *Social Text* 15:52–53 (Fall/Winter 1997), p. 266.

22. Ibid., p. 268.

23. I take these issues up in my *Fugitive Cultures: Race, Violence and Youth* (New York: Routledge, 1996) and *Channel Surfing: Racism, the Media, and the Destruction of Today's Youth* (New York: St. Martin's Press, 1998).

24. For an insightful analysis of this position, see Lawrence Grossberg, "Cultural Studies: What's in a Name?" in *Bringing It All Back Home: Essays on Cultural Studies* (Durham, N.C.: Duke University Press, 1997), pp. 245–71.

25. Kelley, *Yo' Mama's Disfunktional!*, pp. 113–114.

26. Ibid.

27. Iris Marion Young, "The Complexities of Coalition," *Dissent*, Winter 1997, p. 67.

28. Butler, "Merely Cultural," p. 268.

29. Kelley, *Yo' Mama's Disfunktional!*.

30. Gitlin, "The Anti-Political Populism of Cultural Studies," *Dissent*, Spring 1997, p. 81.

31. Ibid.

32. Ibid., p. 82.

33. Stuart Hall, "The Emergence of Cultural Studies and the Crisis of the Humanities," *October* 53 (Summer 1990), p. 18.

34. Gitlin, "The Anti-Political Populism of Cultural Studies," p. 82.

35. Ellen Willis, "We Need a Radical Left," *The Nation*, June 29, 1998, p. 19.

36. Antonio Gramsci, *Selections from the Prison Notebooks*, edited and translated by Quinten Hoare and Geoffrey Smith (New York: International Press, 1971), p. 350.

37. Raymond Williams, *Communications* (New York: Barnes and Noble, 1967), p. 15.

38. T. W. Adorno and Max Horkheimer, *The Dialectic of Enlightenment*, translated by John Cumming. (New York: Seabury Press, 1972).

39. Janet Batsleer, et al., "Culture and Politics," in Janet Batsleer, et al., eds., *Rewriting English: The Cultural Politics of Gender and Class* (London: Methuen, 1985), p. 7.

40. Batsleer, et al., "Culture and Politics," p. 7.

41. Andrew Ross, *Real Love: In Pursuit of Cultural Justice* (New York: New York University Press, 1998), p. 3.

42. Ibid.

43. Jon Katz, *Virtuous Reality* (New York: Random House, 1997), p. 11.

44. See the excellent story on video literacy and schooling in Ellen Pall, "Video Verite," *New York Times,* January 3, 1999, section 4A, pp. 34–36, 38.

45. Anson Rabinach, "Unclaimed Heritage: Ernst Bloch's *Heritage of Our Times* and the Theory of Fascism," *New German Critique,* Spring 1977, p. 8. For a classic example of a critique of the utopian impulse that suggests hoping against hope, see Ilan Gur-Ze'ev, "Toward a Nonrepressive Critical Pedagogy," *Educational Theory* 48:4 (Fall 1998), pp. 463–86. Gur-Ze'ev's is so utterly unreflective and unself-critical that it never occurs to him to question seriously either the shortcomings of his own basic arguments or his complicity with a form of politics in which any possibility that the future can overtake the present is viewed as futile. In this diatribe against hope, now so common among educators, any notion that pedagogy, history, cultural politics, or social struggle contain the possibilities of freedom are often misrepresented and summarily derided.

46. This theme is taken up in Paulo Freire, *Pedagogy of Freedom* (Lanham, Md.: Rowman and Littlefield, 1998).

47. Maurice Berger, "Introduction: The Crisis of Criticism" in Maurice Berger, ed., *The Crisis of Criticism* (New York: The New Press, 1998), p. 11.

48. I have appropriated this idea from James Young, "The Holocaust as Vicarious Past: Art Spiegelman's *Maus* and the Afterimages of History," *Critical Inquiry* 24 (Spring 1998), pp. 668–69.

49. I have taken these ideas from Homi Bhabha, in Gary Olson and Lynn Worsham, "Staging the Politics of Difference: Homi Bhabha's Critical Literacy," *Journal of Composition Theory* 18:3 (1998), pp. 361–91.

50. Lawrence Grossberg, "Toward a Genealogy of the State of Cultural Studies," in Cary Nelson and Dilip Parameshwar Gaonkar, eds., *Disciplinarity and Dissent in Cultural Studies* (New York: Routledge, 1996), p. 142.

CHAPTER 2

1. The advertisement appears in *World Traveler,* March 1998, p. 76.

2. Francis Fukuyama, *The End of History and the Last Man* (New York: Free Press, 1989). This conflation of democracy and capitalism is also celebrated in Robert J. Samuelson, *The Good Life and Its Discontents: The American Dream in the Age of Entitlement, 1945–1995* (New York: Vintage, 1997).

3. Seyla Benhabib, "The Democratic Moment and the Problem of Difference," in Seyla Benhabib, ed., *Democracy and Difference* (Princeton, N.J.: Princeton University Press, 1996), p. 9.

4. Francis Fukuyama, "The End of History," *The National Interest,* Summer 1989, p. 2.

5. Stuart Ewen has traced this trend to the emergence in the nineteenth century of the culture of abundance that allowed "for the flowering of a provocative, if somewhat passive, conception of democracy . . . consumer democracy." See Stuart Ewen, *All Consuming Images* (New York: Basic Books, 1988), p. 12.

6. The classic dominant texts on corporate culture are Terrance Deal and Alan Kennedy, *Corporate Culture: The Rites and Rituals of Corporate Life* (Reading, Mass.: Addison-Wesley, 1982) and Thomas Peterson and Robert Waterman, *In Search of Excellence* (New York: Harper and Row, 1982). I also want to point out that corporate culture is a dynamic, ever-changing force. But in spite of its innovations and changes, it rarely if ever challenges the centrality of the profit motive, or fails to prioritize commercial considerations over a set of values that would call the class-based system of capitalism into question. For a brilliant discussion of the changing nature of corporate culture in light of the cultural revolution of the 1960s, see Thomas Frank, *The Conquest of Cool* (Chicago: University of Chicago Press, 1997).

7. Alan Bryman, *Disney and His Worlds* (New York: Routledge, 1995), p. 154.

8. For example, see Steve James, "Rich Man Gates Just Keeps Getting Richer," *Boston Globe*, June 21, 1999, p. A14.

9. Charles Derber, *Corporation Nation* (New York: St. Martin's Press, 1998), p. 12.

10. The growing extent of such inequality and the amassing of huge fortunes by a limited number of individuals can be seen in a recent report claiming that just three people own more personal wealth than six hundred million people combined in the world; *CNN Headline News*, July 17, 1999.

11. There are many books that address this issue, but some of the most helpful in providing hard statistical evidence for the growing corporate monopolization of American society can be found in Charles Derber's *Corporation Nation*; Dan Hazen and Julie Winokur, eds., *We the Media* (New York: The New Press, 1997); Robert W. McChesney, *Corporate Media and the Threat to Democracy* (New York: Seven Stories Press, 1997); Erik Barnouw, et al., *Conglomerates and the Media* (New York: The New Press, 1997); William Wolman and Anne Colamosca, *The Judas Economy: The Triumph of Capital and the Betrayal of Work* (Reading, Mass.: Addison-Wesley Publishing Company, Inc., 1997); Robert W. McChesney, *Rich Media, Poor Democracy* (Urbana: University of Illinois Press, 1999).

12. Robin D. G. Kelley, *Yo' Mama's Disfunktional! Fighting the Culture Wars in Urban America* (Boston: Beacon Press, 1997).

13. Peter Edelman, "The Worst Thing Bill Clinton Has Done," *The Atlantic Monthly*, March 1997, pp. 43–58.

14. For a context from which to judge the effects of such cuts on the poor and the children of America, see Children's Defense Fund, *The State of America's Children—A Report from the Children's Defense Fund* (Boston: Beacon Press, 1998).

15. Statistics cited in Ruth Sidel, *Keeping Women and Children Last* (New York: Penguin, 1996), p. xiv.

16. Henry A. Giroux, *Stealing Innocence* (New York: St. Martin's Press, 2000).

17. See especially John Dewey, *Democracy and Education* (New York: The Free Press, 1944; originally published in 1916).

18. Robert Zemsky, cited in Stanley Aronowitz, "The New Corporate University," *Dollars and Sense*, March/April 1998, p. 32.

19. For a critically insightful set of commentaries on the politics of work in higher education, see Randy Martin, ed., *Chalk Lines: The Politics of Work in the Managed University* (Durham, N.C.: Duke University Press, 1999).

20. Critical educators have provided a rich history of how both public and higher education has been shaped by the politics, ideologies, and images of industry. For example, see Samuel Bowles and Herbert Gintis, *Schooling in Capitalist America* (New York: Basic Books, 1976); Michael Apple, *Ideology and Curriculum* (New York: Routledge,

1977); Martin Carnoy and Henry Levin, *Schooling and Work in the Democratic State* (Stanford, Calif.: Stanford University Press, 1985); Stanley Aronowitz and Henry A. Giroux, *Education Still Under Siege* (Westport, Conn.: Bergin and Garvey, 1993); Stanley Aronowitz and William DiFazio, *The Jobless Future* (Minneapolis: University of Minnesota Press, 1994); Cary Nelson, ed., *Will Teach for Food* (Minneapolis: University of Minnesota Press, 1997); D. W. Livingstone, *The Education-Jobs Gap* (Boulder, Colo.: Westview, 1998).

21. Katherine S. Mangan, "Corporate Know-How Lands Presidencies for a Growing Number of Business Deans," *The Chronicle of Higher Education*, March 27, 1998, p. A43.

22. Ibid., p. A44.

23. Aronowitz, "The New Corporate University," pp. 32–35. For a detailed analysis of the rise and workings of the corporate university, see Stanley Aronowitz, *The Knowledge Factory: Dismantling the Corporate University and Creating True Higher Learning* (Boston: Beacon Press, 2000).

24. Cited in Martin Van Der Werf, "A Vice-President from the Business World Brings a New Bottom Line to Penn," *The Chronicle of Higher Education* 46:2 (September 3, 1999), p. A72.

25. Van Der Werf, "A Vice-President from the Business World Brings a New Bottom Line to Penn," p. A73.

26. Ibid.

27. Ibid.

28. Louis V. Gerstner Jr., "Public Schools Need to Go the Way of Business," *USA Today*, March 4, 1998, p. 13A.

29. Ibid.

30. Catherine S. Manegold, "Study Says Schools Must Stress Academics," *New York Times*, Friday, September 23, 1998, p. A22. It is difficult to understand how any school system could have subjected students to such a crude lesson in commercial pedagogy.

31. Stanley Aronowitz and William DiFazio, "The New Knowledge Work," in A. H. Halsey, et al., eds., *Education: Culture, Economy, Society* (New York: Oxford University Press, 1997), p. 193.

32. This is amply documented in Jeremy Rifkin, *The End of Work* (New York: G. P. Putnam's, 1995); Wolman and Colamosca, *The Judas Economy: The Triumph of Capital and the Betrayal of Work*; Aronowitz and DiFazio, *The Jobless Future* (New York: Times Books, 1996); and Stanley Aronowitz and Jonathan Cutler, *Post-Work* (New York: Routledge, 1998).

33. Ralph Nader, "Civil Society and Corporate Responsibility," speech given to the National Press Club and broadcast on C-Span 2 on March 25, 1998.

34. Cornel West, "The New Cultural Politics of Difference," *October* 53 (Summer 1990), p. 35.

35. Mangan, "Corporate Know-How Lands Presidencies for a Growing Number of Business Deans," p. A44.

36. James Carlin, cited in William H. Honan, "The Ivory Tower Under Siege," *New York Times*, Section 4A (January 4, 1998), p. 33.

37. Ibid.

38. Carlin, "Restoring Sanity to an Academic World Gone Mad," *The Chronicle of Higher Education*, November 5, 1999, p. A76.

39. Ibid., A71.

40. Bill Tierney, "Tenure and Community in Academe," *Educational Researcher* 26:8 (November 1997), p. 17.

41. Alison Schneider, "More Professors Are Working Part Time, and More Teach at 2-Year Colleges," *The Chronicle of Higher Education*, March 13, 1998, p. A14.

42. Statistics cited in Reed Abelson, "Silcon Valley Aftershocks," *New York Times*, April 4, 1999, section 3, p. 1.

43. Reference to Eisner cited in Liane Bonin, "Tragic Kingdom," *Detour*, April 1998, p. 70.

44. Aronowitz, "The New Corporate University," pp. 34–35.

45. This issue is taken up in Michael Bérubé, "Why Inefficiency Is Good for Universities," *The Chronicle of Higher Education*, March 27, 1998, pp. B4–B5.

46. There are a number of books that take up the relationship between schooling and democracy; some of the more important recent critical contributions include Elizabeth A. Kelly, *Education, Democracy, and Public Knowledge* (Boulder, Colo.: Westview, 1995); Wilfred Carr and Anthony Hartnett, *Education and the Struggle for Democracy* (Philadelphia: Open University Press, 1996); Henry A. Giroux, *Border Crossings: Cultural Workers and the Politics of Education* (New York: Routledge, 1993); Stanley Aronowitz and Henry A. Giroux, *Postmodern Education* (Minneapolis: University of Minnesota Press, 1991); Aronowitz and Giroux, *Education Still Under Siege*; and Henry A. Giroux, *Pedagogy and the Politics of Hope* (Boulder, Colo.: Westview, 1997).

47. Vaclav Havel, "The State of the Republic," *New York Review of Books*, June 22, 1998, p. 45.

48. Robin D. G. Kelley, "Neo-Cons of the Black Nation," *Black Renaissance Noire* 1:2 (Summer/Fall 1997), p. 146.

49. See Cary Nelson, ed., *Will Teach for Food: Academic Labor in Crisis*.

50. Cornel West, "America's Three-Fold Crisis," *Tikkun* 9:2 (1994), p. 42.

51. On this issue, see Nancy Fraser, *Justice Interruptus* (New York: Routledge, 1997).

CHAPTER 3

1. The term *multiculturalism* covers an extraordinary range of views about the central issues of culture, diversity, identity, nationalism, and politics. Moreover, the theoretical and political slipperiness of the term immediately make suspect any analysis that moves from the specific to the general in engaging a topic so diverse. Yet the arbitrary nature of such an analysis seems necessary if certain general tendencies that characterize a field are to be addressed and critically engaged, in spite of the presence of marginal discourses that are sometimes at odds with such tendencies. Some important recent books that address the multiple meanings of multiculturalism include Henry A. Giroux, *Living Dangerously: Multiculturalism and the Politics of Culture* (New York: Peter Lang, 1993); Henry A. Giroux, *Border Crossings* (New York: Routledge, 1992); David Theo Goldberg, ed., *Multiculturalism: A Critical Reader* (Malden, Mass.: Basil Blackwell, 1994); Avery Gordon and Christopher Newfield, eds., *Mapping Multiculturalism* (Minneapolis: University of Minnesota Press, 1996); and David Bennett, ed., *Multicultural States* (New York: Routledge, 1998).

2. For an extensive topography and critical analysis of diverse positions in multicultural education, see Joe L. Kincheloe and Shirley R. Steinberg, *Changing Multiculturalism* (New York: Open University Press, 1997).

3. A classic example of this type of work is Becky W. Thompson and Sangeeta Tyagi, eds., *Beyond a Dream Deferred: Multicultural Education and Politics* (Minneapolis: University of Minnesota Press, 1993).

4. An example of this can be found in Lawrence Levine, *The Opening of the American Mind* (Boston: Beacon Press, 1996).

5. On the reforms in general education that have been enacted under the banner of multiculturalism, see Michael Geyer, "Multiculturalism and the Politics of General Education," *Critical Inquiry* 19 (Spring 1993), pp. 499–533.

6. One important text in this genre is Gloria Anzaldua, ed., *Making Face, Making Soul/ Haciendo Caras: Creative and Critical Perspectives by Women of Color* (San Francisco: Aunt Lute Foundation, 1990). I would include here the emergence of critical scholarship on whiteness studies. The literature is too extensive to cite but some recent work includes Richard Delgardo and Jean Stefancic, eds., *Critical Whiteness Studies* (Philadelphia: Temple University Press, 1997); Ruth Frankenberg, ed., *Displacing Whiteness* (Durham, N.C.: Duke University Press, 1997); Mike Hill, ed., *Whiteness: A Critical Reader* (New York: New York University Press, 1997); Annalee Newitz and Matthew Wray, eds., *White Trash* (New York: Routledge, 1997); David R. Roediger, ed., *Black on White: Black Writers on What It Means to Be White* (New York: Schocken Books, 1998); Abby L. Ferber, *White Man Falling* (Lanham, Md.: Rowman and Littlefield, 1998). For an interesting essay on white studies, see Mike Hill, "'Souls Undressed': The Rise and Fall of New Whiteness Studies," *The Review of Education/Pedagogy/Cultural Studies* 20:3 (1998), pp. 229–39.

7. One example of such work can be found in Robert Gooding-Williams, ed., *Reading Rodney King: Reading Urban Uprising* (New York: Routledge, 1993).

8. See, for example, Michael Awkward, *Negotiating Difference* (Chicago: University of Chicago Press, 1995).

9. This notion of breaking into common sense is taken from Homi Bhabha, in Gary Olson and Lynn Worsham, "Staging the Politics of Difference: Homi Bhabha's Critical Literacy—an Interview," *Journal of Composition Theory* 18:3 (1998), p. 367.

10. John Beverly, "Pedagogy and Subalternity: Mapping the Limits of Academic Knowledge," in Rolland G. Paulston, ed., *Social Cartography* (New York: Garland, 1996), pp. 351–52.

11. For a selection of articles that address these issues, see Goldberg, ed., *Multiculturalism: A Critical Reader* (Malden, Mass.: Basil Blackwell, 1994).

12. On the issue of multiculturalism and border crossing, see Giroux, *Border Crossings*.

13. David Theo Goldberg, "Introduction: Multicultural Conditions," in Goldberg, ed., *Multiculturalism: A Critical Reader*, pp. 7–8.

14. This may explain why such conservatives as Nathan Glazer argue that we are all multiculturalists. Glazer's view of multiculturalism is so fatuous that to subscribe to it is to undermine any critical possibilities it might hold for educators. See Nathan Glazer, *We Are All Multiculturalists Now* (Cambridge, Mass.: Harvard University Press, 1998).

15. For a critique of multicultural texts that depoliticize issues of cultural difference while promoting forms of cultural tourism, see Julie Drew, "Cultural Tourism and the Commodified Other: Reclaiming Difference in the Multicultural Classroom," *The Review of Education/Pedagogy/Cultural Studies* 19:2–3 (1997), pp. 297–309.

16. For example, see Chandra Talpade Mohanty, "On Race and Voice: Challenges for Liberal Education in the 1990s," *Cultural Critique*, Winter 1998–1999, pp. 179–208; Stanley Fish, "Bad Company," *Transition* 56 (1992), pp. 60–67; Katya Gibel Azoulay, "Experience, Empathy and Strategic Essentialism," *Cultural Studies* 11:1 (1997), pp. 89–110.

17. Angela Y. Davis, "Gender, Class, and Multiculturalism: Rethinking 'Race' Politics," in Gordon and Newfield, eds., *Mapping Multiculturalism*, p. 41.

18. A classic example of this type of radical liberalism can be found in Charles Taylor, et. al., *Multiculturalism*, ed. Amy Gutman (Princeton, N.J.: Princeton University Press, 1994), especially Charles Taylor's work on the politics of recognition.

19. David Bennett, introduction to his *Multicultural States* (New York: Routledge, 1998), p. 4.

20. Ibid., p. 5.

21. Avery Gordon and Christopher Newfield, "Multiculturalism's Unfinished Business," in Gordon and Newfield, eds., *Mapping Multiculturalism*, p. 80.

22. Wendy Brown argues that identity has to be explored as a historical production and that some forms of identity politics often locate subordinated groups within a politics of recrimination that reinscribes the discourse of pain, victimization, and suffering as a substitute (an incapacity) for any form of resistance and action. See Wendy Brown, "Injury, Identity, Politics," in Gordon and Newfield, eds., *Mapping Multiculturalism*, pp. 149–65.

23. See, for instance, S. Gillespie and R. Singleton, eds., *Across Cultures: A Reader for Writers*, 3rd ed. (Boston: Bedford, 1992); and G. R. Colombo and B. Lisle, eds., *ReReading America: Cultural Contexts for Critical Thinking and Writing*, 2nd ed. (Boston: Bedford, 1992).

24. Homi Bhabha, cited in Gary Olson and Lynn Worsham, "Staging the Politics of Difference: Homi Bhabha's Critical Literacy—An Interview," pp. 371–72.

25. One example of this approach can be found in Elizabeth Ellsworth, "Double Binds of Whiteness," in Michelle Fine, et al., eds., *Off White: Readings on Race, Power, and Society* (New York: Routledge, 1997).

26. Gayatri Chakravorty Spivak, *Outside the Teaching Machine* (New York: Routledge, 1993); M. Jacqui Alexander and Chandra Talpade Mohanty, eds., *Feminist Genealogies, Colonial Legacies, Democratic Futures* (New York: Routledge, 1997); Ella Shohat and Robert Stam, *Unthinking Eurocentrism* (New York: Routledge, 1994).

27. An excellent version of this argument can be found in Maurice Berger in the introduction to his *The Crisis of Criticism* (New York: The New Press, 1998), pp. 1–14.

28. Herman Gray, "Is Cultural Studies Inflated?" in Cary Nelson and Dilip Parameshway Goankar, eds., *Disciplinarity and Dissent in Cultural Studies* (New York: Routledge, 1996), p. 211.

29. David Theo Goldberg, "Introduction: Multicultural Conditions," in Goldberg, ed., *Multiculturalism: A Critical Reader*, pp. 13–14.

30. Of course, there are many exceptions to this rule, but they are marginal to the multiculturalist discourses within the university. See, for example, many of the essays in Cameron McCarthy and Warren Crichlow, eds., *Race, Identity, and Representation in Education* (New York: Routledge, 1993), as well as William V. Flores and Rina Benmayor, *Latino Cultural Citizenship* (Boston: Beacon Press, 1997); E. San Juan Jr., *Racial Formations/Critical Transformations: Articulations of Power in Ethnic and Racial Studies in the United States* (Atlantic Highlands, N.J.: Humanities Press, 1992); Peter McLaren, *Revolutionary Multiculturalism* (Boulder, Colo.: Westview Press, 1997); Slavoj Zizek, "Multiculturalism, or, the Cultural Logic of Multinational Capitalism," *New Left Review* 225 (September/October 1997), pp. 28–51.

31. George Lipsitz, "Listening to Learn and Learning to Listen: Popular Culture, Cultural Theory, and American Studies," *American Quarterly* 42:4 (December 1990), p. 621.

32. In opposition to this type of textualism, Lawrence Grossberg argues that Edward Said's *Orientalism* is a classic example of a text that focuses on questions of difference, identity, and subjectivity while engaging the related issues of materialism and power. See Lawrence Grossberg, "Identity and Cultural Studies: Is That All There

Is?" in Stuart Hall and Paul Du Gay, eds., *Questions of Cultural Identity* (Thousand Oaks, Calif.: Sage, 1996), pp. 87–107.

33. Arthur Schlesinger Jr., *The Disuniting of America* (Knoxville, Tenn.: Whittle District Books, 1992); Richard J. Herrnstein and Charles Murray, *The Bell Curve: Intelligence and Class Structure in American Life* (New York: The Free Press, 1994); Dinesh D'Souza, *The End of Racism* (New York: The Free Press, 1995); Robert Bork, *Slouching Toward Gomorrah: Modern Liberalism and American Decline* (New York: Regan Books, 1996); Shelby Steele, *A Dream Deferred: The Second Betrayal of Black Freedom in America* (New York: HarperCollins, 1998); Stephan and Abigail Thernstrom, *America in Black and White: One Nation, Indivisible* (New York: Simon and Schuster, 1997).

34. Jack H. Geiger, "The Real World of Race," *The Nation*, December 1, 1998, p. 27.

35. For a detailed treatment of the way in which race shapes these attitudes between blacks and whites, see David K. Shipler, *A Country of Strangers: Blacks and Whites in America* (New York: Vintage, 1998).

36. For a brilliant analysis of support and funding of right-wing attacks on multiculturalism, and other progressive causes, see Eric Alterman, "The 'Right' Books and Big Ideas," *The Nation*, November 22, 1999, pp. 16–21.

37. Stanley Fish, "Bad Company," *Transition* 56 (Winter 1992), p. 64.

38. Pierre Bourdieu, *Acts of Resistance: Against the Tyranny of the Market* (New York: The New Press, 1998), pp. 2–3.

39. See, for example, McLaren, *Revolutionary Multiculturalism*; Goldberg, ed., *Multiculturalism: A Critical Reader*; Gordon and Newfield, eds., *Mapping Multiculturalism*; Lisa Lowe, *Immigrant Acts: On Asian American Cultural Studies* (Durham, N.C.: Duke University Press, 1996); Wahneema Lubiano, ed., *The House That Race Built* (New York: Pantheon, 1997); Montserrat Guibernau and John Rex, eds., *The Ethnicity Reader* (New York: Polity, 1997); Bennett, ed., *Multicultural States*; Rodolfo D. Torres, Louis F. Miron, and Jonathan Xavier Inda, eds., *Race, Identity, and Citizenship: A Reader* (Malden, Mass.: Basil Blackwell, 1999).

40. Wahneema Lubiano, "Like Being Mugged by a Metaphor: Multiculturalism and State Narratives," in Gordon and Newfield, eds., *Mapping Multiculturalism*, pp. 64–75.

41. Manning Marable, "Beyond Color-Blindness," *The Nation*, December 14, 1998, p. 31.

42. Lawrence Grossberg, "Cultural Studies: What's in a Name?" *Bringing It All Back Home: Essays on Cultural Studies* (Durham, N.C.: Duke University Press, 1997), p. 268.

43. Ibid., p. 248.

44. Marable, "Beyond Color-Blindness," p. 31.

45. Grossberg, "Cultural Studies: What's in a Name?" pp. 252–53.

46. David Theo Goldberg, *Racist Culture* (Malden, Mass.: Basil Blackwell, 1993), p. 105.

47. Ruth Bader Ginsburg, cited in "Race On Screen and Off," *The Nation*, December 29, 1997, p. 6.

48. David K. Shipler, summarized in Jack H. Geiger, "The Real World of Race," p. 27. See also David K. Shipler, "Reflections on Race," *Tikkun* 13:1 (1998), pp. 59, 78; and David K. Shipler, *A Country of Strangers: Blacks and Whites in America* (New York: Vintage, 1998).

49. Ellen Willis argues that the two major upheavals in America's racial hierarchy have been the destruction of the southern caste system and the subversion of whiteness as an unquestioned norm. She also argues rightly that to dismiss these achievements as having done little to change racist power relations insults people who have engaged in these struggles. See Ellen Willis, "The Up and Up: On the Limits of Optimism," *Transition* 7:2 (1998), pp. 44–61.

50. For a compilation of figures suggesting the ongoing presence of racism in American society, see Ronald Walters, "The Criticality of Racism," *Black Scholar* 26:1 (Winter 1996), pp. 2–8; The Children's Defense Fund, *The State of America's Children—A Report from the Children's Defense Fund* (Boston: Beacon Press, 1998).

51. For a devastating critique of Randall Kennedy's move to the right, see Derrick Bell, "The Strange Career of Randall Kennedy," *New Politics* 7:1 (Summer 1998), pp. 55–69.

52. Azoulay, "Experience, Empathy and Strategic Essentialism," p. 91.

53. Robin D. G. Kelley, "Integration: What's Left," *The Nation*, December 14, 1998, p. 18.

54. Randall Johnson, "Editor's Introduction." Art, Literature and Culture," in Pierre Bourdieu, *The Field of Cultural Production: Essays on Art and Literature* (New York: Columbia University Press, 1993), p. 19.

55. Ibid., p. 17.

56. This issue is taken up in John Devine, *Maximum Security: The Culture of Violence in Inner-City Schools* (Chicago: University of Chicago Press, 1996). Unfortunately, Devine's remedy for the militarization of school space is to blame students for not being civil enough. Hence he undermines an interesting analysis of the culture of violence in schools by framing his solutions within a paradigm that is utterly privatized and trapped within the discourse of the genteel brigade led by ultra-self-righteous moralizers like William Bennett.

57. These figures are cited in Fox Butterfield, "Crime Keeps on Falling, But Prisons Keep on Filling," *New York Times*, Sunday, September 28, 1997, p. A1. Jimmie L. Reeves and Richard Campbell provide a more extensive picture of prison growth in the United States: "During the Reagan era, in fact, the U.S. prison population nearly doubled (from 329,821 in 1980 to 627,402 in 1989) as the number of drug arrests nationwide increased from 471,000 in 1980 to 1,247,000 in 1989. By 1990 the United States had the highest incarceration rate in the world: 942.6 per 100,000 compared to 333 per 100,000 in South Africa, its closest competitor). In that same year—when about half the inmates in federal prisons were there on drug offenses—African Americans made up almost half of the U.S. prison population, and about one in four young black males in their twenties were either in jail, on parole, or on probation (compared to only 6 percent for white males)." Jimmie L. Reeves and Richard Campbell, *Cracked Coverage: Television News, the Anti-cocaine Crusade, and the Reagan Legacy* (Durham, N.C.: Duke University Press, 1994), p. 41.

58. Marable, "Beyond Color-Blindness," p. 31.

59. Lawrence Grossberg, "The Victory of Culture, Part I," University of North Carolina at Chapel Hill, unpublished manuscript, February 1998, p. 27.

60. Figures cited in The Justice Policy Institute/Center on Juvenile and Criminal Justice Policy Report, *From Classrooms to Cell Blocks: How Prison Building Affects Higher Education and African American Enrollment in California* (San Francisco: Justice Policy Institute, 1996), p. 2.

61. Cited in "From Classrooms to Cell Blocks: A National Perspective," The Justice Policy Institute, February 1997, p. 2.

62. These quotes come from Reeves and Campbell, *Cracked Coverage: Television News, the Anti-cocaine Crusade, and the Reagan Legacy*, pp. 40–41.

63. Michael Bérubé, "Disuniting America Again," *The Journal of the Midwest Modern Language Association* 26:1 (Spring 1993), p. 41.

CHAPTER 4

1. I take this issue up in more detail in Henry A. Giroux, *Stealing Innocence:Youth, Corporate Power, and the Politics of Culture* (New York: St. Martin's Press, 2000).

2. Leon Botstein, "Making the Teaching Profession Respectable Again," *New York Times,* Monday, July 26, 1999, p. A19. Elaine Showalter, "The Risks of Good Teaching: How 1 Professor and 9 T.A.'s Plunged into Pedagogy," *The Chronicle of Higher Education* 45:44 (July 9, 1999), pp. B4–B6.

3. Leon Botstein, "Making the Teaching Profession Respectable Again," A19.

4. Elaine Showalter, "The Risks of Good Teaching: How 1 Professor and 9 T.A.'s Plunged into Pedagogy," p. B4.

5. Ibid.

6. Ibid., p. B5.

7. Ibid.

8. Ibid., p. B6.

9. To be fair to Showalter, she is not alone among humanities scholars in refusing to step outside of her discipline in order to gain some theoretical purchase on important work done in critical pedagogy. Another recent example can be found in Biddy Martin, "Introduction: Teaching, Literature, Changing Cultures," *PMLA* 112:1 (January 1997), pp. 7–25.

10. For an extensive analysis of the ethical grounding of critical pedagogy in the unfinishedness of human beings and their insertion into the permanent process of decision making, freedom, options, breaking with the past, and the ongoing formation of the self, see Paulo Freire, *Pedagogy of Freedom* (Lanham, Md.: Rowman and Littlefield, 1999).

11. See, for example, Homi Bhabha, *The Location of Culture* (New York: Routledge, 1994).

12. Bhabha, *The Location of Culture,* p. 181.

13. Gary A. Olson and Lynn Worsham, "Staging the Politics of Difference: Homi Bhabha's Critical Literacy—An Interview," *Journal of Composition Theory* 18:3 (1998), pp. 361–91.

14. Ibid., p. 363.

15. Ranajit Guha, *Elementary Aspects of Peasant Insurgency in Colonial India* (New York: Oxford University Press, 1983), p. 333.

16. Olson and Worsham, "Staging the Politics of Difference," p. 367.

17. Ibid., p. 369.

18. Homi Bhabha, "Dance This Diss Around," *Artforum,* April 1995, p. 20.

19. Paulo Freire, *Pedagogy of Freedom,* p. 48.

20. On this issue, see Ernesto Laclau's remarks in Lynn Worsham and Gary Olson, "Hegemony and the Future of Democracy," *Journal of Composition Theory* 19:1 (1999), pp. 1–34.

21. Homi Bhabha, "The World and the Home," *Social Text* 30–31 (1992), pp. 141–153. See also Homi Bhabha, "The Commitment to Theory," *New Formations,* Summer 1998, pp. 5–22.

22. Bhabha takes this up in a number of pieces. We particularly like his rendering of the issue in "The World and the Home," pp. 141–53, and "The Enchantment of Art," in Carol Becker and Ann Wiens, eds. *The Artist in Society* (Chicago: New Art Examiner, 1994), pp. 24–34.

23. Homi Bhabha, "A Good Judge of Character: Men, Metaphors, and the Common Culture," in Toni Morrison, ed., *Race-ing Justice, Engendering Power: Essays on Anita Hill, Clarence Thomas, and the Construction of Social Reality* (New York: Pantheon, 1992), pp. 244–45.

24. Olson and Worsham, "Staging the Politics of Difference," p. 372.

25. Ibid., p. 390.

26. This issue is taken up in Lynn Worsham, "Going Postal: Pedagogic Violence and the Schooling of Emotion," *Journal of Compositon Theory* 18:2 (1998), pp. 213–46.

27. Frederick Douglass, *My Bondage and My Freedom* (New York: Dover, 1969), p. 146.

28. Ibid.

29. Ibid., pp. 157–58.

30. Ibid., p. 158.

31. Ibid.; emphasis added.

32. Lawrence Grossberg, "Identity and Cultural Studies: Is That All There Is?" in Stuart Hall and Paul Du Gay, eds. *Questions of Cultural Identity* (Thousand Oaks, Calif.: Sage, 1996), pp. 101–2.

33. This position is taken up in Lawrence Grossberg, "Toward a Genealogy of the State of Cultural Studies," in Cary Nelson and Dilip Parmeshwar Gaonkar, eds., *Disciplinarity and Dissent in Cultural Studies* (New York: Routledge, 1996), pp. 131–47.

34. Stuart Hall, cited in Peter Osborne and Lynne Segal, "Culture and Power: Interview with Stuart Hall," *Radical Philosophy* 86 (November/December 1997), p. 31.

35. Rosalind O'Hanlon, cited in Lawrence Grossberg, "Identity and Cultural Studies," p. 99.

36. Ibid., p. 100.

37. Homi K. Bhabha, "Editor's Introduction: Minority Maneuvers and Unsettled Negotiations," *Critical Inquiry* 23 (1997), p. 432.

38. Shoshana Felman, *Jacques Lacan and the Adventure of Insight: Psychoanalysis in Contemporary Culture* (Cambridge: Harvard University Press, 1987), p. 79. For an extensive analysis of the relationship between schooling, literacy, and desire, see Ursula A. Kelly, *Schooling Desire: Literacy, Cultural Politics, and Pedagogy* (New York: Routledge, 1997); Sharon Todd, *Learning Desire: Perspectives on Pedagogy, Culture, and the Unsaid* (New York: Routledge, 1997).

39. Shoshana Felman, *Jacques Lacan and the Adventure of Insight*, p. 79.

40. Todd Gitlin, *The Twilight of Our Common Dreams: Why America Is Wracked by Culture Wars* (New York: Metropolitan Books, 1995).

41. Cited in Ernesto Laclau, "Lynn Worsham and Gary A. Olson," Hegemony and the Future of Democracy: Ernesto Laclau's Political Philosophy," *Journal of Composition Theory* 19:1 (1999), p. 12.

42. Lawrence Grossberg, "Identity and Cultural Studies: Is That All There Is?" pp. 99–100.

CHAPTER 5

I have developed many of the ideas presented in this chapter in Henry A. Giroux, *The Mouse That Roared: Disney and the End of Innocence* (Lanham, Md.: Rowman and Littlefield, 1999).

1. Stuart Hall, "The Centrality of Culture: Notes on the Cultural Revolutions of Our Time," in Kenneth Thompson, ed., *Media and Cultural Regulation* (Thousand Oaks, Calif.: Sage, 1997), p. 232.

2. A list of Disney's holdings, cited in "The National Entertainment State Media Map," *The Nation*, June 3, 1996, pp. 23–26. See also, Robert W. McChesney, "Oligopoly: The Media Game Has Fewer and Fewer Players," *The Progressive*, November 1999, p. 22.

3. The concentrated power of the media market by corporations is evident in the following figures. According to Robert W. McChesney, "In cable, Time Warner and TCI [now AT&T] control 47.4 percent of all subscribers; in radio, Westinghouse, in addition to owning the CBS Television network, now owns 82 radio stations; in books, Barnes & Noble and Borders sell 45 percent of all books in the United States. . . . In newspapers, only 24 cities compared to 400 fifty years ago support two or more daily newspapers." Robert W. McChesney, "Global Media for the Global Economy," in Don Hazen and Julie Winokur, eds., *We the Media* (New York: The New Press, 1997), p. 27.

4. Don Hazen and Julie Winokur, "Children Watching TV," Hazen and Winokur, eds., *We the Media* (New York: The New Press, 1997), p. 64.

5. Ibid.

6. See Lawrie Mifflin, "Pediatricians Urge Limiting TV Watching," *New York Times*, August 4, 1999, pp. A1, A4.

7. Pierre Bourdieu's analysis of the systemic corruption of television in France is equally informative when applied to the United States. See his *On Television*, trans. Priscilla Parkhust Ferguson (New York: The New Press, 1998).

8. The Disney/Sprewell deal is mentioned in William C. Rhoden, "Long Road for a Short, Wild Season," *New York Times*, June 26, 1999, p. B15.

9. *Disney Magazine*, Fall 1998, p. 61.

10. Ernest Larsen, "Compulsory Play," *The Nation*, March 16, 1998, p. 31.

11. Ibid., p. 32.

12. Karen Klugman, et al., *Inside the Mouse: Work and Play at Disney World* (Durham, N.C.: Duke University Press, 1995), p. 119.

13. Andrew Ross, *The Celebration Chronicles* (New York: Ballantine Books, 1999), p. 310.

14. Klugman, et al., *Inside the Mouse: Work and Play at Disney World*, p. 119.

15. Joshua Karliner, "Earth Predators," *Dollars and Sense*, July/August 1998, p. 7. For an extensive analysis of media concentration and its effects on democracy, see Robert W. McChesney, *Rich Media, Poor Democracy* (Urbana, Ill.: University of Illinois Press, 1999).

16. Robert W. McChesney, *Corporate Media and the Threat to Democracy* (New York: Seven Stories Press, 1997), p. 18. There is an enormous amount of detailed information about the new global conglomerates and their effects on matters of democracy, censorship, free speech, social policy, national identity, and foreign policy. For example, see such classics as Herbert I. Schiller, *Culture Inc.: The Corporate Takeover of Public Expression* (New York: Oxford University Press, 1989); Edward S. Herman and Noam Chomsky, *Manufacturing Consent* (New York: Pantheon, 1988); Ben H. Bagdikian, *The Media Monopoly*, 4th ed. (Boston: Beacon Press, 1992); George Gerbner and Herbert I. Schiller, eds., *Triumph of the Image* (Boulder, Colo.: Westview Press, 1992); Douglas Kellner, *Television and the Crisis of Democracy* (Boulder, Colo.: Westview Press, 1990); Philip Schlesinger, *Media, State and Nation* (London: Sage, 1991); John Fiske, *Media Matters* (Minneapolis: University of Minnesota Press, 1994); Jeff Cohen and Norman Solomon, *Through the Media Looking Glass* (Monroe, Maine: Common Courage Press, 1995); and Erik Barnouw, *Conglomerates and the Media* (New York: The New Press, 1997).

17. Russell Mokhiber and Robert Weissman, *Corporate Predators: The Hunt for Mega-Profits and the Attack on Democracy* (Munroe, Maine: Common Courage Press, 1999), p. 167.

18. Zygmunt Bauman, *Globalization: The Human Consequences* (New York: Columbia University Press, 1998), p. 70.

19. Raymond Williams, *The Politics of Modernism* (London: Verso Press, 1989).

20. Two recent critical commentaries can be found in Robert W. McChesney, *Corporate Media and the Threat to Democracy* (New York: Seven Stories Press, 1997); and Erik Barnouw, et al., eds., *Conglomerates and the Media* (New York: The New Press, 1997).

21. Figures taken from Michael D. Eisner, "Letter to Shareholders," *The Walt Disney Company 1997 Annual Report* (Burbank, Calif.: The Walt Disney Company, 1997), p. 2. For the 1998 reference, see Lauren R. Rublin, "Cutting Back the Magic," *Barron's*, July 26, 1999, p. 28.

22. Michael Ovitz, cited in Peter Bart, "Disney's Ovitz Problem Raises Issues for Showbiz Giants," *Daily Variety*, December 16, 1996, p. 1.

23. Kenneth Burke, *A Rhetoric of Motives* (Berkeley and Los Angeles: University of California Press, 1962), p. 26.

24. Eisner, "Letter to Shareholders," p. 5.

25. Michael D. Eisner, cited in Peter Bart, "The Mouse Mess," *GQ*, August 1999, p. 82.

26. Mokhiber and Weissman, *Corporate Predators*, p. 168.

27. Ibid.

28. Ray Sanches, "'Misery' for Haitian Workers," *New York Newsday*, June 16, 1996, pp. A4, A30.

29. Blair Kamin, "Faking History," *Chicago Tribune*, August 5, 1999, section 5, p. 1B.

30. Disney's stock was the worst performer on the Dow Jones Industrial Average from August 1998 to August 1999; Lauren R. Rublin, "Cutting Back the Magic," *Barron's*, July 26, 1999, pp. 27–30.

31. Karen Klugman, et al., *Inside the Mouse*, p. 125. For an excellent chapter on Disney's relations with its workers at Disney World, see Jane Kuenz, "Working at the Rat," also in Klugman, et al., *Inside the Mouse*, pp. 110–61.

32. Michael Eisner, "Planetized Entertainment," *New Perspectives Quarterly* 12:4 (Fall 1995), p. 9; emphasis added.

33. Mike Wallace, *Mickey Mouse History* (Philadelphia: Temple University Press, 1996), p. 170.

34. Chris Rojeck, "Disney Culture," *Leisure Studies* 12 (1993), p. 121.

35. Philip Corrigan and Derek Sayer, *The Great Arch* (London: Basil Blackwell, 1985), p. 4.

36. Toby Miller, *Technologies of Truth* (Minneapolis: University of Minnesota Press, 1998), p. 90.

37. Susan Willis, "Problem with Pleasure," in Klugman, et al., eds., *Inside the Mouse: Work and Play at Disney World*, p. 5.

38. See Ernst Bloch, *The Utopian Function of Art and Literature*, trans. Jack Zipes and Frank Mecklenburg (Cambridge, Mass.: MIT Press, 1988). Ernst Bloch, *The Principle of Hope*, vol. 1, trans. Neville Plaice, Stephen Plaice, and Paul Knight (Cambridge, Mass.: MIT Press, 1986).

39. Ernst Bloch, cited in Anson Rabinach, "Unclaimed Heritage: Ernst Bloch's *Heritage of Our Times* and the Theory of Fascism," *New German Critique*, Spring 1977, p. 8.

40. I invoke here Meaghan Morris's argument in which she identifies the chief error of cultural studies to be the narcissistic identity that is made "between the

knowing subject of cultural studies, and a collective subject, the 'people.'" The people in this discourse "have no necessary defining characteristics—except an indomitable capacity to 'negotiate' readings, generate new interpretations, and remake the materials of culture. . . . So against the hegemonic force of the dominant classes, 'the people' in fact represent the most creative energies and functions of critical reading. In the end they are not simply the cultural student's object of study, [but] his native informants. The people are also the textually delegated, allegorical emblem of the critic's own activity." See Meaghan Morris, "Banality in Cultural Studies," *Discourse* 10:2 (Spring/Summer 1988), p. 17.

41. David Buckingham "Dissin' Disney: Critical Perspectives on Children's Media Culture," *Media, Culture, and Society* 19 (1997), p. 290.

42. Edward W. Said, *The World, the Text, and the Critic* (Cambridge, Mass.: Harvard University Press, 1983), p. 169.

43. This issue is raised in an interesting way in Roger Silverstone, "So Who Are These People," *Sight and Sound* 9:5 (May 1999), pp. 28–29.

44. On another political register expanding democratic public culture means working hard to get organized labor and progressive social movements to join together to forge new partnerships willing to pool some of their intellectual and material resources in order to create alternative public spheres in which democratic identities, relations, and values can flourish and offer multiple sites of resistance to a culture industry such as Disney in which the call for innocence, happiness, and unity appears to be "transformed into a prohibition on thinking itself." Theodor W. Adorno, *Critical Models* (New York: Columbia University Press, 1998), p. 290.

CHAPTER 6

1. Sarah Pollock interview with "Robert Haas," in *Mother Jones*, March/April 1997, p. 22.

2. Lawrence Grossberg, "Bringing It All Back Home—Pedagogy and Cultural Studies," in Henry A. Giroux and Peter McLaren, eds., *Between Borders: Pedagogy and the Politics of Cultural Studies* (New York: Routledge, 1994), p. 248.

3. Lawrence Grossberg, "Toward a Genealogy of the State of Cultural Studies," in Cary Nelson and Dilip Parameshwar Gaonkar, eds., *Disciplinarity and Dissent in Cultural Studies* (New York: Routledge, 1996), p. 143.

4. Ibid., p. 143.

5. David Bailey and Stuart Hall, "The Vertigo of Displacement," *Ten 8* 2:3 (1992), p. 19.

6. My notion of interdisciplinary comes from Mas'ud Zavarzadeh and Donald Morton, "Theory, Pedagogy, Politics: The Crisis of the 'Subject' in the Humanities," in Mas'ud Zavarzadeh and Donald Morton, eds., *Theory Pedagogy Politics: Texts for Change*, (Urbana: University of Illinois Press, 1992), p. 10. At issue here is neither ignoring the boundaries of discipline-based knowledge nor simply fusing different disciplines, but creating theoretical paradigms, questions, and knowledge that cannot be taken up within the policed boundaries of the existing disciplines.

7. Martha C. Nussbaum, "The Professor of Parody," *The New Republic*, February 22, 1999, p. 42.

8. Robert W. McChesney, introduction to Noam Chomsky, *Profit Over People* (New York: Seven Stories Press, 1999), p. 9.

9. Lawrence Grossberg, "Toward a Genealogy of the State of Cultural Studies," p. 145.

10. Stuart Hall and David Held, "Citizens and Citizenship," in Stuart Hall and Martin Jacques, eds., *New Times: The Changing Face of Politics in the 1990s* (London: Verso, 1990), pp. 173–88.

11. Simon Frith, *Performance Rites* (Cambridge, Mass.: Harvard University Press, 1996), p. 204.

12. Grant Kester, "(Not) Going with the Flow: The Politics of Deleuzean Aesthetics," in Amitava Kumar, ed., *Poetics/Politics: Radical Aesthetics for the Classroom* (New York: St. Martin's Press, 1999), p. 25.

13. Needless to say, cultural studies theorists such as Stuart Hall, Meaghan Morris, Tony Bennett, Lawrence Grossberg, Angela McRobbie, Doreen Massey, Herman Gray, and Stanley Aronowitz, to name only a few, have long refused reducing cultural studies to a form of textualism.

14. Gordon cited in Joy James, *Transcending the Talented Tenth: Black Leaders and American Intellectuals* (New York: Routledge, 1997), p. 175.

15. Ellen Willis, "We Need a Radical Left," *The Nation*, June 29, 1998, p. 19.

16. Raymond Williams, "Adult Education and Social Change," in *What I Came to Say* (London: Hutchinson-Radus, 1989), p. 158.

17. Raymond Williams, *Communications* (New York: Barnes and Noble, 1967), p. 15.

18. Antonio Gramsci, *Selections from the Prison Notebooks* (New York: International Press, 1971), p. 350.

19. I take this issue up in great detail in Henry A. Giroux, *Border Crossings: Cultural Workers and the Politics of Education* (New York: Routledge, 1992).

20. Cary Nelson, "Cultural Studies and the Politics of Disciplinarity," in Nelson and Gaonkar, eds., *Disciplinarity and Dissent in Cultural Studies*, p. 7.

21. Stuart Hall, "Race, Culture, and Communications: Looking Backward and Forward at Cultural Studies," *Rethinking Marxism* 5:1 (Spring 1992), p. 18.

22. The term *professionalist legitimation* comes from my personal correspondence with Professor Jeff Williams of the University of Missouri.

23. Lawrence Grossberg, "Cultural Studies: What's in a Name?" in *Bringing It All Back Home: Essays on Cultural Studies* (Durham, N.C.: Duke University Press, 1997), p. 261.

24. See Suzanne Lacy, "Introduction: Cultural Pilgrimages and Metaphoric Journeys," in Suzanne Lacy, ed., *Mapping the Terrain: New Genre Public Art* (Seattle: Bay State Press, 1995), pp. 19–47; Guillermo Gomez-Peña, *The New World Border* (San Francisco: City Lights Books, 1996).

25. Pierre Bourdieu, *Acts of Resistance* (New York: New Press, 1999), p. 8.

26. For a summary of some of Lacy's work, see Jeff Kelley, "The Body Politics of Suzanne Lacy," in Nina Felshin, ed., *But Is It Art?* (Seattle: Bay Press, 1995), pp. 221–49.

27. George Lipsitz, "Facing Up to What's Killing Us: Artistic Practice and Grassroots Social Theory," in Elizabeth Long, ed., *From Sociology to Cultural Studies* (Malden, Mass.: Basil Blackwell, 1997), p. 252.

28. Peggy Phelan, *Unmarked: The Politics of Performance* (New York: Routledge, 1993), see especially the afterword, "Notes on Hope."

29. Stuart Hall, "Race, Culture and Communications: Looking Backward and Forward at Cultural Studies," p. 11.

30. For a response to the charge that critical pedagogy, especially the work of Paulo Freire, is overly doctrinaire and impositional, see Paulo Freire and Donaldo

Macedo, "A Dialogue: Culture, Language, and Race," in Pepi Leistyna, Arlie Woodrum, and Stephen A. Sherblom, eds., Breaking Free: The Transformative Power of Critical Pedagogy (Cambridge, Mass.: Harvard Educational Review, 1996), pp. 199–228.

31. This issue is taken up brilliantly in Paulo Freire, Pedagogy of Freedom (Lanham, Md.: Rowman & Littlefield, 1999).

32. bell hooks, "Narratives of Struggle," in Philomena Mariani, ed., Critical Fictions: The Politics of Imaginative Writing (Seattle: Bay Press, 1991), p. 56.

33. Gerald Graff, "Teaching the Conflicts," Darryl J. Gless and Barbara Herrnstein Smith, eds,. The Politics of Liberal Education (Durham, N.C.: Duke University Press, 1992), pp. 57–73.

34. Paul Gilroy, The Black Atlantic (Cambridge, Mass.: Harvard University Press, 1994).

35. Suzanne Lacy, "Introduction: Cultural Pilgrimages and Metaphoric Journeys," p. 20.

36. For a brilliant analysis of the importance of radical democracy as a project for progressive and left cultural workers, see Stanley Aronowitz, The Death and Rebirth of American Radicalism (New York: Routledge, 1996).

index